1985

Bill Kurtis
ON ASSIGNMENT

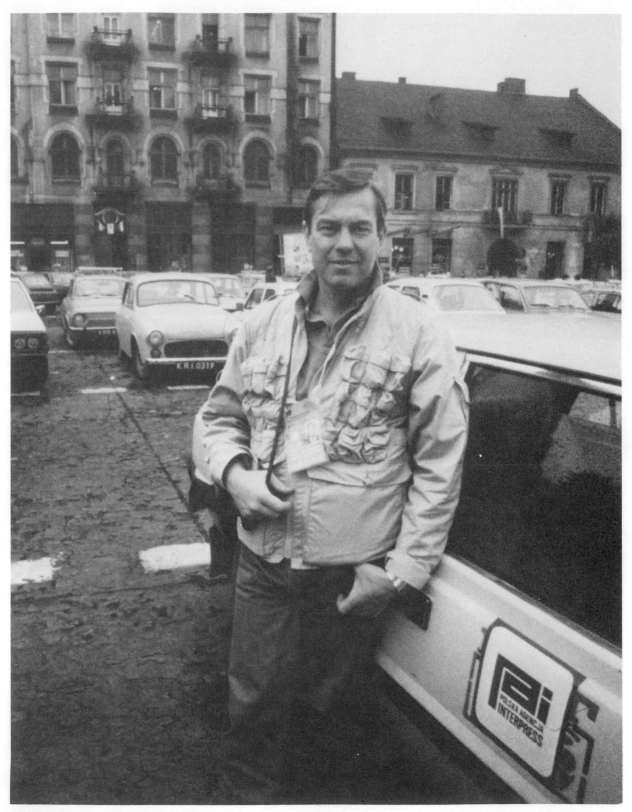

The author in Krakow, Poland, 1983.

Bill Kurtis
ON ASSIGNMENT

Rand McNally & Company

Chicago • New York • San Francisco

Photo Credits

United Press International, 44, 48 (by Dennis Cook), 73, 182

All other photographs were taken by Bill Kurtis or are from the author's collection

Portions of "Saigon Revisited: Finding the American Faces" appeared in slightly different form in the *New York Times Magazine*, March 2, 1980; parts of "Searching for the Spirit of Solidarity" appeared in the *Chicago Sun-Times*, February 15 and 16, 1981

Library of Congress Cataloging in Publication Data

Kurtis, Bill.
 Bill Kurtis on assignment.
 1. Kurtis, Bill. 2. Journalists—United States—
Biography. I. Title.
PN4874.K86A33 1983 070'.92'4 [B] 83-13988
ISBN 0-528-81005-7

Acknowledgments

Any communications enterprise, whether it is
a book or a television documentary, necessarily
involves the efforts of many people.
This work covers so many years, and there are
so many individuals who have touched my life
and career, that I hope they will understand
if I thank them collectively here rather than
risk the embarrassment of facing someone
whose name was inadvertently left out.

Some of the material might be vaguely
familiar if you read the *New York Times Magazine*
and the *Chicago Sun-Times* or watch CBS Television.
I thank them for the use of material gathered
while I was on assignment. Finally, I salute
those members of my profession who search
diligently for the truth in the crucible
of deadline reporting.

—B.K.

Contents

Introduction 7

Persian Odyssey 13
 Media Held Hostage 35

Agent Orange: Anatomy of a Documentary 39

Saigon Revisited: Finding the American Faces 81
 The Rice Flight 103

The Priest Who Walked Away 108

Witness to Extinction 128
 Massacre in Northern Kenya 166

Searching for the Spirit of Solidarity 171
 Under Arrest 189

Introduction

If it looked like rain, we'd work until the hay was in the barn and the pastures of big bluestem grass were cut as smooth as a front lawn. Only then would they turn us loose, a bunch of rangy youngsters who had put in a day's work that would have crippled older men, and we'd pile into my '48 Chevy and head back to Independence, Kansas.

Dog-tired, caked with sweat and hay dust that turned our faces black, weak-kneed from hoisting hundred-pound bales in hundred-degree temperatures, we panted for the first breeze that funneled past the coupe's old wing windows as we headed for home.

There was a magic time in Kansas when the sun lost its violence and hung on the edge of Dyer's Hill, spraying the mountainous thunderheads with the color of spring roses. An airless quality took hold, as if time stopped to enjoy the moment.

Although we had the inconscience of youngsters who don't have a responsibility in the world, we were always struck with a near-religious appreciation for that special time. Almost every evening we would stop the stumpy black car at the highest point around, turn off the engine, and listen.

Crickets were still cautious about starting their evening concert, not quite sure if the sun had gone completely. Oil-well pumps miles away chugging in a mechanical choir supplied the background music for the most dramatic sound we would hear that evening, the crack of a church key stabbing the top of a Coors beer can. We sprawled on the bulbous fenders, passing the single warm beer among us and watching the orange umbrella above turn to purple.

When the last drop was drained away, it was time for the finale in this evening ritual. We were ready to "fly."

Our perch was high by Kansas standards only, but we could survey the plains for miles and the black asphalt ribbon that sloped forever into town. Poised there like skiers at the top of a jump, we prepared for flight, opening both doors wide. My cohorts took positions clinging to the fenders, lying on top of the turtle back, or spread across the hood.

Leaving the engine off, I stood on the running board and reached across to shove the floor shift into neutral. Soon the heavy bulk of the old Chevy overcame inertia and moved slowly forward, by agonizing inches at first, then picking up speed as a schooner would catch the wind, sailing through the sweet evening air until the rush pressed our hair back and drew tears in the corners of our eyes. The illusion of speed was intoxicating, liberating. For there was a point at which our whimsical airship would lift ever so slightly and send our fantasies soaring beyond the hedgerows of that Kansas summer into a future full of adventure, in which anything could be attained if you wanted it badly enough.

I wonder if that simple moment of freedom was typical of every childhood or if we were unusually naive in that summer of 1958, possessed of some natural innocence that precedes eras of great turmoil. In the blustery decade of the sixties we would be unbelieving witnesses to assassinations, military defeat, and political scandal that shook our patriotic faith. The calamities descended with such a vengeance that a whole generation was stripped bare of the optimism acquired in so many carefree evenings.

I was lucky in one respect. I got to watch it all from the closest thing I could find to the front seat of that '48 Chevy, as a reporter in the young profession of television journalism.

My career in broadcasting began on my six-

teenth birthday, when I got a work permit from the state of Kansas and walked around the corner to my first radio job, at KIND, the only station in my hometown of Independence. It was a world away from the broadcast centers of the nation, but to me it was Hollywood, and I waited that first week for a network talent scout to come and pluck me from oblivion.

Fortunately the call never came, for those years above the Booth movie theater were a priceless education in broadcasting. I was a disc jockey, announcer, newsman, play-by-play sportscaster, and studio engineer, and after my shift I would sweep out the studio. I also was fortunate to receive private tutoring from a man of character, Nelson Rupard, who taught me the meaning of being a professional.

I spent more time in commercial broadcasting during the next few years—at KTOP-AM and WIBW-TV, both in Topeka—than in class at the University of Kansas. Maybe that's why I decided to concentrate on my education for a while and went on to Washburn University School of Law after a brief spell in the Marine Corps. As graduation approached in 1966, I accepted a job with a personal-injury law firm in Wichita headed by attorney John Frank. But I still wasn't sure I should be abandoning broadcasting. Then an incident blew my way on June 8, 1966, that strongly influenced that decision.

I had taken some time off from my studies for the Kansas bar examination to fill in for a friend, Tom Parmley, on the early evening newscast on WIBW-TV so he could get a head start on his vacation. Shortly after 7:00 P.M. we broke into live programming with a weather bulletin. In Kansas, the constant threat of severe weather turns broadcasters and the Civil Defense into an army, equivalent to Great Britain's Home Guard searching the skies for German bombers. The bulletin reported some damage from high winds 60 miles to the west. It was quickly followed by a message phoned in by station cameraman Ed Rutherford, who was driving home, that a tornado was approaching the city from the southwest.

No sooner had this information left my mouth when, on camera, I was handed the bulletin we had all feared might come one day. It was *not* a warning. Gone were the fine distinctions grading weather conditions between "watches" and "warnings." This message stated succinctly that an apartment complex had been wiped out by a large tornado that appeared to be still on the ground and heading for downtown Topeka.

A couple of thoughts shot through my head in the few seconds it took to read the information. I realized that my wife, Helen, was on the university campus, directly in the path of the storm, with our six-month-old daughter, Mary Kristin. My next concern was, How do I convince an audience inured to hearing tornado warnings that this is the real thing? The next few words would mean life or death. That responsibility brought me to the edge of tears. Somehow the words came, the alert was sounded, the deaths held to a surprisingly low number. Helen, Mary Kristin, and our campus friends all huddled safely in the basement of the science building until the tornado had passed. When they came out, they found cars in trees, sandstone buildings toppled and strewn about the campus. Over it all, sunlight glistened off raindrops fresh from the dark clouds that had passed over, creating a celestial air, truly like the end of the world.

The tornado, more than half a block wide at its base, had cut the city in two, and emergency crews rushed toward the path of destruction it had left behind. We at WIBW-TV were on the air for 24 straight hours, broadcasting pleas for ambulances and additional emergency vehicles, and—because telephone lines were down—reading the names of endless lists of survivors trying to contact relatives and friends to let them know they were alive.

In Topeka and much of the state, time is now measured as before or after the day the tornado hit the capital. For those of us on duty that evening, the memory of the event would stay with us for the rest of our lives.

I went ahead and passed the bar exam but notified John Frank in Wichita that I was going to stay in broadcasting. The tornado had been a life-altering experience, an extreme example of how

television could save lives. Within a few months, I joined WBBM-TV in Chicago as a street reporter and discovered how television could change lives as well.

Innovative forces were on the march in America, and television carried new images and ideas from one part of the country to another. We reporters said we were just mirroring events; indeed, everything we pointed our cameras at seemed to be happening for the first time because it was the first time television news had recorded it. But this new medium of pictures and sound was more than a mirror. It was an instrument of change.

In the late evening of August 28, 1968, I was at the corner of Balbo and Michigan avenues in Chicago, covering a demonstration during the Democratic National Convention for WBBM-TV. From my perch on top of a car I watched a line of policemen holding back a crowd of 10,000 demonstrators. They stood face to face, the protesters showering the policemen with rough language, the cops holding firm. Then, without signal or warning that I could see, the police line moved forward into the young people, creating a whirling, confused image of violence. Blue police helmets flashed under the streetlights. Nightsticks rose and fell. Protesters were dragged into police vans and peppered with blows.

I puzzled about how to report the scene until I realized it didn't matter. The pictures captured by our television cameras carried messages, unedited and raw, that along with other pictures would split the nation on the issues of the Vietnam War, and law and order. With television, I realized, a new language of electronic images was being created. Good writing could shape it, color it, enhance it, but basically this visual language carried the writing. As reporters we were riders on a subliminal force, in many cases just struggling to hold on.

We eventually learned that to fight the pictures was useless. The most effective reports shared an experience with the viewer, as if we were both watching the same images. We could help the viewer understand them, but we could not ignore them. This understanding led to a simple axiom for television writing: "Write to picture."

Covering the confrontation that August night marked another turning point of sorts for me. Someone had loaned me a 35-mm still camera, almost as if they had foreseen the history I would witness that night. As the police line advanced on the crowd, I raised the camera and began triggering the shutter. Aside from the excitement and fear I felt as a result of the police charge was the new thrill of *taking* pictures instead of watching my unionized colleagues have all the fun. One of these pictures became a prize-winning photo that gave me the encouragement to begin carrying a camera on the stories I was covering. It became a process of trial and error until, after many assignments and many years, I felt I could combine words and pictures to tell a story in print much the same way we do in television.

After three years as a CBS News correspondent in Los Angeles, I returned to Chicago and WBBM-TV in 1973 for what would be a nine-year anchoring stint alongside an extremely gifted reporter, Walter Jacobson.

It would be a period of many difficulties; Helen died in 1977, of cancer. There were also rewarding challenges, the first of which was to establish an electronic version of the respected Chicago school of journalism. Guided by CBS News expatriates Robert Wussler, general manager, and Van Gordon Sauter, news director, we set up shop in a working newsroom, rolled up our sleeves, and waited for the ratings. They came over the years but much too slowly, we thought.

In the course of practicing the craft we loved, we were able to set some new standards, introducing electronic news-gathering by minicams, which our technical crews mastered until they became routine to the profession. Walter worked the phones from morning until the evening broadcast and became the finest political reporter in the country.

We were all sensitive to criticism that television news didn't provide in-depth reporting, so inspired by executive producer Donna LaPietra's idea, we initiated a special Focus Unit, which expanded headline stories to give substance to

what so often was written off in 30 seconds. We knew television could tell these stories better than any other medium, but in so many cases this magnificent tool had been reduced to a headline service, condensing, squeezing, and in the process obscuring understanding. During my nine years as anchorman, successive management teams bought into the concept—general managers Neil Derrough, Ed Joyce, David Nelson, Peter Lund; and news directors Jay Feldman, Dick Graff, Eric Ober, and Frank Gardner. The activities of the Focus Unit included investigative reports, some of which involved extensive travel, which I undertook always with my own camera in hand.

This book is an attempt to satisfy two urges: first, to communicate with words *and* pictures; and second, to add another level of understanding to stories that have dominated the headlines by approaching them from a slightly different perspective.

In most cases, the stories were international in scope but directly connected with the Chicago community. For instance, I got into Iran during the hostage crisis through a special contact, an Iranian émigré who had settled in a Chicago suburb and felt compelled to return to experience the new Islamic regime. I saw the revolution's dreams through his eyes, then left him there to help turn them into reality. Sadly, his hopes for a new Iran went unfulfilled.

It may seem today as if the controversy over Agent Orange has been with us since the Vietnam War. Not so. It faded in the early 1970s, and not until 1978 did the issue become explosive again. Complaints by veterans that their exposure to the defoliant had caused them serious health problems surfaced in the newsroom of WBBM-TV, Chicago, and blossomed into the most serious issue for veterans since the war ended. In "Agent Orange: Anatomy of a Documentary," I pick up the beginning of the investigative trail that led to Vietnam and back.

Strange how stories come to you as a reporter. I arrived in Ho Chi Minh City in 1980 by invitation of the Socialist Republic of Vietnam, which wanted me to witness some of the aftermath of

defoliation by Agent Orange. One afternoon as I walked alone through the city, I became suddenly aware that while I was one of three Americans in-country at that moment, I was surrounded by American faces. Thus began my coverage of the Amerasian children abandoned in Vietnam.

In 1981, the real story of El Salvador—the indiscriminate killing of civilians in staggering numbers—didn't seem to be making any impact on the American people. But the involvement of the Roman Catholic Church in the turmoil there made the situation of particular interest to Chicago's substantial Catholic population. In an unexpected turnabout, when we flew to El Salvador to discover who was really killing the people, *we* became the story.

Every photographer longs to visit Africa to be able to take pictures of the incomparable wildlife. But when I went, the trip was bittersweet, for we were investigating a poaching trade that supplies animal products and denudes Africa's magnificent landscapes of life.

And when your audience includes a large and influential Polish community, Solidarity becomes an important story. I traveled to Poland to see the trade union in 1981 at its peak and again in 1983, when hope had gone underground, during Pope John Paul II's second trip.

I also offer descriptions of a few side trips, typical escapades that reporters always seem to find in their pursuit of the larger theme.

All these experiences were grand adventures for a Kansas boy who had thrilled to the thought of what was beyond the distant hills. By living them with me in this book, I hope you get an insight into the world of television reporting, as interesting behind the camera as it is in front of it.

Maybe that urge to know what was out there on the horizon led me to close the Chicago chapter of my journalistic efforts in 1982 and open another in New York as co-anchor with Diane Sawyer on the CBS Morning News. I believe there will be many other chapters, as long as I can go to work each day with the same ingenuous spirit that climbed out on the running board of that '48 Chevy, waiting for the magical lift as it caught the wind.

Bill Kurtis
ON ASSIGNMENT

Dateline: Tehran

Focus: Iran in the days of the

hostage crisis

Persian odyssey

We ran through a thicket of groping fingers tearing at our shirts and camera gear.

It had changed so quickly. One instant the inhabitants of this South Tehran opium district were submissive addicts, intent only on sniffing the opium they were melting on foil gum wrappers; the next they were an angry mob, passing a phrase from one to the other until a single voice cried out from the rear of the crowd, "They're Americans! Kill the Americans!"

He was a maelstrom of contradictions. Pugnacious yet possessed of a tender healing hand. Self-assertive yet instantly depressed if he thought he had treated someone unjustly. He was violently religious, but his eyes would smile when he explained the part of the Koran that allows a man, if he is away from his wife for more than four days, to take another woman. An intelligent man, he knew a liberal application of such ancient writings might be taking advantage of Muhammad, but the sparkle in his black eyes said, Why make a big deal out of it?

To protect his identity I'll call him Farhat Kermani; he was an Iranian emigré and a doctor. He could enter a room with the cockiness of a street brawler looking for a fight and then, when the skin of his opponents began to tingle at the challenge, would cool the atmosphere with a grin that burst from his trimmed salt-and-pepper beard.

Although some would say he had a chip on his shoulder, those more knowledgeable about the Ira-

nian character would explain that it was a perfect example of the martyr complex that sometimes results from being a Shiite minority in a Sunni Muslim world, something like being the only Jewish kid on an Italian block in Brooklyn.

Without the slightest encouragement the doctor would trace his lineage from the Aryan foot soldiers who followed Cyrus the Great into Palestine to the hordes of Persian conscripts forced to march with Genghis Khan back into his Mongol Empire.

"A culture rich enough to produce the courage of these campaigns," he would declaim, "also could spawn the delicate poetry of Omar Khayyam, who celebrated the sweetness of life and the pleasure of love." He was probably describing his own self-image, feeling Cyrus and Omar Khayyam measured up just about right.

I might never have discovered such ethnic passion—indeed, Dr. Kermani might have spent the rest of his years ministering to his patients in a Chicago suburb—except for the hostage crisis.

Kermani had been politically opposed to the Shah of Iran, Muhammad Reza Pahlevi, since the early 1960s but managed to hide his feelings until 1968. Then SAVAK, the Shah's notorious security force patterned after the CIA, applied sufficient pressure for the doctor to move his family to the United States, along with a wave of Iranian emigrants who sought education and professional advancement in America.

He became a U.S. citizen but continued to communicate with his comrades still working in Iran to sow the seeds of unrest, which 11 years later would topple the Shah.

In the final months of the revolution, Kermani watched the fighting on television with the unrestrained enthusiasm of a Chicago fan seeing the Bears drive for a score.

At first, this partisanship was amusing to his neighbors. But his Iranian loyalties suddenly became a liability on November 4, 1979, when militants claiming to be students seized the U.S. Embassy in Tehran and took about 60 Americans hostage. In exchange for their release, the militants demanded the return of the Shah, who at that time was in the United States undergoing medical treatment.

It wasn't the injustice of holding American citizens that flushed Kermani from his suburban nest but the blasphemy heaped by a frustrated American public on his beloved leader, the Ayatollah Ruhollah Khomeini. He was also disturbed by the impression growing in the United States that the proud revolutionaries of Iran were little more than madmen, bearded camel-jockeys who should be gifted with a stick of B-52 bombs on the main street of Tehran.

And always there were the newscasts, relentlessly pouring pictures of angry faces into American living rooms. Fists punching the air. Chants. Hatred for the United States. Patriotic emotions rose in the bosoms of Americans, and Kermani was also moved, but in the other direction. He could remain silent no longer.

First he responded to the request of some Iranian students at the University of Nebraska to investigate the death of one of their friends, arrested for threatening his landlord's life after an argument over the hostages. The Nebraska county coroner reported that the student had died from an epileptic seizure while confined in a Lincoln, Nebraska, jail. On the basis of his own inquiries, Kermani concluded that the law-enforcement authorities had been negligent in withholding prescribed drugs that would have prevented the seizure. Therefore, he announced publicly, they must be guilty of murder.

Bearing his "truth" like a Muslim scimitar, he called me at the newsroom and confronted me with an open challenge to cover the story. "We have 53 Americans at the U.S. Embassy in my country and they have not been harmed. You can't even keep one Iranian alive." In a single moment he was defiant, charming, and exasperating.

"Why don't you tell the truth?" he cried.

"I'll tell the truth, but what is the truth? You kidnapped American diplomats!"

"I will take you to Iran and show you the truth that you refuse to see, that the Shah was a monster! If you have the courage to go!"

And that's how we became friends.

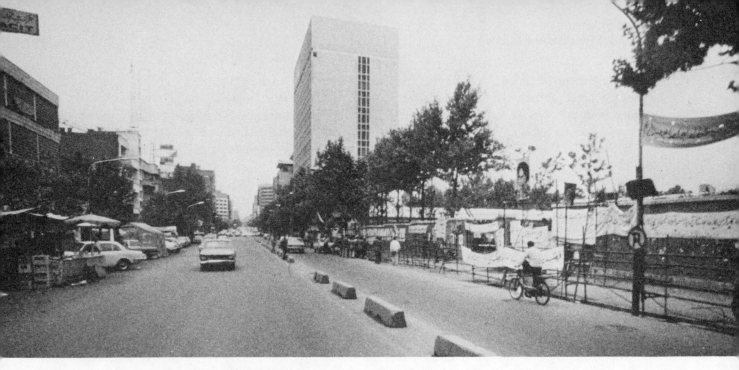

Contrary to the violent scenes Americans saw on television, by April 1980 the street in front of the U.S. Embassy was often empty. Demonstrations were more state-controlled events than spontaneous outbursts.

On April 25, 1980, after hurried preparation, I was on my way to Tehran. General Manager Ed Joyce and I agreed that this would be a good opportunity to get a side of the Iranian problem we hadn't seen before. Although I would make daily phone calls to WBBM-TV, Chicago, during my visit, the main result of my reportage would be three five-minute Focus Reports, aired after my return.

With me were cameraman Skip Brown and his sidekick, Phil Weldon, the sound man. A tall man of liberal politics and a technical turn of mind, Phil doubled as an electronic wizard who could repair the magical gadgets that record pictures and sound and could thus keep us operating in the event of a breakdown. Skip was one of the best cameramen in the business, and we had enjoyed a long and close friendship that, along with exotic assignments, made for especially memorable trips.

This one had all indications of being among the most adventurous. The papers were filled with reports that all Western reporters were being expelled from Iran, and that the Revolutionary Council was becoming increasingly uneasy as the hostage crisis stretched into its sixth month. Kermani had shrugged off the stories in his typical fashion

and fixed on what we would see when we got there, giving us his personal guarantee of admission. I decided to take a chance, and we entrusted our lives to this unusual little man.

The only hesitation between Chicago and Tehran was a layover in Paris. Kermani had gone ahead on another flight. When we stepped off the plane at DeGaulle International Airport, a frantic TWA employee came running toward us, begging us not to go into Iran, obviously feeling the urgency of the message he was relaying from our office in Chicago. "There has been bloodshed," he said. "An American rescue attempt was made, and men were killed in the desert."

With a million questions I rushed to learn more about the mission. Were we at war? Would there be another attempt? Were any other Americans put in jail? What was the Iranian reaction?

I thought the Iranians might consider the attempt an act of war and be incensed, but after we reached Kermani by telephone in Tehran, he assured us that the feeling there was one of jubilation. "We have beaten the Great Satan," he said, and took advantage of my transcontinental call to draw a parallel between the Koran's story of an

invading army on elephants turned back by a sudden desert dust storm and the U.S. mission, whose aircraft had collided in swirling sand in the salt desert of eastern Iran.

Within hours I was watching the purple spine of the Elburz Mountains warm with the light of dawn. We made our approach into Tehran, and the sleeping mud-colored city seemed to tingle as its lights dimmed in the soft pastel sunrise.

Our arrival was not without anxiety. The Air France flight we had been on was the only one entering that day, one of the few that had landed since the rescue attempt. Not only were we arriving in that aftermath but also at a time when most of the Western press had been denied entry visas. And, we were walking into customs without a single document that would allow us to enter the country legally. Such was the confidence Kermani inspired. He had made it sound so simple in Chicago, saying that his old friends were on the Revolutionary Council. But now that we were finally in Iran, he was nowhere to be seen.

A revolutionary guard checked my passport. He was very young, trying, I thought, to hide behind a black stubble of a beard to look more fearsome. What kind of reaction should I expect when I told him, "I have no visa," in tones as innocent as a Kansan could evoke? His ebony eyes studied my face, the name on the passport, the photograph. This was no civil servant engaging in petty intimidation. I said, "These two men are also with me," introducing Skip and Phil. Phil was something of a poor man's Bolshevik and was looking forward to seeing the revolution firsthand. Skip, like me, was warming to yet another encounter with the unknown and anticipating the surge of adrenaline one more time. At the moment, however, the spotlight was mine. Did I or did I not have a special contact?

The guard waved us toward an office about 30 feet away. The beard covered any hint of what he might be thinking. I could see an Iranian cell in my future, or a plane ride back to Paris. I had felt the unloving chill of customs officers before but never in the ominous atmosphere of a holy revolution, where decisions apparently could be made with very little basis in reason.

Two men approached, one dressed in official-looking blue and the other in khakis and sandals. The second man was short, with the solid build of a light heavyweight fighter, and his smile, visible even at a distance, looked like a benevolent Muhammad's. I tried to clear away enough of the jet lag to superimpose on this native Iranian the image of the Western-dressed doctor I knew in Chicago. The closer he got the better I felt, because I realized the good doctor had really come through.

His greeting was unexpectedly warm; he used both hands to pull my face toward his, then touched each cheek with his rough beard. The goodwill spread to the others, and the tense atmosphere fell away. In making good on his promise on this and other occasions, Kermani gradually won our trust and friendship. He would escort us into a world we had only partly viewed on television, filling in a background for us as one weaves a fabric. Throughout our trip, he would prove to be far more accurate than any official statement of events from the Revolutionary Council.

Before we could leave the airport, one final clearance was needed from the doctor's mysterious contacts somewhere within Tehran's revolutionary structure. He put the young cadres on the telephone to hear the orders for themselves. The receiver passed among a trio of young men in ill-fitting fatigue jackets, emphasizing their shared authority. The voice at the other end sent them rushing back to us with anxious movements, grabbing for the heavy boxes of television equipment in an effort to speed us on our way.

This flurry of bodies was followed by an almost serene Kermani, sauntering behind with the swagger of an oil sheik leaving the Ritz. He didn't have to say a word. The delight of having passed the first crucial test of his influence radiated from the little sparkles in his eyes and a slight, almost invisible upturn in the corners of his beard. I shared his feeling of satisfaction. After all, it was a supreme use of clout—Chicago-style.

The airport was heavy with the feeling of Khomeini. His flaring eyebrows peered from photographs that hung everywhere, positioned even

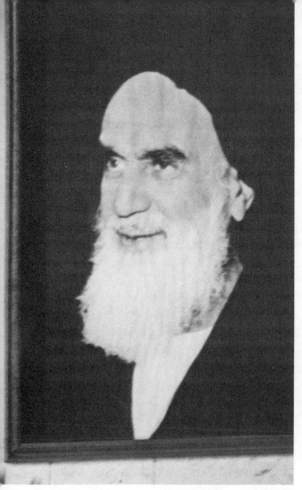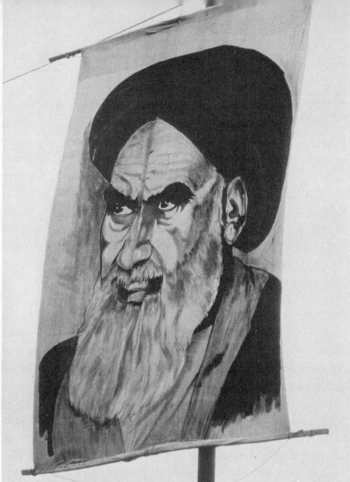

The two faces of the Ayatollah: Left, a benevolent religious patriarch watching over his people; right, a stern protagonist, shown here on a banner that flew above the U.S. Embassy.

more prominently than the likeness of Ho Chi Minh had been in Hanoi. It was not the same picture, showing an angry tyrant, that was broadcast daily to the United States; rather it was of a smiling *religious* figure gazing warmly upon his subjects. Or was he a *political* leader?

That ambiguity now stands out as a clue to understanding the Iranian revolution. It escaped me at the time, as it did most observers, who were anxious to fit him into the traditional revolutionary mold. But Khomeini's true stature and intentions surfaced late in Iran's crisis. By the time he became a dominant force in the growing turmoil in 1978, signs of the revolution were already apparent in a widespread hatred of the Shah's regime. While many revolutionaries focused on a variety of complaints from torture to corruption, Khomeini was voicing the same appeals for change in language rooted in

something that touched every Iranian—religion.

The Iranian form of Islam is perplexing because it grew not only from Muhammad's teachings but from the struggle to determine who would succeed the Prophet, who died in A.D. 632. This debate was motivated as much by racial and geographical prejudices as by faith. Persian Shiites broke from the majority Arab Sunni worshipers to become a minority sect in one of the world's largest religions. Within the Shiite line, certain imams, or leaders, became successors to Muhammad. They represented God on earth and interpreted the meaning of his writings in the Koran. One successor followed another until the Twelfth Imam, who mysteriously disappeared 1,100 years ago. Current belief, which proved terribly convenient to the revolution, still holds that he did not die but is still waiting, somewhere, for a victorious return to

earth and his chosen people in Iran.

When Khomeini left France and triumphantly reentered Iran on February 1, 1979, just two weeks after the Shah had fled the country, many Muslims believed it was part of a grand cosmic scheme, as if the Twelfth Imam himself had returned. They had been suitably prepared for the occasion by the Ayatollah's fellow mullahs, or clergy, who repeated his messages in the mosques, which the Shah had decided not to interfere with, undoubtedly a serious flaw in his counterrevolutionary strategy. Khomeini's sermons were also recorded on cassettes and smuggled into Tehran through the ancient bazaar, a catacomb of stalls where subterfuge was a way of life.

But most crucial to Khomeini's emergence as a leader was his stay of several months in the Paris suburb of Neauphle-le-Château, which began in the fall of 1978. Communication with Tehran had been difficult and time-consuming from the Ayatollah's previous place of exile in Iraq. In France, however, he had access to a modern communications system that could transmit his messages directly to Iran, by radio, telephone, and television. Even more helpful to Khomeini was the almost constant scrutiny of British Broadcasting Company reporters, whose daily television reports were beamed back to Iran as the movement against the Shah gained momentum. "Thanks to such attention," wrote Michael Ledeen and William Lewis in *Debacle: The American Failure in Iran,* "Khomeini suddenly became a real person to the Iranians. It must be recalled that, prior to the autumn of 1978, Iranian newspapers were not permitted to print his photograph, and while his cassettes were played in the mosques on Fridays, Khomeini remained a remote figure. Not only was he a disembodied voice, but his message—couched as it was in dense theological prose—was not of the sort readily packaged as a guide to daily tactics. All this changed in October. Now he was seen to be not only a grand ayatollah but a commander, a highly picturesque individual with charismatic qualities that astonished even his most devoted followers."

In one of history's curious twists, the Ayatol-

lah had almost been ousted from his advantageous perch in France. Former president Jimmy Carter, in his memoirs, *Keeping Faith,* writes, "Giscard reported that he had decided earlier to expel Khomeini from France so that his country would not be the source of dissension and revolutionary efforts, but that the Shah had thought it would be better to keep Khomeini there, instead of letting him go to . . . some other place where he might orchestrate even more trouble." As it turned out, things couldn't have worked out better for the Ayatollah.

Although members of many political groups participated in the revolution, Khomeini took on special significance due to his constant media exposure, and touched a common chord among most Muslims. He expressed what so many others felt; he became the revolution's voice. Communists, liberals, and radicals who had dreamed of power in the post-Shah government saw their hopes fade in the rabid prayer chants supporting Ayatollah Ruhollah Khomeini.

Khomeini wisely disclaimed identity as the Twelfth Imam, but he did accept the position as his representative on earth. It made him the supreme sovereign in an Islamic state with the authority to interpret God's will, a position that amounted to ultimate power.

So the airport picture? Did it show a political leader or religious figure? The answer is both, despite the difficulty Westerners have imagining a government that does not separate church and state.

All this seemed as natural to Kermani as the first rays of morning sun on the Elburz Mountains. We walked through the airport, listening to his enthusiasm shift from detailing the sins of the Shah to explaining the Ayatollah's rigid prescriptions for living, which were increasingly reflected in Tehran's population. Women were pressured to return to the *chador,* a full body covering of thin black material. Western fashions were stripped from stores, as were the signs that told of Western businesses, such as the word "Kentucky" that was torn from the red-and-white plastic sign adorning the Kentucky Fried Chicken franchise in

downtown Tehran. (The chicken remained popular.) The television system became the Ayatollah's personal vehicle for Islamic teaching. The airwaves were filled with religious music, chants, sermons, and programs deemed suitable for proper Muslim viewers. Swimming, or "mixed bathing," was banned along with dancing. Alcohol was considered worse than heroin because it was prohibited specifically in the Koran, so the city's cocktail lounges now held only memories of past sins, their doors closed and their tables gathering dust.

Although throughout my several days in the city Kermani would repeatedly endorse this religious cleansing process, it appeared to me that the lifeblood was slowly draining from Tehran. Sadness was replacing laughter. There just wasn't a lot to do there on a Saturday night.

The doctor skipped ahead of us, leading the moving mountain of camera equipment through veiled women and dirty taxi drivers to waiting vehicles, each exhibiting scars that one might find on the survivor of a demolition derby. He looked back often, like a child who can't contain his energy and wishes his parents would hurry along.

"I want to show you two things on our way to the hotel," Kermani yelled. "It's important that you understand the way our revolution began."

Tehran resembles Albuquerque, New Mexico, in the way that the city slopes upward from an arid desert where temperatures reach 130 degrees Fahrenheit in summer to heights that receive snow in winter. As in Albuquerque, Tehran's population spills over the varying elevations according to income and class, with the elite choosing the more desirable climate of the upper regions, and the middle class and poor spreading beneath them. Unlike its counterpart in Albuquerque, however, is Tehran's traffic, which approaches grid-lock during rush hours as a grayish shroud settles over the city, a cocoon of automobile pollution and dust. Its extremes are memorable, for the talcum-fine grit can choke a healthy donkey or be transformed into a Persian fantasy when the sun pierces the diaphanous veil of smog and turns it red, orange, and mauve.

This fusion of nature and man that greeted us outside the airport gave Kermani an opportunity to blame the Shah once again—for the terrible traffic congestion, for the pollution that ruined his homeland, and for an unusual sight resting at the edge of Tehran's cluster of apartment dwellings.

"This is Tin City," he said, as the car in which we were riding pulled to a halt. "It shows how the people of Iran sat on the outside of the Shah's city and watched him give it away to the foreigners."

Tin City at first appeared to be no more than open acreage studded with mounds of dirt and refuse piles, but closer examination proved astonishing. Each of the mounds was actually a home of ingenious construction, using the rubbish of the twentieth century as building blocks. Metal oil-cans, each about a foot high, were stacked row upon row to form the walls, the spaces between them chinked with mud. The roofs were dirt, which gave them their earthen appearance, in some cases supported with bicycle frames, wheelbarrow beds, and automobile hubcaps. A worn-out chair sprouted at an angle from one roof. Discarded pieces of wood created the look of a shipwreck, and plastic sheets peeked out from the mud packing to flap wildly in the breeze. The place had the feel of a city dump, where the sweepings of a society are condemned to toss in the wind forever.

Skip and Phil beat me out of the car and began taping the small inhabitants playing among the debris as other children might climb the jungle gyms of middle-class apartment buildings. Their hair burst in all directions. One child sucked an orange as a smaller brother playfully kicked at her leg for attention. Here in Tin City, peasants from Iran's countryside had created homes from the cast-offs of those who had fared better.

Inside one of the hovels two men sat cross-legged on a handsome Persian rug laid on the bare earth. Above them in the most prominent space they had was a picture of Khomeini, the airport picture.

In spectacular contrast, a backdrop of uncompleted skyscrapers that seemed gigantic in com-

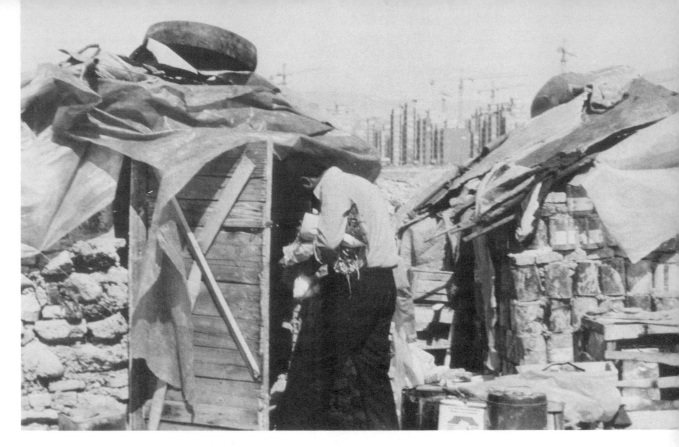

On the outskirts of Tehran, residents of Tin City built hovels of oilcans, refuse, and mud while the Shah put up the towering housing projects in the background for foreign workers.

parison loomed behind the mud shanties. The construction of this mammoth housing complex had been stopped midway by the revolution. Its gray concrete forms were as alien to the land around it as the oilcans that formed the walls of the mud homes. It was a signpost to guide us in understanding the gulf between the people of Iran and the Shah's world.

Feeling momentarily like peasants gaping in awe at some Emerald City they couldn't enter, we began to understand some of the frustration felt by poor Iranians who watched the country's oil money being spent on housing for foreigners, while they crawled into houses of mud.

As we walked toward the towering structures, Kermani began to explain. "This will let you understand the revolution better than anything else. These people are from the country. They come here because the Shah's land-reform revolution has changed their small villages, so they come to find jobs. But when they get here they only find

this," he said, pointing to the complex, "and they are forced to live like this," looking sadly back toward the dirt homes.

"Wasn't the Shah doing it for his countrymen," I asked, "building these structures to lift Iran out of the sixteenth century?"

"Perhaps," replied Kermani. "But you can't build a modern city for a few rich or even middle class and leave the great masses behind. There will be revolt if the people have nothing to lose," he said, arching his eyebrows to emphasize his point.

The Shah's land-reform program was intended to transform Iran into a modern power, using mechanized farming methods and a redistribution of land that altered the ancient feudal system of ownership. The change ushered in large-scale agricultural methods and displaced thousands of peasants. Unable to find unskilled work on the farms, they flowed into the cities. By the end of the 1970s nearly 100,000 people a year were moving from the

country into the urban centers, creating Tin Cities throughout Iran and more than doubling the country's urban population. Most of them were young people; at the time of the revolution, half of Iran's population of 36 million was under 20.

As we stood among the dirty children, it was easy to imagine their parents' anger at the sight of modern glories so near yet so out of reach for the native Iranian. Such resentment, combined with the fact of their own unemployment as thousands of foreigners worked on the projects around them, amounted to a ticking bomb.

"It started with Persepolis," Kermani told us as we walked toward the hole in the fence around the ghostly complex. "You remember the huge celebration that the Shah staged to commemorate the 2,500th anniversary of the Persian Empire? He wanted to build a connection between his monarchy and the ancient Persian kings like Cyrus, Xerxes, and Darius. So he staged a lavish birthday party near the tomb of Darius II. It was really something."

We stepped lightly over the building materials still piled around the tall skeletonlike structures and listened to Kermani pour his emotion into his country's recent history. "He had to build an electric power station just to provide energy in the desert. There were huge tents, and food brought in by Maxim's of Paris. Five queens, nine kings, and 21 princes and princesses dined there along with other Western leaders, but this dazzling show of wealth was viewed from the miserable villages around it as a sign of decadence that served only the elite. People began to talk about his waste, and it became the real beginning of the uprising. That was 1971. It was a true crossroads for the movement against the Shah because many people, up to that point, were uncertain about his attempts to modernize. Watching the excess at Persepolis, they realized that Iranians would not share in the splendor."

Around us loomed the eerie shapes of empty cranes, scaffolds, and concrete blocks. In hollow buildings standing ten stories high, rivulets of desert wind snaked through the paneless windows, beginning the eternal cycle of the desert, which erodes structures into bizarre shapes. Fifteen identical buildings stair-stepped down a terraced slope.

Two impressions flashed through my mind in that moment—one of a futuristic space community assembled on some stark landscape; the other of an archaeological excavation that had unearthed this monument of past cultures, of twentieth-century man. How shocked the archaeologists would have been at the truth, that no one had ever lived in these elaborate dwellings, and that they were built by a ruler not for his people but for imported workers.

Kermani continued: "The religious leaders, the mullahs, used these buildings against the Shah, reminding the people they were not for them and stressing his failure to provide the people with decent living places. They also preached that we should not live stacked upon one another like the Western world but should stay on the ground in a single home with a garden. So the buildings have become symbols of the Shah and now no one will live in them. They probably will not be completed."

Huge construction cranes, evidence of the Shah's desperate attempt to speed completion of the mammoth projects, stood silent in the shadow of the half-completed buildings, like erector sets idled by a bored child. They extended over the tops of the buildings and were the kind that rise floor by floor on a single steel beam of support. In most projects, only one crane is used because of the expense, nearly one million dollars. But here, as many as five cranes could be seen at a single building, an obvious attempt to increase the rate of construction.

The Shah seemed to be trying to accommodate, perhaps create, a middle class that he counted on to stabilize his emerging "modern" society. Once a large middle class enjoyed the benefits of a Western life-style, he hoped, they would not revolt. Also, the new class would render the mullahs impotent politically before they could swing their influence against him. And this instant city in the desert was only part of the Shah's grand plans—for a Tehran subway to beat the traffic jams, 16

nuclear power plants, a new airport, billions of dollars of additional arms purchases. He had already completed a soccer stadium that would seat 100,000 people. But the dreams dealt with things, not people.

Whether foreigners were destined to fill such buildings as these was irrelevant; the projects had become the symbol of a foreign "invasion" of skilled workers, imported by the Shah to move Iran toward its Western destiny. Even as late as the final days before Khomeini's return on February 1, 1979, there were 45,000 Americans living in Iran, assisting in the oil refineries, instructing the defensive weapons personnel in the Shah's army, even administering corporate outlets for American companies. Kermani drew a picture of foreigners walking the streets in their Western designer clothes, driving big cars, building shopping centers, ignoring the religious customs of a Muslim country, and liberalizing everything, including women's rights. They had easy access to the U.S. Embassy, while Iranians were forced to line up at the gate at 4 A.M. if they wanted to apply for visas or help. Kermani summed it up: "So you see, there was much more at stake than where we would live or work. We were all afraid the culture was changing, that the rich Persian culture of 2,500 years was being degraded and in many cases destroyed in this effort to create a Western lifestyle to exploit our resources. The Shah gave preferential treatment to all foreigners, even over his own religion."

Kermani and Iranians like him showed the Shah and his family no mercy; every problem, every sin was laid at their feet. Many claimed that the family had its fingers in every part of the economy: condominiums, oil, even heroin traffic. The Shah's twin sister, Princess Ashraf, was accused of many scandalous crimes, from running opium (the source of heroin) to gouging Iranians by charging exorbitant interest on loans. Most tales were probably exaggerations or untrue but, as Professor Marvin Zonis of the University of Chicago writes in *The Political Elite of Iran,* "Some member of the Pahlevi family [had] a direct and legitimate voice, by dint of ownership, in the operation of

nearly all commerce and industry in Iran."

From the housing complex we drove toward the Intercontinental Hotel and straight into a typical Tehran traffic jam, one of the worst side effects that "progress" could heap upon any culture. Since gasoline was cheap in oil-rich Iran, the automobile was one Western product in which everyone who could possibly afford it indulged. It provided status, freedom, transportation, and recreation to the Iranians, and twice a day in Tehran so many of them exercised this freedom that the streets were filled curb to curb with puffing, grinding, polluting vehicles. Those in Tehran drove offensively—like drunks in an amusement park—but since the speed was reduced severely during the congested rush hour, there was little chance of serious injury. Curiously, we never heard the automobile itself listed among the sins of the Shah, only its ugly by-products.

This Middle Eastern version of grid-lock gave me a chance to watch the sidewalk traffic. Filmy black veils trailed *chador*-wrapped women as they outdistanced the automobiles and passed walls scrawled with political slogans, a Harlem with Arabic script.

Most Western reporters had already been given their deadlines for leaving the country, so there was some amusement when we checked into the Intercontinental, where most of the television networks had rented suites of rooms to serve as offices since the beginning of unrest in Iran. John Kifner of the *New York Times* was inquisitive about how we got into the country, for he had heard that the rescue mission was to have been coordinated with CIA agents who had infiltrated Iran and would be ready to eliminate the revolutionary guards outside the embassy when the helicopters landed in the compound. I thought about trying to explain my unusual friend Kermani but then decided to let it pass.

Actually, Kifner's sources were quite accurate. That was confirmed in Jimmy Carter's memoirs, which reveal that "our agents, who moved freely in and out of Tehran under the guise of business or media missions, had studied closely the degree of vigilance of the captors." Carter's use of "media

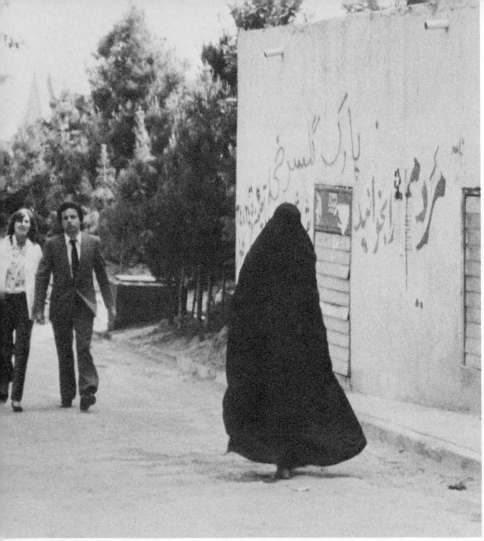

A few of the marks left by the Shah's attempts to modernize Iran: Chevrolets and condominiums, Western fashions and goods. The revolution rejected these influences, calling for a return to such traditions as the wearing by women of the full body covering known as the *chador*.

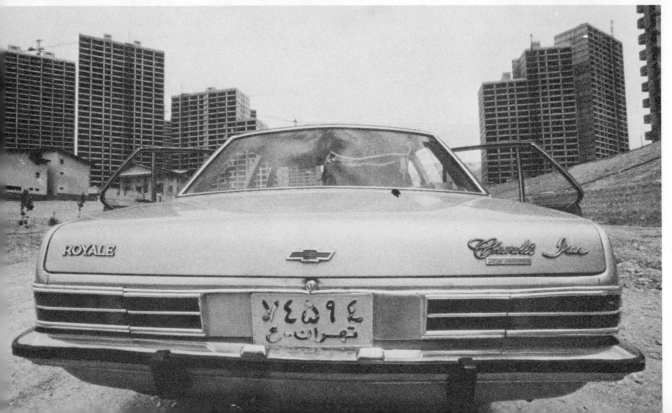

missions'' is disturbing because such a precedent could jeopardize the safety of American correspondents if in the future they are routinely suspected of being CIA agents.

The city was awash with rumors following the aborted rescue mission. Isolated bombings by various political groups were blamed on ''Americans staging a countercoup.'' There was little hard evidence of any connection with the CIA, but the rumors and explosions created a very tense atmosphere between Iranians and Americans.

Talking with some old friends among the press, I found they had some questions about the media's coverage of the hostage crisis. I had been on the other end of the television reports and also thought there was an inordinate concentration on the shouting crowds in front of the embassy and the latest shift in the political winds as Khomeini tried to establish control. The reports didn't include many of the things I had seen just riding from the airport to the hotel, which left a disquieting gap between the Tehran Kermani had shown us and the one we saw on television. Several correspondents shared my views, and we wrestled with the problem late into the night, periodically bemoaning the lack of distilled spirits.

Kermani picked us up the next morning with fire in his eyes. ''Bazaar!'' he cried, motioning our driver to accelerate. ''The bazaar is the largest in the world, with a history that goes back before the written word even recorded its existence.'' (Although pinpoint accurate about current events, Kermani was slightly prone to exaggeration when it came to Iranian achievements.) ''It is a place of mystery and commerce, of revolution and religion.''

This was Kermani the tour guide, working at peak energy, skirting routine points of interest to take us into areas of the city that most reporters were not privileged to see. In this case, the destination was not uncommon but still intriguing, since the bazaar was a caldron of discontent that played a significant role in the Ayatollah's revolution.

There are two Tehrans. One is modern and Western, in the northern part of the city; it was called Little Chicago by American businessmen for its modern buildings of steel and glass. There are international hotels with names that give it an undeniably American feel: Hilton, Holiday Inn, Hyatt. Paris fashions stood alongside American television sets in store after store along the boulevards. The Intercontinental Hotel showed John Wayne movies on its in-house television system in English without subtitles. Visitors were directed to restaurants with such names as Chez Maurice. The upheaval, of course, changed it all.

The other Tehran is in the southern part of the city. It had missed the touch of the Shah's oil money and belonged to the Ayatollah. So did the bazaar.

The sidewalks and streets all around the central bazaar were jammed with intricate Persian rugs, aluminum lanterns that filled entire shops, automobile parts and shiny hubcaps hanging from the ceiling—seemingly part of the stuff of centuries carried across the land bridge connecting Europe and Asia, and still available in the shops of Tehran.

Suddenly, a hole opened in the pedestrian traffic and we were swept down off Buzarjomehri Avenue toward a dark entrance, almost like that of a cavern. This was the central bazaar, a mixture of ancient sights, sounds, and smells totally foreign to Western senses: Aromas of coffee and coriander were thick in the air; cooking mutton mixed with the smell of ginger and poppy seeds being crushed; waves of turmeric, saffron, lemons, and oranges collected into one huge curry powder that dazzled the nostrils.

It was a dark place, six miles of passages set in a maze. Grizzled features peered from deep within small merchant stalls, questioning the foreign faces, deciding if it was worth making an effort to sell to them. Most often, they looked away or smiled at the contraption of metal and wires that Skip and Phil carried, the electronic presence of a country more technologically advanced. We paused often to catch the flavor of the bazaar—a poster of Khomeini in a silver shop, a young man wearing a sweat shirt that bore a strange non-Iranian script, ''U.S. Navy—Great Lakes.''

Tehran's bazaar, six miles of winding passageways, was one of Khomeini's main sources of funds.

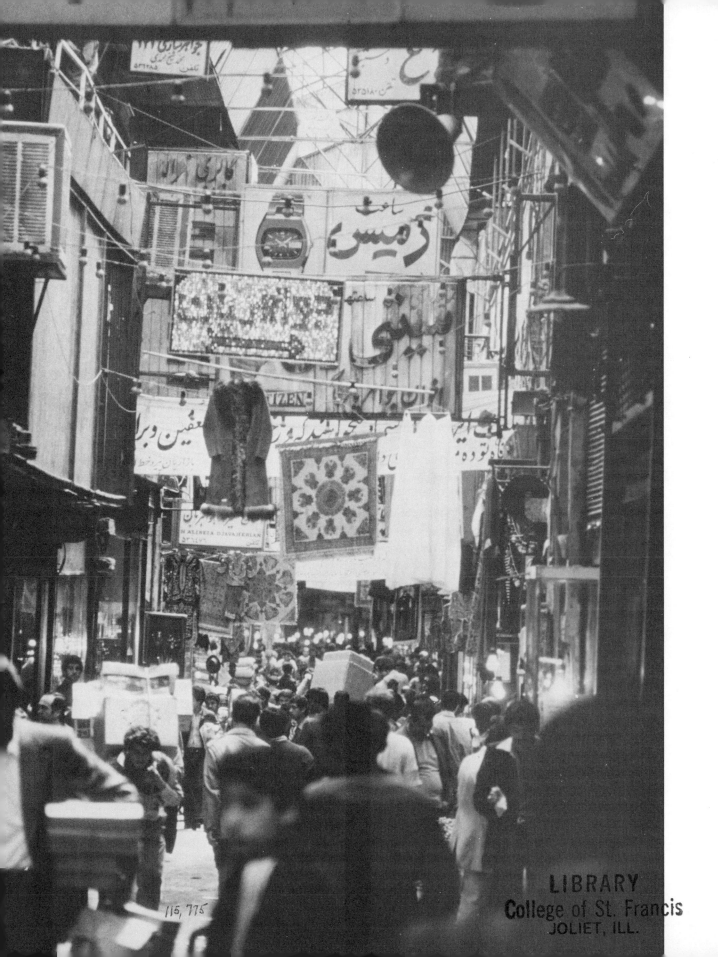

Kermani tried to shout an explanation above the din of merchants selling their wares. "This is where the revolution went through an incubation stage, among the *bazaaris*. They didn't like the Shah's program because he introduced a different banking system that would have driven them out of business. Their old method of loaning money was at a very high interest rate, almost like loan sharks, and a more equitable system threatened their livelihood. The Shah also imposed a tax on the merchants that forced them to keep books for the first time. It raised the prospect that they would lose a great deal of money. Then a rumor swept through the bazaar that the Shah wanted to tear down this old building and replace it with a more modern structure. That was the end."

"They turned against the Shah?" I asked. "So how did they help the Ayatollah?"

"In money, of course. This place may look like it's falling down, but that is very deceptive. Millions of dollars pass through here every day, and the *bazaaris* collected it to finance the revolution. Look there!"

Kermani pointed to the rear of one stall, where men were forging copper pitchers, pounding their edges on old stones just as their distant ancestors had done about 2,500 B.C. in one of mankind's first major cultures. "Back in places like that, no one could ever find the messages or money of a revolution. The Ayatollah would send tape cassettes with his instructions on them. The merchants would hide them and distribute them to people who passed through the bazaar. Even SAVAK was stymied."

In the bazaar one could enter the oldest and most important mosque in Tehran or buy a rare Koran from a hidden library of antiquity. A rug salesman offered me tea, which he mixed in front of elaborate Persian rugs and then served so hot that the small glass burned my fingers.

Kermani listened to comments among a crowd of men who gathered around the small scene of hospitality. They asked him if we were American. Obviously, Americans were not the most welcome of guests, in view of what was happening at the embassy and an explosion in the bazaar the previous day. He leaned down to whisper in my ear as I was sipping the thick tea, "If they ask about your nationality, tell them you are French."

I replied "Oui," which was nearing the limit of my knowledge of the language. I listened intently, exaggerating my expressions to encourage the merchant to talk on about his craft—how the rugs were woven, transported to Tehran from Kurdistan, and how he sold them in a bazaar stall as generations of his family had done before him.

There was a convenient pause for translation, which Kermani provided for our English-speaking audience. This shifted the men's attention to Kermani and away from me. I hoped none of them spoke English and would question why he wasn't translating into French. Perhaps they knew all the time. We smiled, thanked them, and rushed back to the waiting car. Kermani told us, "It is a very nervous time. There are all these rumors that the Americans and Bakhtiar [the former prime minister, ousted by Khomeini] are staging another revolution, and these bombings are thought to be part of it. So we will just have to be very careful. You must do as I tell you when we are in these places."

It must have been a curious experience for Kermani. Now that he was home, after an absence of years, he was forced not only to explain the ancient points of pride but to justify the revolutionary changes that were sweeping the city before his eyes. I could see the effect, hear it in his voice as we dodged the activity of Tehran's streets, turning our heads at Kermani's direction to catch glimpses of an ancient samovar, Parisian perfumes sold next to prayer beads, apricot halves alongside a sidewalk barber.

We passed shops that displayed Western fashions, and Kermani shook his head in disapproval, as if his religious sense of duty was increasing within him.

"That shop will soon be closed. Women should be seen in public only in *chadors*."

I didn't take issue because I detected a serious change taking place. The atmosphere of the revolution was permeating his thinking. Kermani's American ways were dropping like a suit of old

clothing, replaced by a new Iranian spirit.

It suddenly occurred to me that Kermani was not going to use his return-trip ticket to the States; he probably had never planned to. This Muslim who had left his homeland to take on Western ways was now exchanging them. He had wanted to come home all the time.

I didn't feel deceived—he could do what he wanted—but his actions were a key to the contradictory Iranian personality, torn between East and West. Western books, appliances, movies, fashions, and liberal sexual mores had intruded upon this society and clashed with Iranian culture. There was talk of returning to the traditional values of Islam, which placed human concerns above material ones. Kermani symbolized the tension between the two ways of life. His example helped us understand the undercurrents of the revolution and why Khomeini was violently rejecting all Western influence. I couldn't help wondering, however, if a country could turn back the clock by centuries; whether Kermani, having once enjoyed the freedom of the West, could really put it aside. That was the true dilemma of Iran.

A young Iranian outside the embassy at one of the soft-drink stands that were out of television cameras' view. This revolution moved along on Pepsi.

We had a decided advantage over other reporters covering Iran. They were pursuing the latest headline, which kept them close to the U.S. Embassy and Iranian officials. We were under no such restrictions. Kermani provided access to parts of the city that one could never see without inside help. He peeled back the layers of superficiality to reveal an Iranian view of the truth.

The U.S. Embassy was not totally what we expected. To our mild surprise, there was no sign of the screaming demonstrators whose images had crowded the television screens of America. City traffic passed by but, except for some curious Iranian tourists and a handful of guards, the scene was deserted. Six months into the hostage crisis, the Revolutionary Council was as interested in getting the country back to work as in showing its political support for the militants, so the demonstrations were scheduled further apart. There was one sight familiar to us from television still in evidence: political slogans denouncing the United

States and President Carter all over the block-long wall that surrounded the embassy compound. There was something peculiar about the slogans—many were written in English so they could be read by American television viewers. The other scribblings around town were all in Arabic script, for Iranian eyes.

At this particular hour, the militants had banned all pictures in front of the embassy. There were rumors that the Americans would make another attempt to take the compound, and the guards were on full alert (which didn't appear to be a high state of readiness).

As Kermani tried to persuade the cadre at the embassy gate to give us permission for pictures, one of the young guards, exactly the kind who appeared so fierce on American television, climbed over a carefully stacked bunker of sandbags. He was wearing olive fatigues and carrying an M-16 rifle. The young man handed his weapon

to a comrade and, with a short, skipping jump, bounded over the metal barricade that served as a fence around the front gates. A whistle, a wave, and a cab was stopping. Suddenly he was gone— probably headed for home—in the most unceremonious changing of the guard I have ever seen. I thought about the hostages still inside the embassy and couldn't help concluding that teenagers were holding the United States of America at their adolescent mercy.

Kermani again did well, and Skip was soon collecting the footage that, frankly, seemed redundant after watching that same gate for six months in the United States. I meandered to the other side of the four-lane boulevard, Takht-e-Jamshid, that ran in front of the compound. Without the rows of chanting demonstrators you could see the concession stands that were stacked high with Pepsi-Cola. An art gallery called Iran Galleries displayed attractive paintings, and an Electrolux vacuum-cleaner dealership faced the gates head-on. Western products were sold in shops up and down the entire block. They must have benefited considerably from the windfall of business that came tramping past their doors by the thousands in the form of demonstrators.

We left the embassy and drove to a housing development high up on the city's slopes, where the afternoon sun was turning the snow-covered Elburz Mountains a pinkish hue. It was a tract full of American-style homes set among tall condominium buildings, all but a few unfinished. The houses were very large, built for families of Iranian oil executives, the Shah's defense contractors, his professors at Tehran University, or his administrators in the many Pahlevi businesses around the country.

Construction had been interrupted by the revolution, and the homes stood sadly orphaned along unpaved streets. There were gabled Tudors, columned mansions from America's South, contemporary suburban designs, all planned with an American touch, right down to the streetlights and fire hydrants—even the green lawn dividers that separated the U.S.-built highway leading to the development and seemed so alien to the arid soil

around them. It was an eerie sight to find resting in the shadows of Iran's mountains, above the city smog line where residents could get a clear view of the expanse of desert below.

We watched a dog sniff its way down a sidewalk, past open electrical connections whose installation had been interrupted, when a flash of light revealed some movement in a large walled home at the end of the street. The neighborhood had seemed abandoned.

"Does anyone still live in these homes?" I asked the doctor.

"Only a few people, mostly caretakers. The owners have moved to Beverly Hills," said Kermani, smiling as he delivered the line.

We stepped up the dusty curb and followed a meandering path along a hill that led behind the house in which we had seen the light. Four of us picked our way through the stones beside a neatly bricked wall that made the home seem like a huge fortress, built to withstand assault. The front lawn contained a pool bordered by an intricately patterned patio, which led to the front door.

The heavy wooden door seemed to muffle our knocking rather than carry a greeting, but after a long wait we heard some shuffling.

The door swung back to reveal a bizarre sight. A small tribesman, tiny beside the door, timidly held the knob in one hand and in the other a rope, which was tied around the neck of a goat chewing grass. The man's skin was dark and weathered. His clothing was little more than layers of wrapped cloths set off by a small, round skullcap on the back of his head. To see him standing in the doorway of this mansion like some Junior League hostess was comical. After a conversation with Kermani, the small man motioned for us to come into the house.

"This is not a caretaker," Kermani explained. "He is a Kurdish tribesman who moved his family in here after the owner left for America. If we're lucky you'll be able to see something quite interesting."

That phrase is always the most intriguing thing anyone can say to a television cameraman, and Skip pushed past me with his gray rectangled cam-

Part of the Shah's extravagant building program for the new middle class he hoped would support him. But the upheaval of 1979 swept him from power, abandoning these buildings to squatters and the desert wind.

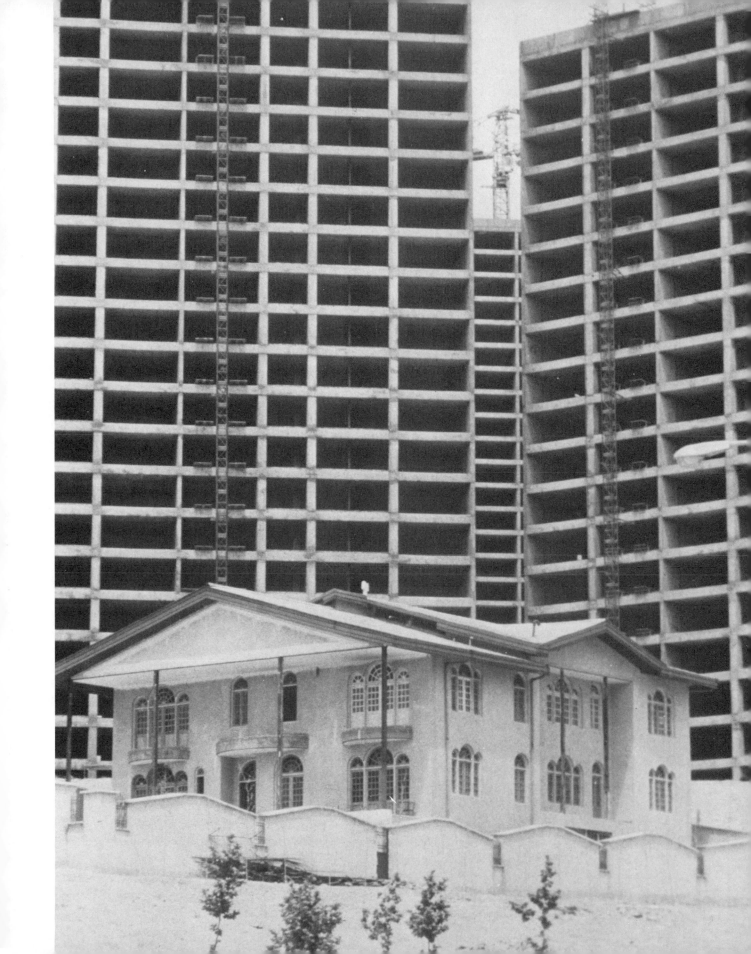

era on his shoulder. As always he pulled Phil behind him, tethered by the black cords that linked the camera to the sound and video recorder and connected them like two spacewalkers in orbit.

It must have been a humorous sight, the four of us in a single file following this funny little man with a goat as if he were conducting a tour of some ancient castle. Instead, reality was even stranger. This inhabitant of an ancient land was leading us through a modern "castle" abandoned in the haste of escape. In the living room, paneling lay stacked on wooden sawhorses beside a fireplace layered with cement dust. The dust was everywhere, a gray fur that clung to the walls and expensive tile floors. The house was immense, large enough for a very rich Iranian—or many Kurdish peasants.

At the head of an interior staircase that led to bedrooms above, the tribesman stopped and spoke to Kermani, who in turn gathered us together to hear the conditions. "The Kurd will permit us to look at his apartment, but we must all agree not to photograph the women. It is all right to take pictures of the men but not the women. In fact, you must turn your heads while the women pass out of view, and please don't look at them. These men are very serious."

My feeling was that this secrecy was not due to the dictates of religion but could be traced to a very natural instinct: jealousy. The *chador* and the circumscribed role of women isolate them, thus eliminating conflict between these men by preventing the "coveting of thy neighbor's wife." Prohibiting strangers from looking upon the faces of their ladies reinforces the men's authority.

So we turned around and faced a blank wall as the four Kurdish men escorted their women past us down the stairs that led to the basement. They say the *chador* enhances a woman's beauty by creating an air of mystery, leaving only the eyes and nose free of the black veil. Having to restrain even a glance at these Kurdish women heightened the mystery almost beyond bearing. Judging from the effort it took to keep our eyes off those women, they were the most beautiful in the world. I will always have a great deal of respect for the willpower that Skip exhibited on this particular occasion.

Unless he peeked.

When the women had passed, we were led into the apartment with great courtesy and gentleness. The "apartment" turned out to be the master bedroom of the mansion. It had been chosen by the Kurds, an outdoor people, because windows at either end kept a strong breeze flowing. Ten people lived in the one room, decorated as simply as if they had been sleeping in a cave. Persian rugs were spread upon the floor, much as nomads furnish their tents. A few pieces of clothing hung on the walls. The only furniture was a small stove for cooking tea and meat, in the middle of the room.

We were instructed to remove our shoes before we entered. The headman waved us to a door, which led to the master bathroom. There, in a spacious tub complete with ornate gold-plated fixtures, stood a goat nibbling on a stack of straw.

In that nonsensical world of revolution, death, and Americans held hostage, the incredible scene seemed almost normal. The entire past, present, and future were symbolized within a single picture. It spoke eloquently of the old overtaking the new and of the ancient ways gaining sway over Western material goods, which were now dead as corpses, shells into which illiterate peasants of the revolution had moved.

Each day added another vignette to our Iranian experience. One night, as I telephoned a report back to Chicago, four Phantom jets passed close to the hotel, trailing an engine whine that possessed all the horror of apocalypse. Reporters poured into the corridors seeking an explanation, but there was none available. Soon the moment was lost in the emptiness of the Persian night and the muffled sound of typewriters as correspondents faced deadline.

The bombings continued through the week. One of Khomeini's favored mullahs, Ayatollah Muhammad Beheshti, called a news conference for the remaining foreign press within the grounds of the U.S. Embassy to show off the charred remains of pilots retrieved from the failed rescue mission. The militants announced they had moved the hostages to a number of different cities around

Iran to foil further rescue attempts.

While other journalists rushed to chronicle the continuing events, Kermani pointed us in a different direction, toward the seamier side of the city. He was taking us to the opium district in South Tehran so we could film what he believed was an example of the Shah's crimes against his people. Kermani implied that the Pahlevi family had benefited from heroin traffic and tacitly encouraged the existence of this netherworld we were about to enter.

The district was dusty. Storefronts were open to the street. Tinsmiths and blacksmiths stretched long pieces of metal across the sidewalks for extra space, working in the glow of blue welding light to a chorus of acetylene torches popping in unison. Pipe threaders. Carpenters. Copper molders. These men were practicing the old crafts of Iran, which had seen political disorder before and had barely been interrupted by it. Small children without shoes ran in and out of an open gutter littered with debris. And everywhere was the dust. Foosball, the tabletop soccer game, seemed to be a national sport, scattered up and down the street wherever a table could be crowded in among the tradesmen. Hordes of young boys spun the handles madly and cheered with each score.

Among the frivolity were the denizens of this unique community, men kneeling on the sidewalks and injecting heroin into their veins without fear of arrest. Our driver, formerly a sergeant in the Shah's army and a man of bulk who did not seem easily cowed, spoke nervously to Kermani. He was clearly disturbed at being here.

Our car shuddered to a halt in the one-lane street, and I caught a glimpse of a man huddled against a fence, another man assisting him. As the car pulled forward, I could see both men holding a large syringe, carefully pressing the plunger farther into the cylindrical vial, letting white diluted heroin flow into the man's arm. We were stunned by the public display, but others streamed around the sidewalk with hardly a glance. Down the alley sat more men, resting their arms on their legs, their heads hanging slackly.

"Hold it!" I cried to the driver, wanting a chance to take more pictures. I pointed two doors away at a bearded man, disheveled, who was holding a match under a crinkled section of cigarette wrapper. The heat melted pure opium into a liquid that was then inhaled. Ten men stood on a corner and shared the aroma of burning opium. Three others were sitting in a doorway, gazing off into space with burned-out eyes, their faces drawn and creased. Here, as in some Dantean circle of hell, the occupants walked in a permanent haze, their

I witnessed blatant drug use in Tehran's opium district, such as this young man injecting heroin on the sidewalk. The Khomeini regime eventually instituted rehabilitation programs for addicts.

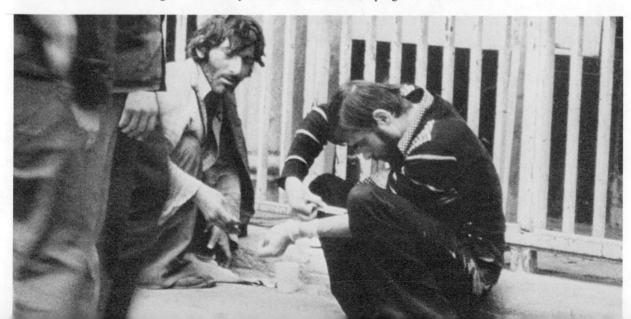

eyes distant and glazed by drugs. Drifting aimlessly along the street in a phantasmic stupor, they seemed to be looking forward only to the next moment when the surge of drugs would rush into their heads.

Suddenly, a young man appeared next to our car and began questioning Kermani. The driver gripped the steering wheel tightly, unable to move in the traffic and afraid of it.

Kermani turned to the back seat. "This man is a revolutionary guard looking for someone," he said. "I explained we want to see the good and bad of the revolution, what the Shah did to create such a place. The man will accompany us if we want to get out of the car. I think it will be all right."

I glanced at the driver, whose face had turned ashen. He did not object, however, and said he would park the car several blocks away, then return to find us. The look on his face should have been a warning to the real danger ahead, but we eagerly jumped out of the car to begin videotaping the spectacle around us.

The street people, these walking dead men, at first seemed surprised and then almost glad to see us, assuming perhaps that we were fellow travelers in misery. We came upon an opium den, just a wooden shack that looked like a newsstand and had a cloth draped across the door to keep the smoke inside. The opium pipes were being prepared: Small balls of the gum were rolled carefully to fit into the pipe and then punctured to release the smoke, which was inhaled. A black man pulled back the cloth to watch us.

Dust turned to mud where the sewer water spilled across it. Among the dispossessed ran the children, as American youngsters might race behind the bleachers at a baseball game. A few addicts peered at us through half-lidded eyes, surprised to see such an unusual collection of people in their midst. We moved through the street, shedding these followers when they became interested in a new scene of drug-sampling.

Then we made a mistake. One never goes back a second time in such a volatile situation. The first pass of a television crew is aided by the element of surprise—whether in riots or demonstrations or

heroin collectives, people don't organize themselves or think about their reactions until the crew has left and they have time to talk about what has happened. But our car was somewhere on the other side of the opium district, so we had to retrace our steps. And since we had just witnessed something that to our knowledge had never been filmed before, we couldn't resist the temptation to record just a little more of it.

Skip and Phil, still taping, plunged back into the crowd, not noticing that it was larger and noisier than before. What had seemed a fantasyworld of dreaming, oblivious addicts was quickly turning hostile. Kermani was alarmed. His face was no longer that of the warm, confident host but now showed fear. He pulled my head down so he could whisper, "Run!" That single word had the impact of a grenade. I motioned toward Skip and could see our driver gripping his elbow. Kermani was pulling me and speaking louder. "They are saying, 'Kill the Americans!'" I glanced at the dirty men around us. They had turned sullen, their faces angry, and were thrusting their hands in our direction. I moved into a jogging pace, brushing away two men in front and parting them easily. At the forward edge of the crowd, I could see some daylight, but Skip and Phil were caught in the middle of the packed mob. The camera bobbed and thrashed above their heads. We came to a street. Kermani was pointing to a drugstore as a sanctuary. I asked, "Where's the car?" "No time for that," he shouted back. "We'll rest in there while the crowd settles down."

As Skip and Phil stepped into the street, blurred figures tried to peel the videotape recorder from Phil's shoulder. He grabbed at the strap and lunged forward, jerking it out of their hands. Now the shouts were louder, in cadence. Kermani said he heard someone ask for a knife. It was hard to think in the chaos. Our escape tunnel of light became smaller as the bodies closed around us; I felt as if I were crawling out of a hole filling up with sand. I could see Skip was trying not to run, fearing it would incense those around him and Phil to close tighter, perhaps fall upon them. Our driver was helping to hold the angry ones back, and sud-

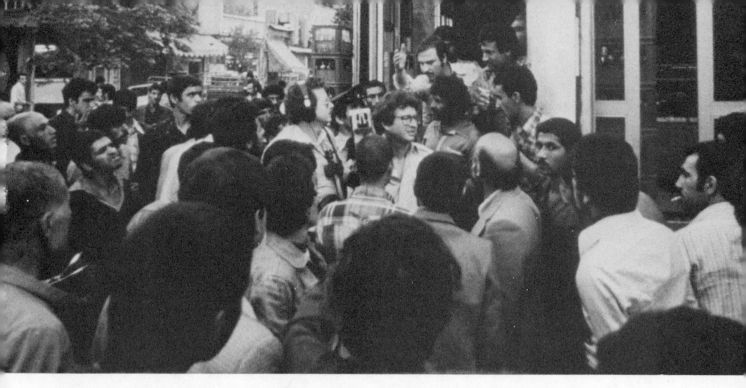

The walking dead men of the drug district suddenly came to life, surrounding us and shouting threats. Skip and Phil, trapped in the middle, fought to hold on to their equipment.

denly we were over the far curb and inside the drugstore, guided by Kermani and a local policeman who had come to help.

Our backs were cold against the wall as the crowd stood at the large windows, straining to see inside the store, looking for the Americans. We were afraid to raise the camera, afraid the mob would smash the glass. As we sat there waiting, strangers in a land that already held 53 Americans hostage, I opened my eyes to find a friendly-looking man standing beside his counter and staring back at me. He was obviously pondering this turn of events that now endangered himself and his property. I asked if he spoke English. He did not. "Then," I said to Kermani, "would you ask him if there is anything we might pay him for letting us stay here for a little while?"

Kermani communicated the question. The only reaction was a slight smile from the man, who was neatly dressed in an open-collared blue shirt, had graying hair, and looked about 55 years old. Then he answered in Parsi, which Kermani interpreted, "I do not like Americans. They exploited my country with their culture and modern technology,

and I support the revolution against the Shah. The Shah created this," he said, pointing to the men at the windows, who were chanting slogans and demanding that the Americans be released to them. Our attention at the moment, however, was riveted on the proprietor and whether he was preparing to throw us to the rabble. We could hear him even above the deafening cries outside the windows.

"I am a religious man of Islam. I live by the Koran. It provides me answers for everything in life, even for this." He smiled again, and his eyes glanced toward the distraught faces at the glass. It would have been very easy for him to give us up; no one would have blamed him. But his manner was not one of seeking vengeance. His blue eyes were cool and peaceful as he delivered his decision in a quiet, controlled tone: "The Koran teaches us that we must open our doors to visitors within our land. Guests must be afforded the same protection that we give our family; indeed, they must be fed first and in more substantial portions than the host. Only after they have eaten can I eat. I must protect them with my own life to ensure their safety until

they are once again outside my control. You gentlemen came into my store peacefully, needing safety, and it is my decision to allow you to stay until you can leave safely. It is my belief as a Muslim.''

Seldom have I experienced such magnanimity. This man's decision combined courage against the mob, conviction in the teachings of his faith, and a determination to do that which he believed was right even at the risk of angering those with whom he must live. Within minutes, he opened the door and escorted us through the crowd. The group was still chanting but made no move at us.

Safely away, the thought crossed my mind that such an Islamic rule might also apply to the ''guests'' being held at the U.S. Embassy. In fact, if I had considered this experience in trying to divine the fate of the hostages, I might well have found reason for hope in the example set by a stranger who breathed a living meaning into the teachings of the Koran.

As it turned out, the hostages were released unharmed eight months later, on January 20, 1981, the day Ronald Reagan was inaugurated as president. There was no single key to the crisis because, we later learned, the Iranian motivation was part political, part religious. It seemed as if, once the militants had taken the hostages, the revolution's leaders continued to hold them because they found in them a means to end their internal chaos and disarm the various leftist groups threatening the Ayatollah's grip on the power structure. The national hatred of the Great Satan and the ''spies'' inside the U.S. Embassy became a rallying point around which they could forge a national self-sufficiency.

I last saw Kermani standing on the other side of customs at Mehrabad Airport. His face shone with the same pride he had exhibited throughout our trip, that of a man whose dream of a new country, justice, and freedom had come true. But the end of my involvement with Iran was only the beginning of a tragic lesson for Kermani.

At first his physician's expertise was valued. He even talked his way into an important position with Khomeini's hanging judge, the Ayatollah Mohsadeq Khalkhali. One day, while Kermani was seeking the imam's counsel, an agent entered the office and told Khalkhali that a man they were seeking had been apprehended.

''Good,'' replied the imam, ''kill him!''

Kermani found the speed of it all stunning. He heard a scuffle in the hall outside and a voice crying out that he was innocent, that the agent had picked up the wrong man.

''I pleaded with the ayatollah to stop the execution for at least 24 hours while someone checked his story,'' Kermani later told me. ''I was crying, tears coming down my face as I realized what was happening. As I spoke, a gunshot interrupted me. It was over. Khalkhali was disturbed by my protests and instructed me not to do it again. He told me, 'If the man is guilty it doesn't make any difference. If he is innocent he gets a free trip to heaven.' ''

It was clear that the revolution would not bring about the changes Kermani had expected. Khomeini, he claimed, allowed Iran to drift into chaos with power concentrated in the hands of the mullahs, who were ignorant in the ways of government and the modern world. Prisons swelled with political internees, and torture was widespread. The number of executions far exceeded those in the days of the Shah.

Twice Kermani sought and received clearance to leave Iran from the Revolutionary Council, and twice he was stopped at the airport on the whim of student revolutionaries. He gradually realized that his name was being placed on an execution list. Finally, in the summer of 1983, he made it out of the country with help from friends.

Back in America, without money or a job, Kermani told me about the sickening disappointment he felt over his country's fate. His arrogance was gone, and so was the dream that had fired his imagination. ''On the airplane when we left, no one spoke until the pilot announced we had passed from Iranian territory into Turkey. Then we all cheered. I cried and said a prayer for my countrymen left behind. I prayed they would know what I was lucky enough to be feeling at that moment—the knowledge of true freedom.''

Media Held Hostage

There was a time, before the age of instant communications, when the foreign correspondent operated at a relaxed pace. The slow speed at which overseas reports traveled to the newspaper back home lengthened deadlines, creating a civilized delay in which the reporter could deliberate about his story.

Radio changed things somewhat, permitting much faster coverage, but by the time the Vietnam War came along television had moved the deadline pressure a step backward. Pictures required more time to prepare. The war in Southeast Asia was covered by television film crews who shot their stories in 16-mm film and had it airlifted to San Francisco or New York, where it was processed and edited for broadcast on the national news programs. Eventually, satellite facilities were established in Hong Kong that cut the time necessary to "make air" in half. But even then, with a four-hour flight from Saigon to Hong Kong, the reporter was looking at an average of 12 hours before his pictures and narration on a firefight in Vietnam could be broadcast. The final stages were usually handled by a producer, allowing the reporter to get some sleep and get ready for the next day's assignment. He could cultivate his contacts and explore the stories beyond the headlines, which might provide a deeper understanding of what was happening in Vietnam.

When the American hostages were taken in 1979, foreign coverage had changed dramatically. Iran's communications were extremely sophisticated, from its satellite ground station to intercontinental direct-dial telephones, installed by U.S. firms. The foreign correspondent no longer had the luxury of pondering his story over a gin and tonic in the hotel bar. The ability to broadcast literally within a few minutes of an event had reduced his deadlines drastically. The television network reporter was forced to service two broadcasts a day, in addition to hourly radio broadcasts. The physical demands were grueling. It was hardly the comfortable, glamorous job of an earlier time.

In Iran, correspondents were covering the crisis as if it were a local story happening down the street in the United States. Television correspondents operated like wire-service reporters, competing with a variety of news services to get the latest hint, utterance, or even facial expression that might provide new details to feed the insatiable appetite for the story back in the States. So the reporters became hostages, too. They were so busy checking the militants at the embassy, the latest demonstration, or the foreign ministry that they had little extra time for background coverage. And even if the correspondents had been freed from the demands of that daily routine to produce "sidebars," the primary broadcasts—the network evening-news programs—would have

been reluctant to make room for them.

The Iranians took advantage of the media, playing their hostage card with the style of a flimflam man. By creating hope night after night that the hostages might be released, they managed to keep American reporters breathless trying to cover every halting phrase. The result was that the wire services and networks were tied to the immediate source points, the embassy and the foreign ministry. After months of having to provide time for the "latest" from Tehran, the producers of evening broadcasts were hardly in a mood for extensive background pieces. Squeezing shots of demonstrations and official Iranian statements into those few minutes

The slogans on the long banners that stretched the length of the U.S. Embassy compound wall were written in English, obviously for American eyes. "Viva Khomeini," they proclaimed, and "Death to Carter."

resulted in a system that, according to diplomat George Ball, provided one-way communication with Iran—their way.

The fault lies not in the judgments made by producers and editors of the major broadcasts; no one could turn down the latest revelation from Tehran. It was the format and time limitations that constricted the coverage. Condensing material to fit the allotted time has long been considered the villain, the factor that most distorts television reporting. Although technological advances have enabled us to see almost anywhere in the world at a moment's notice, the basic vessel into which the information is poured dates back to 1962, when CBS initiated the half-hour news broadcast, with Walter Cronkite as the anchor.

Cronkite himself has often called for extending the program to one hour, which would permit just the kind of lengthy reporting needed to put the hard facts in perspective. But this idea has failed to become a reality, for two reasons: The additional time is too valuable to the local stations that carry the network news, and many of these stations have developed news operations sophisticated enough to compete with the network for the time.

During the hostage crisis, the problem with television's concentrated dose of angry Iranian faces was that it risked giving the impression that the demonstrators represented the only view held in Iran, which was not the case. I found a spectrum of opinion among Iranians far broader than people in the United States would have expected. Many did support the Ayatollah's handling of the hostages, but others believed Iran should release them immediately. I was surprised to have young Iranians plead with me in a reasonable way—not shouting slogans—to communicate their feelings, some even saying that they loved America, with a few reservations. One who had attended an American college said, "They send all these foreign workers to Iran, they support a dictator to rape this country, and they don't even know where Iran is!"

There is a nagging question left about the Iranian coverage: Did the daily news presentations raise the pitch of reactions in the United States, fostering a war mentality the way the Hearst papers did before the Spanish-American War? Or did it perhaps avert a war by relieving tensions among observers?

Statements from Tehran, reaction from the White House, emotional sidebars about the hostage families, demonstrations in Tehran's streets, chants about the Great Satan, violent retaliation against Iranians in the United States—it became a nightly pounding with no letup. Some analysts say it played a major role in the fluctuating popularity of the various presidential candidates in 1980. More important, they argue, it pressured the White House into the tragic rescue mission that failed.

Carter's chief of staff, Hamilton Jordan, told me that popularity polls had had no effect on decision-making in the White House, but when the media were the only source of information from Iran; when they were bypassing the official diplomatic channels to reach the people directly;

when the nightly dribbles of *maybe's* or *we're-hopeful-tonight's* or *perhaps-in-the-near-future's* increased the expectations of the public, one finds it hard to believe that the White House wasn't a hostage to Iranian manipulation of the best communications system in the world.

The Iranians seemed to be one step ahead of us. One way they achieved that impression was by monitoring the reports of all the television networks in the United States and communicating the scripts back to Iran by the superb U.S. direct-dial telephone system. There were many sympathetic Iranians in America willing to "spy" on public information and send it back to Iran. That feedback enabled the propaganda leaders not only to criticize reporters within Iran but to design its media assault on the United States as effectively as Khomeini had used the electronic media to orchestrate the revolution from France.

These officials were equally interested in the print media. I remember visiting the office of the Iranian foreign minister in Tehran and, while waiting in an outer room, noticing a copy of the *New York Times* on a desk. It was only one day old.

Iran also attempted to influence the media by placing pressures on journalists that ranged from denial of visas, censorship, and delay of baggage at the airport to expulsion, eventually applied to all news-people. Even Kermani got into the act. He had been watching the news in Chicago and became upset by the work of NBC reporter Rick Davis. Three days after Kermani returned to Iran he registered a complaint that the reporter was slanting his stories against Iran. Davis was kicked out.

Eventually the Iranians found that their power to manipulate the American media had a double edge. Their messages were broadcast to the United States as they wanted, but against the backdrop of the hostages they created an emotional backlash without illuminating the real issues, such as the crimes of SAVAK and the Shah. The Iranians finally chose to expel the press rather than use it.

Television tends to have a short memory, jumping from one emergency to another, often without making a stab at analyzing yesterday's headlines. Although I might not have performed any differently from the other newspeople covering the hostage story, it might be useful to try to extract some lesson from the crisis instead of leaving it behind.

We need more time for longer reports. We should press for thorough coverage of the issues from all points of view. As Chicago Mayor Richard Daley said during the turbulent 1968 Democratic National Convention, "Television may show two sides to a story but not necessarily all sides. The two sides are often the most extreme views which eliminate the more reasonable middle ground."

Wouldn't it be tragic to cover a crisis and conclude that the only solution was all-out war simply because we had failed to adequately understand the people and issues we were confronting?

Dateline: U.S. and Vietnam

Focus: Probing a potentially deadly

legacy of the Vietnam War

Agent Orange: anatomy of a documentary

The memorandum provided only the suggestion of a story that, if true, would grow to immense proportions. I could immediately foresee the potential issues: an international dispute involving the waging of chemical warfare by the United States in Vietnam; health claims by American veterans that could amount to billions of dollars; and the sickening realization that after all the Vietnam vets had endured, they might have to bear yet one more burden— a time bomb dropped on them by their own government.

Brian Quinn swung the shovel in a short arc over his left shoulder. He had to shift his weight to handle ten pounds of the snow that threatened to become as synonymous with his hometown as the Great Chicago Fire. An overnight storm had left a pristine six-inch blanket of white across his driveway that had to be cleared before his wife, Carol, could go to the supermarket.

It almost went unnoticed, the small touch of pain in his lower back that he felt in midswing. Better take smaller scoops, he thought, as he heaved another one into the air.

Couldn't be anything serious, Brian thought. He hadn't been sick a day since he was discharged from the Navy in 1971. Of course, that was six years ago. Even 33-year-olds could use an exam now and then. If it gets any worse, he promised himself, I'll see the doctor. Carol would feel better, anyway.

They had been sweethearts at Kelvyn Park High School on Chicago's Northwest Side and got

39

married when Brian returned from Vietnam. He was a Navy corpsman assigned to grunt marines running patrols out of Da Nang. Carol remembered only one incident from the war that had bothered him through the years: A high school buddy caught a mortar round in a direct hit, and Brian watched him disintegrate. Otherwise, he didn't talk about Vietnam very much. Not that he was internalizing some bitter trauma; he was just normal.

Brian represented the hundreds of thousands of veterans we don't hear much about, who rotated through Vietnam, some without ever seeing Saigon, and then returned to quiet adjustment in the States. They would have liked more of a hero's welcome, and they were cheated of that, but it didn't destroy their lives.

"Coming home" for these veterans meant returning to parents, jobs, the old neighborhood, all of which helped them slip back into the twentieth century after seeing the "other world" of Nam. They married, started families, joined churches, attended Rotary Club lunches on Wednesday, and played golf. They were not part of any lost gener-

ation suffering from Vietnam syndrome, freaking out and shooting at some invisible Charlie.

Brian was like so many other returned veterans, anxious to get on with his life. By 1977, he had a good job with Warshawsky Brothers Auto Parts in Chicago, and he and Carol were expecting their first child.

So when the needle-point stitch caught him as he lifted the shovel, any connection with Vietnam seemed as far away as the end of the snowy driveway he still had to clear.

Probably pulled a muscle, he guessed. If it gets worse I'll get a checkup.

The evening of November 15, 1977, was one of the busiest of the year in the newsroom of WBBM-TV, Chicago. I was trying to follow an excited voice on the other end of the telephone, typing as fast as I could while cradling the phone between chin and shoulder.

"Collapse of a savings and loan institution right in the stockyards, been there for years," the voice said. "Federal agents are in there right now."

"Is there going to be a run on the bank, like in

Once part of a magnificent forest, this lone mangrove tree in the Saigon River Delta is the only survivor of Agent Orange spraying missions during the Vietnam War.

the thirties?'' I asked.

''No, no. Nothing like that. The feds will pay back all the depositors.''

Still, financial institutions don't go out of business every day, I thought. It would make a nice lead for the ten o'clock newscast.

In the middle of the conversation, our assignment editor/dispatcher, the newsroom link to a handful of videotape crews around the city, pointed to another flash on the telephone display board. I put my financial source on hold.

''Got a good one for you,'' whispered the familiar voice of Bob Wussler, then president of the CBS television network and a former boss.

''The new president of NBC is Freddie Silverman.'' His voice trembled slightly as he spoke, for he realized this was a bombshell that would put us hours ahead of any official announcement. In a competitive town like Chicago, that would be an enormous edge.

Getting back-to-back exclusives is rare; in fact, I can't remember another instance of it. But this occasion was fixed forever in my mind because of yet a third memorable interruption.

Into this frenzy—juggling two calls, rolling paper into the typewriter to get it all down—a manila envelope fell onto the desk in front of me.

Phil Ruskin, a director at WBBM and instructor at Chicago's Columbia College, told me, ''Don't want to bother you, but one of my students asked me to give this to you. She couldn't get you on the phone. Says it might be a good story.''

My expression made it clear that this was the wrong time for chitchat. He backed off, leaving the envelope.

Time sped by as I worked against deadline. Everything is intensified under that pressure, including curiosity. The same instinct that makes a reporter wonder where the fire truck is going every time he hears a siren made the thickness of that envelope seem enormous. Someone has gone to a great deal of trouble, I thought. Of course, few letters that came to me in the newsroom contained press-stopping news—usually they were from a lonely widow asking for a photograph because I reminded her of a distant son-in-law, or someone

who had lost a lawsuit and was mailing the entire legal file as a last resort, hoping I could do something about it.

But this reasoning was no match for my curiosity. I often think that even if I had been typing my own reprieve from death row I couldn't have resisted reaching over to that envelope.

As it turns out, the two exclusives that seemed so important have long been forgotten. But the envelope contained the seeds of a story that may never be resolved; certainly it would become the most important issue related to our involvement in Vietnam since the fall of South Vietnam in 1975.

Inside the eight- by ten-inch package, marked only by my name, was a list of military personnel—veterans—and a paragraph introducing a woman named Maude DeVictor. DeVictor was a counselor at the Chicago regional office of the Veterans Administration who evaluated veterans' claims to benefits paid for service-connected health problems.

DeVictor explained that several months earlier she had seen one of my reports about the controversy over the use of the defoliant Agent Orange by the U.S. military during the Vietnam War. The report pointed out that although the issue had faded with our memories of the war, the two herbicides that composed Agent Orange, 2,4-D and 2,4,5-T, were still being manufactured and used in the United States and had been the subjects of environmental complaints.

I remembered the report, but I had filed it away, thinking it was no more than an interesting follow-up to something that had died with the Vietnam era.

DeVictor noted that I had mentioned Vietnamese claims that the herbicides had caused health problems, even stillbirths and birth defects, but that these had been dismissed at the time as North Vietnamese propaganda.

She said the report rang a bell because when it was aired she had been interviewing a number of U.S. Vietnam veterans who complained of physical and psychological problems for which there seemed to be no medical explanations. Their complaints fell into roughly similar categories: respira-

tory problems, nervous ailments, numbness in the fingers, lessened sexual drive, headaches, and skin rashes that wouldn't go away. Alone they meant nothing. They were so general that anyone might file for benefits on such a basis. Maude realized that, so she asked the veterans one more question: When you were in Vietnam, did you ever see a white mist or fog used for defoliation?

About 20 answered yes.

My mind began to jump ahead of her notes to the obvious question: Was the vets' exposure to Agent Orange harmful enough to qualify them for benefits for a service-related injury?

Still explaining, DeVictor wrote that she had tried to find the answer by getting in touch with the Department of Defense, which responded by sending her a thick pile of scientific information. Although it went into great detail about the herbicide's potency and extensive use in the United States, it offered no conclusions about its effect on humans. There was no evidence, it said, to support any claims that Agent Orange caused veterans long-term problems.

With that, DeVictor had packed up her information and used her connection with Phil Ruskin to make sure it was delivered to me.

Her memorandum contained no evidence that, if broadcast immediately, would become nationwide headlines. It provided only the suggestion of a story that, if true, would grow to immense proportions. Even in those first few moments I could see the potential issues: an international dispute over the waging of chemical warfare by the United States in Vietnam; health claims by American veterans that could amount to billions of dollars; and the sickening realization that after all the Vietnam vets had been forced to endure, they might have to bear yet one more burden—a time bomb dropped on them by their own government.

In the time it had taken me to leaf through DeVictor's package, I still questioned whether we had a story. There was a lot of hard work ahead before we could know that. I say "we" because I quickly enlisted the help of two producers, Brian Boyer and Rose Economu, to work with me in what we at the station called the Focus Unit. This investigative group was designed to bring an understanding to the headlines of the day, delving into issues and expanding on them beyond the brief mention they might normally receive in a newscast so that the complete story could be told. Brian and Rose had as much enthusiasm for the project as I, and together we outlined our approach.

First, we must verify the symptoms. Were they real or imagined? Trying to think like medical researchers, we had to answer the question, Why couldn't these symptoms be explained as general complaints not attributable to any cause as specific as Agent Orange?

Second, to prove a connection between these complaints and the defoliant, which would give us our story, we had to establish that the veteran had been exposed. Had he really been in areas that were sprayed with Agent Orange and seen its effects on the foliage, or had he only heard about it? And if he was exposed to the defoliant, how close did he get?

A third area had to be explored before we could broadcast anything suggesting a link between these veterans and Agent Orange. Was the defoliant harmful to humans? Did it have the potential for causing symptoms like those named?

For me, a considerable barrier to believing it was dangerous was the fact that farmers had used both 2,4-D and 2,4,5-T for years on their pastures and croplands with no apparent problems, or at least no known complaints. Even I had sprayed pastures in Kansas with my father to kill blackjack oaks and wild blackberry bushes. We had mixed these two herbicides in a 55-gallon drum, which we pulled around the pastures behind a tractor. With a high-pressure nozzle powered by the tractor motor, we soaked the trees from all sides, shooting the white liquid high into the air until it covered the leaves, hanging like droplets of milk. Sure enough, within a few weeks the trees were dead, standing brown and ugly in the green fields like victims of premature autumn. Damn good job, I always thought. It sure did make a pretty pasture after we cleared away the dead brush.

I remembered two other things from those

working days during high school. Despite the precise instructions on the containers for mixing the herbicides, there was always the temptation to mix a stronger dose to speed up the process. And, it's almost impossible to apply it without drift. Once you spray it into the air, it rides the wind for miles. We were applying it from the ground—which certainly gave us better control than a helicopter would have—but we found that the chemicals didn't care whose fence they blew across. My father and I had both felt dizzy at the time, but neither of us had any lasting problems even though we had been completely soaked in the solution.

So I went into the Agent Orange story with a shadow of skepticism. I also felt we needed to digest a few basic facts before we went off in search of something that might not be there. This story had a very great potential, probably too great, I thought, to have dropped on my desk the way it did. One axiom of journalism is that big stories usually look big because you're seeing only one view. "Better not get too deep into a story," goes the old city editor's joke, "you just might find two sides." With that point never far from mind, Rose set up interviews using two names supplied by DeVictor's memo. The first was Charlie Owens.

Chicago winter had taken the color from the leaves, but even in that chill bleakness the South Side neighborhood of the Owens home was impressive with its well-kept lawns and fortress-tight bungalows. As Rose and I drove toward our appointment, we were both waiting for the other shoe to drop, exposing some obvious truth we had failed to grasp. If the charges that the defoliant had caused health problems among the Vietnamese were true, we asked each other, why hadn't we heard from our own soldiers?

Ethel Owens was a charming woman who kept her home spotlessly clean. Housework had become her therapy after losing her husband to cancer several months earlier.

She described U.S. Air Force Staff Sgt. Charlie Owens with great reverence. "He worked in the office while everyone else did the flying. They loved him and he loved what he was doing, the Air Force. He had been in for 30 years and thought about staying longer. But we decided to leave it to younger fellows and retired here. Chicago was always home to us. He felt fine until just a couple of months ago, when he went into the hospital to check on some pains he was having. They found cancer. He was dead in a month."

Her retiring manner showed no sign of tears; that stage had passed. It was as if Charlie were away on one of his long assignments. She added, "I guess I should be glad he didn't suffer."

DeVictor had listed Charlie's name because of something she remembered him saying about Agent Orange, so I asked, "Did he ever mention the white mist they used as a defoliant?"

"Why, yes, he did. His squadron sprayed the material, I believe. We were talking about how he got cancer and how it was so strange because he had never ever been a sickly man. He just thought it might have something to do with that spray. He said, 'The spray was often so thick it looked just like Los Angeles smog.' "

It happens like that, piecing a story together. Rarely do neon signs herald, "Here's your story, dummy!" Rather, it comes in little winks that stick somewhere so you remember them.

In the case of Charlie Owens, we were a few months too late. But there was that pregnant phrase, "It looked just like Los Angeles smog." Charlie had left a clue, which kept us going.

The next night we went to the second meeting Rose had arranged, with Milton Ross. He lived in Matteson, Illinois, not far beyond Chicago's southwest edge. It was a long drive, especially since I was trying to get there and back from the Loop without missing either the six o'clock or ten o'clock newscast. But we were at a critical stage. These initial interviews would rank among the most important we would do because without evidence of legitimate symptoms from the veterans we wouldn't go any further. If Rose and I struck out with Milton Ross, it would probably be the end of the story in our minds.

Milton met us at the door of his tract home; his small children, dressed in Dr. Denton sleepers, clutched at his legs, peeking out bashfully to see

This pair of 1970 photos testifies to the efficiency of Agent Orange: Left, an unsprayed mangrove forest near Saigon; right, a herbicide-treated forest. Agent Orange destroyed 200,000 acres of mangroves during the war.

the "television people."

"They're excited to see the camera," Milton explained, and I asked our crew to set up the lights while we talked. His wife, Bobbi, confirmed the problems Milton had mentioned to DeVictor: psychological disorders to the extent that he was seeing a psychiatrist, and "diminished sex drive," she admitted with some embarrassment.

"He's tired so much of the time and finds it hard to stay on the job. In fact, he's been off the job for a month, taking sick leave, and we're afraid he might be laid off soon."

Bobbi explained that they were also a month behind in their mortgage payments and were afraid of having their home repossessed.

"We're trying to work something out with the bank," Milton added. "But we don't have any agreement yet. If I get laid off we'll only have Bobbi's income, and that's not enough."

He certainly had problems, I thought as Milton

talked, but hardly the kind of information that would advance our story.

To the delight of the children, our cameraman flipped on the portable quartz lights, transforming the dim, comfortable living room into the 50-yard line of the Astrodome. We laughed and adjusted our eyes as I said hello to Milton's son, who was pushing his way alongside his father's knee. Milton lifted Richard's hand toward me, and for the first time I saw the chilling reason DeVictor had included Milton Ross's name. Several of Richard's fingertips dangled by a piece of skin as if the last joint had been severed and then badly reattached. The ends of his fingers on the right hand were useless; on the left hand several fingertips were missing, probably the result of deformation in the fetal stage. His leg was marked with a circle as if a rubber band had just been taken off. Medically the abnormality was called congenital banding.

Milton and Bobbi could see I was at a loss for

words, and they volunteered, "He has a few manual dexterity problems, of course, because of his deformities, but aside from that he's a normal 6-year-old."

"He was born like that after you returned from Vietnam?" I asked.

"Yes. About 18 months after I got back."

"Where did you serve?"

Milton said he was stationed with a special forces unit in the Central Highlands, one of 22 advisers working with 200 Vietnamese. "I remember it being sprayed out of helicopters for bugs and vegetation, and to keep the perimeter clear," he said. "We had ten forward posts we supported, and I made frequent spot checks of those areas. Efforts were always being made to keep the vegetation down around those posts. I probably came in contact with the spray on several different occasions in different ways and locations."

The sight of Richard's fingertips dangling grotesquely from the rest of his fingers would be one of the most dramatic examples of the veterans' problems in the entire Agent Orange controversy. For Rose and me, it came at a crucial moment, when we were deciding whether we had a story. After seeing Richard's birth defects—whether they would ever be attributed to Agent Orange or not—we knew that the veterans were sincere, that their complaints were not imagined. Yes, Milton Ross and his family had serious problems. Yes, he had been exposed to Agent Orange. Suddenly the story had grave implications.

Many similar interviews in the course of our investigation would confirm our belief in the veterans' plight, but none would have more impact than the sight of this boy's fingertips. The picture needed no narration. In an instant, it communicated a message with an emotion that couldn't be forgotten. That is television's strength. It also carries a responsibility. Because certain pictures are so strong, the reporter must ensure they are properly qualified. In this case, we would use the videotape of Richard's fingertips not as absolute proof of a connection with Agent Orange but to demonstrate the kinds of problems the veterans were talking about and to question whether they could have

been caused by Agent Orange.

I drove back from the interview feeling as if we had just pulled a gold nugget out of the Feather River in California. That presented a frustrating problem. I confess to being a terrible keeper of secrets. My job is to communicate, and keeping a lid on information is like holding an ice-cream cone and not eating it. But running around telling everyone is just what we couldn't do. Competition is a very large element of journalism. Most of the time it is beneficial, driving reporters to work faster and harder. However, it can also have a negative effect if, in the name of beating out another reporter who might have come upon the story, news is released before facts are properly checked. A leak would force us to break our story early, without proper preparation. So Rose, Brian, and I had to be content with discussing the matter in private.

In a small office just outside the high-ceilinged newsroom, we decided on our plan of attack. The task was to show what the veterans' complaints were and find out if the scientific community believed there might be a link with the herbicides used in Vietnam. A journalist can do little more than that, inform intelligent people about problems so they can solve them. In the process, a story can take strange turns, often helped along by other journalists who pick it up, people who stand to benefit from the outcome, and even those who might be hurt and unintentionally take measures that magnify its importance.

After two weeks of intense research on dioxin and the history of herbicide use, as well as our interviews with Ethel Owens and the Rosses, it seemed clear that we needed more than a few minutes of air time. We would ask News Director Jay Feldman and General Manager David Nelson for an hour, which meant we'd have to "crash" on the documentary, putting all other projects aside and splitting the country into two parts. Rose would pick up interviews and visuals east of the Mississippi, while Brian would travel west. I would join each as time permitted. Somewhere along the path of our many phone calls, we had come upon a tip that "60 Minutes" was also working on the story, which caused us to move our

broadcast date up considerably. That gave us about one month of shooting to gather our visual material; another month of editing time, and we would have our program ready.

Nelson and Feldman were very supportive and immediately gave us the go-ahead. We all agreed to a pact of secrecy to prevent any leaks. The most difficult task would be to conceal our activities from the assignment desk, which jealously guards its authority and is easily rankled when crews are used for purposes it doesn't fully understand. Also, the videotape crews posed a problem. They have to be one of the strongest links in any news operation because they're called upon to make the hard, physical sacrifices required to get to the scene of a story, often in inclement weather. They also have more contact with competitive crews than anyone else within a newsroom. A cameraman engaged in friendly conversation with a rival station's crewman could inadvertently include a valuable piece of information that would give away a story. So we swore the crews to secrecy, short of using a Bible, and stressed the importance of our story and the need for keeping it quiet. They lived up to our highest expectations. Our shooting would begin almost immediately, and we would continue researching as we went along.

One of our most valuable sources was a series of articles by *New Yorker* Assistant Editor Thomas Whiteside that documented the chemical harm done to the environment by the herbicides 2,4,5-T and 2,4-D—the ingredients of Agent Orange—during and after the Vietnam War. These detailed accounts helped us immeasurably.

We quickly found that the other information available on the herbicides had been compiled by two groups: agricultural scientists who had studied their effect on pastures and croplands, and a handful of research scientists who concentrated on a highly toxic ingredient within 2,4,5-T, a contaminant that results from the manufacturing process. Its imposing technical name is 2,3,7,8 tetrachlorodibenzo-*p*-dioxin, known also as TCDD dioxin or just dioxin. It is widely regarded as the most toxic substance made by man, up to 100,000 times more poisonous than cyanide or arsenic.

Most of the scientific studies of dioxin began in early 1973, when Dr. Matthew Meselson of Harvard University and Dr. Robert Baughman developed a technique to detect it at extremely low levels. Previously, tests could measure only concentrations in the parts per billion; the new system allowed the detection of dioxin at parts per trillion (one part per trillion is comparable to 30 seconds in a million years). This advance was significant because it cast doubt on earlier studies that had found no evidence of any adverse effects of 2,4,5-T and 2,4-D.

For example, the Council for Agricultural Science and Technology (CAST), an industry group, responded to our inquiries in December by pointing out that thousands of scientific papers about phenoxy herbicides (the family to which 2,4,5-T belongs) concluded that they had been used safely for years. A recurring phrase in its reply was "There is no evidence to suggest the herbicides cause harmful effects to humans."

A careful reading exposed the weakness of the statement. "*No* evidence to suggest" is much different from "There *is* evidence to suggest *no* harmful effects to humans." It meant that tests on human beings hadn't been done. Even if they had, the new Meselson-Baughman system would have rendered them irrelevant.

There were a number of other problems with the claims of the chemical and agricultural interests. The mixtures used in the United States by farmers, foresters, and gardeners were much different from those used as weapons of war. In our first interview with Dow Chemical Company, then one of the principal American manufacturers of 2,4,5-T, its herbicide expert Dr. Lewis Shadoff admitted, "The normal label directions say that the dosages should be roughly two pounds per acre on rangeland. The Vietnam use was roughly 15 pounds per acre, and it was sprayed repeatedly over the same area, which again is not recommended practice, so that materials that have higher concentrations of TCDD than are presently contained in 2,4,5-T were sprayed at higher levels and more often than would be used in present agricultural practices."

Dow's lawyers would later expand on these remarks in arguing that the company could not be held liable for damage caused by 2,4,5-T.

We also found that many of the groups that were most helpful in our investigation had vested interests in making sure industry had a herbicide with a clean bill of health. CAST, whose report had assured us of 2,4,5-T's harmlessness, was, not surprisingly, funded by chemical and agricultural interests. There was much at stake. Dow Chemical was only one of several manufacturers still making 2,4,5-T and 2,4-D at a considerable profit, albeit a pittance compared with overall company profits. The U.S. forestry industry estimated it would lose $50 million a year without 2,4,5-T. Helicopters sprayed it onto broad-leaved plants that shut out the sunlight from young Douglas fir trees and caused them to grow more slowly. Without the aerial weed killers, crews of laborers would have to climb the mountainsides and hack away the plants by hand.

These economic considerations were typical of the issues that can easily sidetrack reporters. Being bombarded with them was part of the hard slog of investigative reporting, and we were not unaffected. You can't hear about thousands of research studies and not feel that the story has run headlong into an abyss. That's when it was helpful to think about Richard Ross's fingertips and realize that none of the so-called research answered the primary question: Could exposure to Agent Orange in Vietnam, used in concentrations much higher than anything sprayed in America, have produced health problems in our own veterans?

One of the first scientists within the small dioxin research community of whom we did ask that question was Dr. Val Woodward, a geneticist at the University of Minnesota. He had been interested in the complaints of herbicide poisoning made by the Vietnamese and in 1971 had visited Bach Mai Hospital in Hanoi, North Vietnam. He remembered that their descriptions of symptoms were very similar to the U.S. Vietnam veterans' complaints. His words made it shockingly clear that dioxin is a teratogen—a generator of deformities in fetuses—and is very likely a cause of can-

cer. Did it have the potential to produce health problems among U.S. veterans? Yes, he said emphatically, based on his own genetic research and his study of the available data. He gave affirmative answers to all of the key questions: Symptoms? Real. Exposure? Established. Potential of dioxin? Deadly.

It was time to get a clearer picture of what had happened in Vietnam. The history of Agent Orange seemed well documented by the Department of Defense. We would later find some important omissions, but at this stage it seemed accurate.

Early in the 1960s, when it appeared likely that America might find itself fighting guerrillas in the jungle, military analysts were given a problem: How do you fight an indigenous force under thick foliage with as little loss as possible when the enemy can attack and then retreat into the cover of the jungle? The question had been asked before, near the end of World War II, when the United States faced protracted jungle warfare in the Pacific, and in the 1950s by the British in Malaysia. In both instances tests of herbicides were conducted at Fort Detrick, Maryland, and the data on 2,4,5-T were readily available.

As early as 1961, the U.S. Military Advisory Group was testing a combination of the phenoxy herbicides to provide a solution for how to wage jungle warfare. The potential of these agents was very tempting. If we could spray the jungle with something to take away the enemy's cover and deny him the food he needed to live off the land, we could make him fight our kind of war, enabling us to use our big weapons. This just might be the secret weapon that would shorten the war.

There seemed to be no reason not to use the herbicides. They had been employed in the United States without any problems for years, according to the available data. It should be as simple as hooking up a set of nozzles to an airplane and dousing the triple-canopy foliage. Of course, the mixture would have to be more powerful to cut through the heavy jungle.

By 1962, American officials granted the South Vietnamese request (a political courtesy much like a son asking his father for the car) to begin using

During a nine-year period, U.S. transport planes like these unloaded millions of gallons of defoliant over South Vietnam in an effort to destroy enemy cover.

defoliants along the road between Saigon and Vung Tau on the South China Sea. It was a 40-mile stretch, subject to harassment and ambush by Viet Cong who would fire their weapons and then escape into the thick underbrush. A heavy infiltration route nearby in the Saigon River Delta was also sprayed. It consisted mainly of mangrove trees that reached 60 feet or more into the air, standing above the tidal marshes on aerial roots that reached deep into the mud.

But the issue of whether the U.S. military should begin spraying defoliants was not without debate among American tacticians. Roger Hilsman notes in his book *To Move a Nation* that some feared it would open the United States to criticism for waging biological warfare. There were also questions about the effectiveness of defoliation. If it opened fields of fire for friendly troops to kill the enemy, wouldn't it also do the reverse?

Nevertheless, the decision was made to go ahead, and the task was given a special campaign title, Operation Ranch Hand (certainly an improvement over the first descriptive effort of Operation Hades). Spraying operations would be carried out by a special squadron, the 309th Air Commando Squadron, whose more creative personnel adopted the motto "You, too, can prevent forests."

Twin-engine C-123 transport planes were fitted with high-pressure nozzles and large tanks that could carry a variety of mixtures code-named by color. Agents Orange and White were defoliants and Blue a desiccant—a drying agent—that contained arsenic. Although the various agents amounted to a toxic cocktail that was poured on jungle and inhabitants, Orange has been singled out because it contained TCDD dioxin, which, because of its extreme toxicity, would seem to have the greatest potential for human harm.

Between 1962 and February of 1971, the spray missions dumped between 10 million and 12 million gallons of defoliants over 5 million acres of

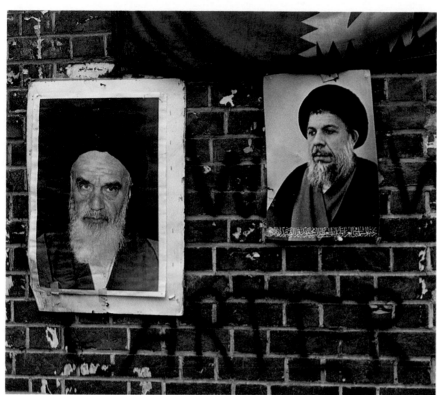

Khomeini's presence in Tehran was inescapable, whether on a wall of political slogans (left) with another imam or brooding in anger within the U.S. Embassy compound (below).

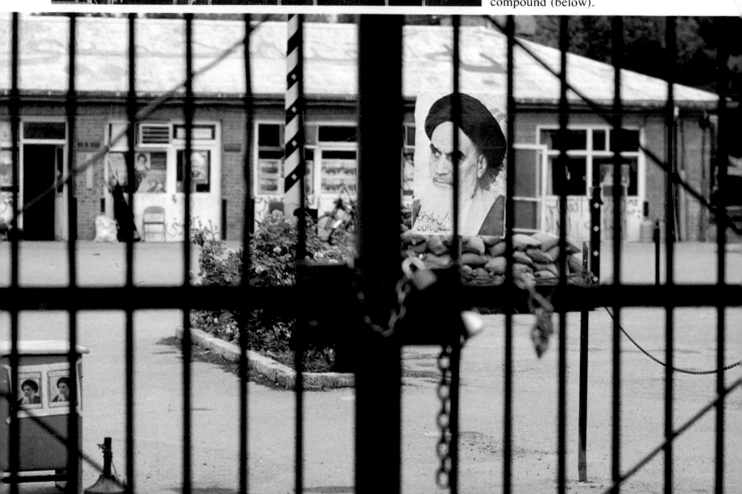

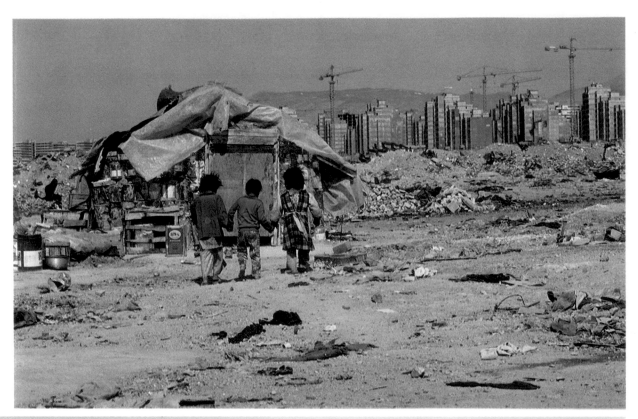

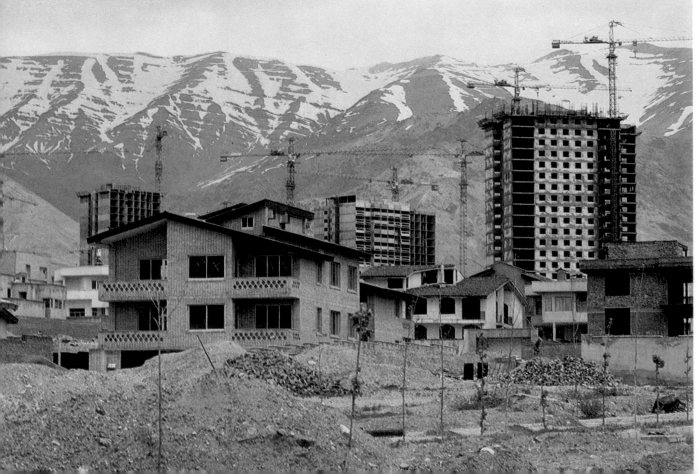

The turbulence of Iran's recent history has spawned different styles of living in present-day Tehran.
Opposite page: Tin City, top, a collection of pitiful shanties within sight of a colossal building
project transformed by the revolution into a ghost town; bottom, luxurious residences
left unfinished during the revolt of 1979 that are now home to peasant squatters.
Below: The master bedroom of a mansion now occupied by a Kurdish family of ten.

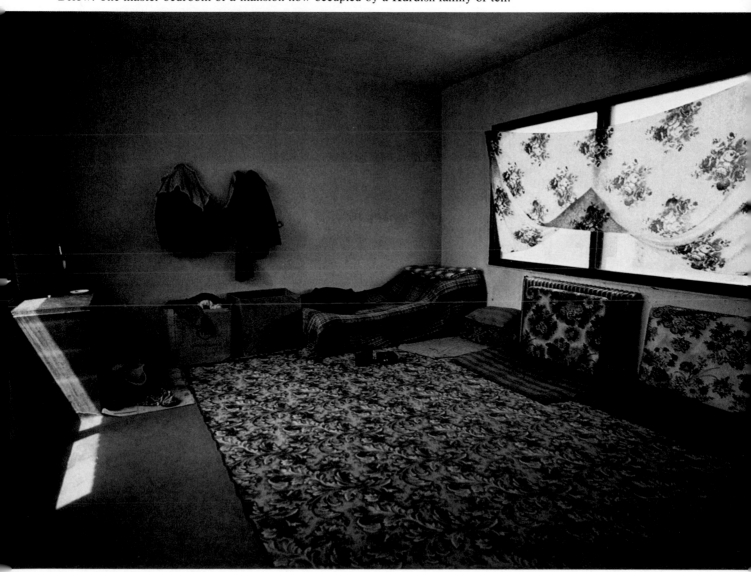

Scenes from Tehran's bazaar (clockwise from right): Turkoman artifacts; a stall jammed with aluminum objects; a wary merchant.

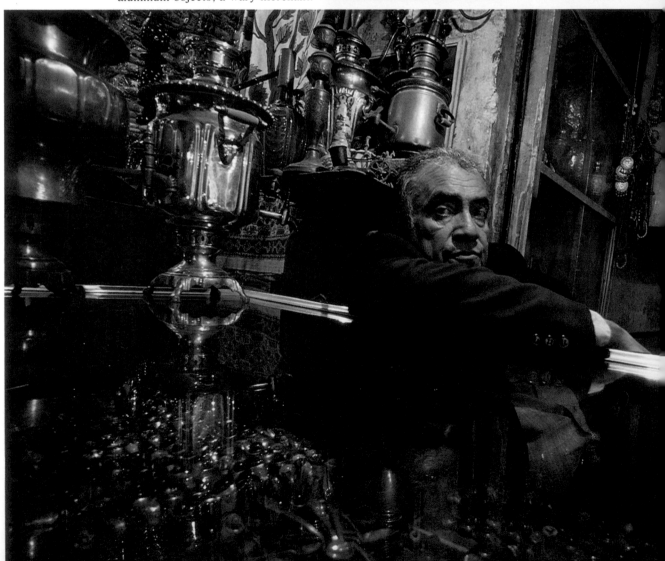

In South Tehran addicts such as these were living evidence of Iran's enormous drug problems.
Heroin was as plentiful in this district as goat's milk was in other parts of the city,
opium as common as tobacco.

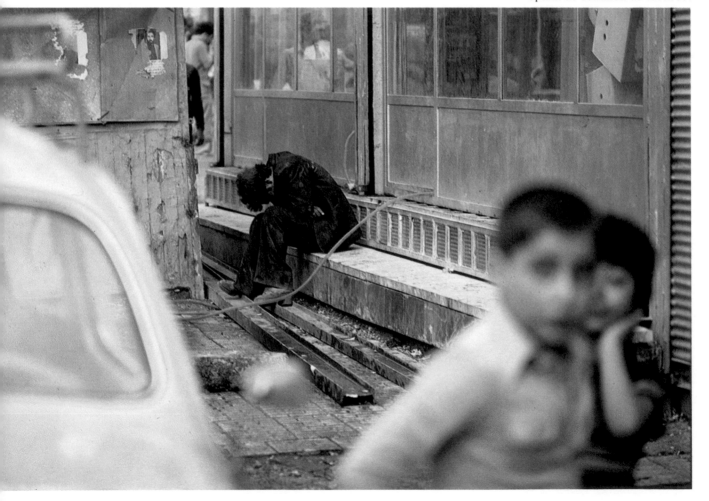

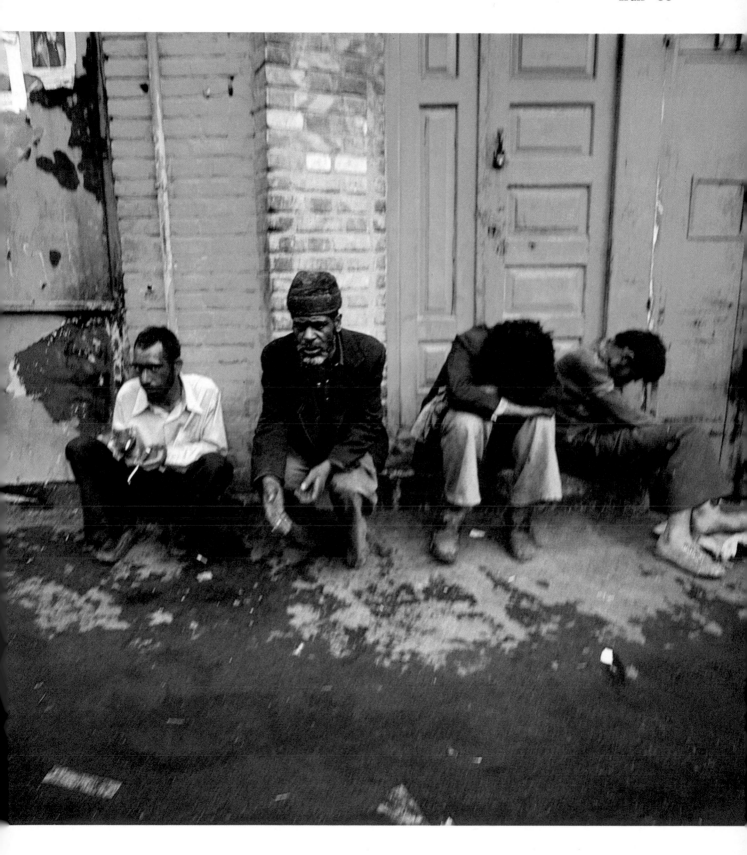

Left: A North Vietnamese woman seems transfixed by our camera. Few Hanoi citizens had seen an American; most thought we were Russians.
Below: A farmer in North Vietnam watering an ox in a pool created by a B-52 bomb a decade earlier.
Opposite page: A casualty of war in South Vietnam— a mangrove tree felled by Agent Orange.

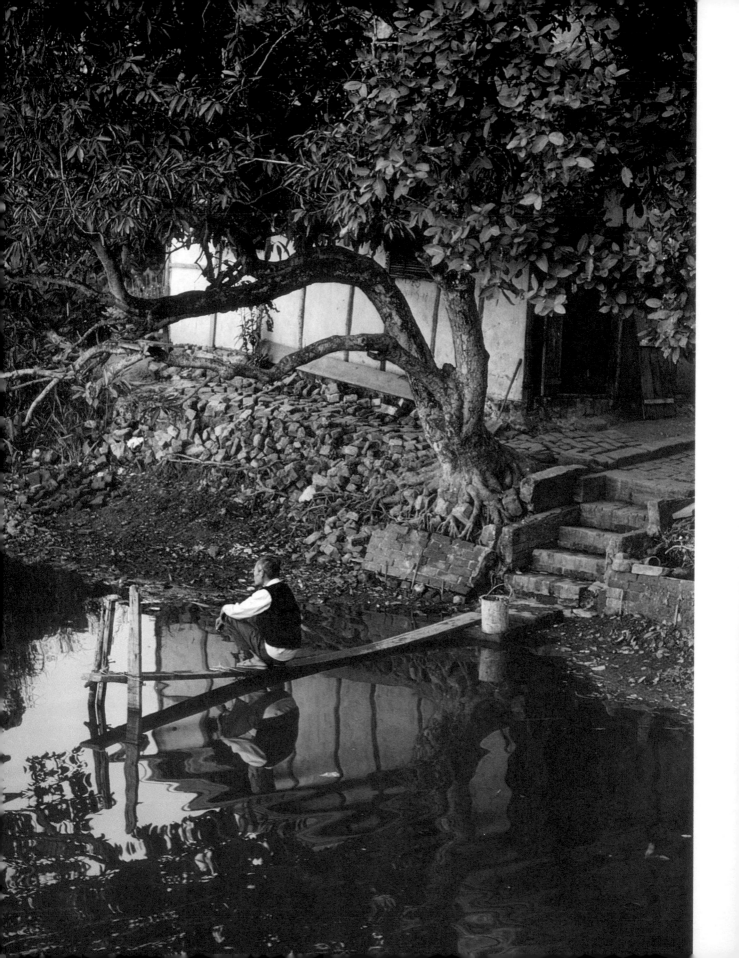

Opposite page: A Vietnamese man musing by a brook. This page: Years of war have left Hanoi with the look of a city under siege, frozen at a depressed standard of living. Although there are a few dilapidated streetcars, rickshaws and bicycles are still the predominant means of transportation.

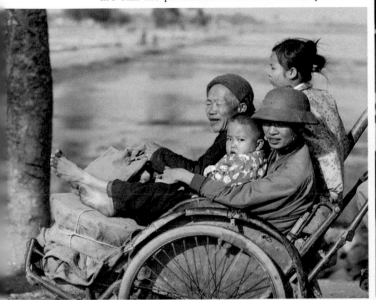

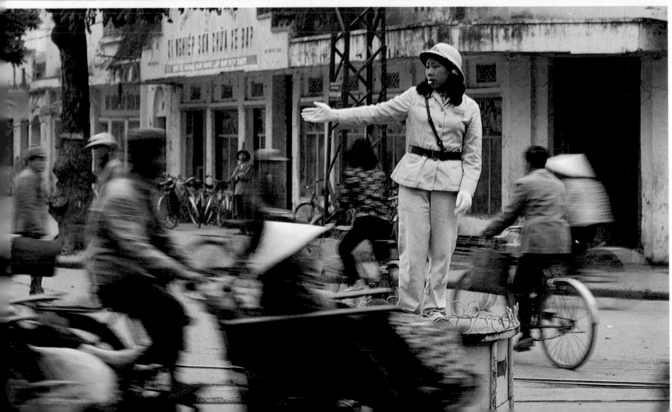

Right: Two of Hanoi's Huckleberry Finns, rowing with their feet, pause to look for carp so they can slap the water and scare them toward fishermen near shore.
Below: Evening in Unification Park, in the center of Hanoi.

Fishermen untangle their nets before casting for an early morning catch near the shore of Vung Tau, South Vietnam, known as the Riviera of Southeast Asia.

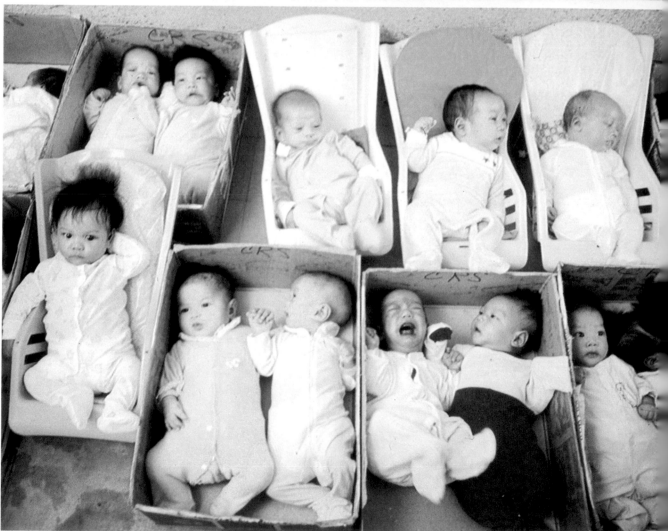

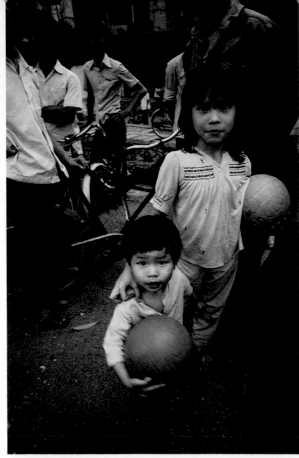

Reminders of the war in Vietnam (counterclockwise from left): Some of the children I met on Ho Chi Minh City's streets; an Amerasian girl named Mee; Vietnamese infants placed in boxes for loading aboard a special babylift flight to America just before the fall of Saigon, in 1975; Vietnamese women who have gathered their children together to ask for our help in finding their American fathers.

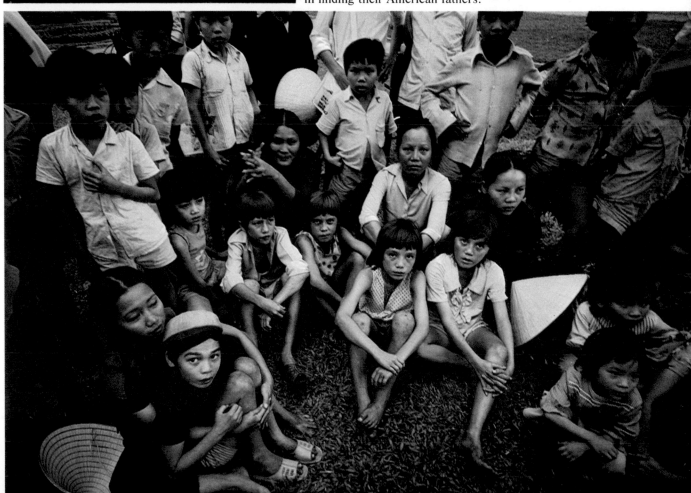

A local militia passes majestic Saigon Cathedral. Mass is still celebrated each morning, but the Communist state has taken over the elementary and secondary church schools.

South Vietnam, the white mist stretching like ribbons from the low-flying armada of planes. The herbicides were also sprayed from helicopters, trucks, boats, jeeps, and individual backpacks.

Like a deadly rain, these agents withered leaves and left vast stretches of brown amidst the jungle green. On pastures, the hormones within the herbicides sped up the growth cycle and caused plants to die within two weeks. Some Vietnam veterans reported seeing leaves turning brown within hours of a spraying. Although these observations may be exaggerated, it is true that measurements after the war showed levels of dioxin within the herbicides heavier than any known before—one estimate, by the Stanford Biology Study Group, put the rate at 13 times that recommended by the U.S. Department of Agriculture for domestic use.

An estimated 260,000 acres of valuable mangrove trees were destroyed. Two million cubic meters of timber were decimated. Another 11 million cubic feet of jungle wood were wiped out, all of which could have been used by Vietnam in the postwar recovery. Defoliation also resulted in severely reduced production of such crops as rice, pineapple, sugar cane, manioc, tomatoes, beans, and papaya.

As early as 1964, reports began circulating in South Vietnam of increased numbers of miscarriages and stillbirths among women exposed to the spray, as well as birth defects in their offspring. By 1969, movies were being distributed in Vietnam by the National Liberation Front allegedly showing the deformed births called *Quai-vat,* or monsters, children born without brains. Antiwar groups in the United States used the pictures to promote a volatile and emotional issue.

Two groups of scientists appealed to President Lyndon Johnson in 1966 to halt the use of defoliants, citing damage to the environment. Others visited South Vietnam to assess the program's effectiveness and warned of permanent damage to the landscape. The emphasis was on the environmental impact of defoliation; at the time there was no hard evidence of its effect on humans, only "rumors" from the South Vietnamese.

But the most serious blow to the program was leveled in 1969, when results were made public from tests conducted by Bionetics Research Laboratories of Bethesda, Maryland, for the National Cancer Institute, an agency of the U.S. government. The findings, not released until nine months after the report was completed, revealed that a significant number of the offspring of female rats and mice exposed to 2,4,5-T were born dead, without eyes, or with such deformities as cleft palates, cystic kidneys, and enlarged livers.

The scientific community had been eagerly awaiting the results, hoping they would resolve the controversy over the defoliation program. According to Thomas Whiteside, given the nature of the findings, scientists believed the government had delayed making the test results public to allow spraying to continue and to buy time to prepare a defense.

Dow Chemical ran a few tests of its own and objected to the Bionetics study, claiming that the samples of 2,4,5-T used contained abnormally high levels of TCDD dioxin. New tests were then made by the Food and Drug Administration with lower amounts of dioxin, but even near the parts-per-trillion range similar teratogenic effects were found. Finally, on April 15, 1970, the use of 2,4,5-T in Vietnam by the American armed forces was suspended. Several units, including the Americal Division, continued spraying until 1971, apparently having failed to get the word.

Although the emotional furor over the use of Agent Orange began to fade with its restriction, several additional scientific studies were made. One notable effort was conducted by a group sent to South Vietnam by the National Academy of Sciences (NAS) in the early seventies. It found evidence of dioxin even in the Saigon River in the center of the capital, but the difficulty of studying the matter while the country was at war resulted in inconclusive findings. The study's majority opinion stated that "there was not enough evidence to draw any conclusions about the defoliant's effect on humans." That phrase and, indeed, the entire NAS study were cited for years by chemical and agricultural interests as the final word on herbicide

use in Vietnam. They regarded the opinion as absolution and reprinted it for distribution.

After reading the entire NAS report in early 1978, we found it was anything but an exoneration. The group had simply been unable to conduct a full study. Both majority and minority opinions called for an "immediate study of the long-term effects of 2,4-D and 2,4,5-T on human beings."

As our research trail heated up, the life of Brian Quinn was vacillating between its highest and lowest moments. Carol gave birth on December 8, 1977, cloaking Christmas in a magic memory.

But in mid-January Brian's back pains were bad enough to send him to the emergency room of Holy Family Hospital in Des Plaines. A mass was detected in the initial tests. Nurses assured him it was probably a cyst—no problem. The hospital staff routinely contacted his physician and told Brian to go home, saying, "If anything turns up, we'll call you." They called within the hour.

Five days later, doctors were cutting into his stomach. It wasn't a long operation. Once they saw the massive tumor that had wrapped itself around Brian's abdomen, intestine, and pelvic area, they knew it was so cancerous nothing could be done immediately, so they closed him up. It was leiomyosarcoma.

No investigative research follows a single line of inquiry from beginning to end; many questions are being answered at the same time. The task is to keep the information properly sorted and to not become overwhelmed by the mountain of data that inevitably piles up.

As the scientific answers began coming in, so did additional cases of veterans.

James Simmons greeted me at the door of a damp basement apartment on Chicago's South Side. It looked as dark as a cave inside, smelled of boiling tea and cement soaked by rain, and sounded like a nightclub, the pulse of rhythm and blues driving against the temples.

This black veteran had returned home from the war to his old neighborhood and all its problems. He had been unemployed for two years. Despite

what appeared to be a peacetime existence just as depressing as combat, Simmons was still proud of serving his country. He had served well, having enlisted in the Marine Corps in 1966 with immediate assignment to Vietnam.

"Where were you in 1968?" I asked.

"I was a side gunner on a chopper," Simmons said. "We carried guys in and out of Hue [in South Vietnam] during the Tet offensive. You know, we provided fire support and that."

A small child cried in the next room, adding to the noise. He turned on a light to show a rash that covered his chest.

"Sometimes it's worse than others," he told me. "Maybe once a month I get these white blisters on top of the rash that's there. The VA can't give me any answers for it. They did give me some lotion, but it doesn't do any good."

"Have you ever heard of Agent Orange?"

No, Simmons said candidly, but he did recall that when his helicopter wasn't providing fire support or transporting troops it was fitted with a long string of nozzles to spray a white mist over the jungle foliage around their base camp. He and the other marines were told it wasn't dangerous. He could remember being covered with the fluid a number of times when the chopper whipped it up in the rotor backwash.

"I didn't think much about it at the time," he said. "Still have some numbness in my fingers."

I left Simmons shooting billiards in a pool hall near his apartment, one of a collection of unemployed men who gathered there every day. I was staggered by the contrast between the marine who had seen more difficult combat than most veterans of World War II, Korea, or Vietnam and the welfare recipient he had become. I thought James Simmons deserved better.

By mid-January we had a good handle on dioxin's history, the use of Agent Orange in Vietnam, and the veterans' complaints. It was time to push ahead into new territory, the more up-to-date tests of dioxin that might hold the secrets to connect the veterans with their exposure to Agent Orange.

That search led us to the University of Wisconsin Medical School and Dr. James Allen, professor

Researchers for Dr. James Allen examine a rhesus monkey for reactions to a minute amount of dioxin in its diet. Dr. Allen's tests found no safe level of dioxin.

of pathology, who was studying the effects of low-level doses of dioxin on rhesus monkeys, animals regarded as closer to humans than any others available for testing.

Dr. Allen and his staff were mixing the extremely small amount of 500 parts per trillion of dioxin per day into the diets of eight female monkeys, hardly the equivalent of a teaspoonful in a dump truck of dirt. Between the seventh and twelfth month of this diet, five of the monkeys died after hemorrhaging. Their symptoms included chloracne, the rash commonly associated with dioxin poisoning; growths on the extremities that finally turned into gangrene; loss of hair; and exhaustion. Only one pregnant monkey out of eight gave birth to live offspring.

The doctor was trying to find a base at which dioxin was safe. He didn't find it; even at only five parts per trillion it caused tumors in rats during an 18-month experiment. In comparison, when some of the unused mixtures of Agent Orange were tested after the Vietnam War, dioxin was found in amounts as high as 45 parts per *million*, with an average of one to ten parts per million.

These were impressive studies, but they dealt with laboratory animals. Although such tests are commonly used to gauge the toxicity of chemicals so that human beings can be protected, they are always subject to the argument that no laboratory animal can fully substitute for man. So we started to delve into yet another stage of study, those documented cases in which humans had accidentally been exposed to dioxin.

In 1953, an industrial accident in West Germany exposed 31 workers to dioxin. They developed chloracne, and experienced abdominal pain, liver ailments, and severe depression and other psychological changes.

Between 1965 and 1969, Czechoslovakian workers exposed to dioxin at an industrial plant complained of fatigue, numbness in the extremities, weight loss, and nervous ailments persisting as long as eight years after the first exposure.

The most widely publicized incident—one that became a national scandal—occurred in a village outside Milan, Italy, called Seveso. On July 10, 1976, a chemical plant vented a cloud containing dioxin formed by the manufacture of trichlorophenol, a mother chemical of 2,4,5-T and dioxin. It spread across the town and settled on humans and animals. Rabbits, chickens, and birds died. Residents experienced nausea, chloracne, nervousness, loss of appetite, and irritability. Dioxin had penetrated about a foot into the soil; authorities fenced off a section of Seveso and rebuilt homes for families exposed to the toxic cloud.

Many people representing various interests watched the living example of Seveso for definitive proof of whether dioxin was harmful to humans. But it will be years before reliable information can be assembled. Although some Italian doctors said they observed double the normal amount of spontaneous abortions as well as increases in soft-tissue sarcomas and problems afflicting the nervous and immunological systems,

others stressed the *lack* of harm done. The matter became a political issue, making accurate medical research difficult. Even determining how many therapeutic abortions had been performed was hard because many women feared recriminations in a Roman Catholic community and were reluctant to register their names.

We found two incidents closer to home that involved symptoms remarkably similar to those of the veterans. The first had occurred in Moscow Mills, Missouri, a small town northwest of St. Louis, population 379.

Judy Piatt and Frank Hampel owned a horse arena outside town, a huge barn where the horses were presented and then sold. In May 1971, a salvage-oil dealer named Russell Bliss contracted with a chemical plant in Verona, Missouri, to get rid of its waste. The plant made a germicide that contained dioxin. Bliss mixed the sludge from the plant, which was contaminated with dioxin, with waste oil and sprayed it on the dirt floor of the Moscow Mills horse arena to keep the dust from disturbing the horses.

Sixty-seven horses died within a matter of weeks. Nine people, children and adults, still have problems they associate with exposure to dioxin. The soil in the barn contained concentrations of dioxin at 31 to 33 parts per million.

For several years after the spraying, Missouri environmental authorities, although admitting the presence of dioxin, denied any connection with the human problems. The phrase commonly heard by the Piatt family when they sought medical help was "There is no evidence that suggests dioxin is harmful to humans," and their symptoms were often dismissed as "mental problems."

I sat across from Judy Piatt and saw a woman whose life had been changed by the ordeal. She had seen her business destroyed and had to watch as her entire stock of beloved horses withered and died in pain. Yet there was no ready medical answer. She and her children and Hampel knew the cause was dioxin, but they had to wait years before general knowledge of its harmful potential proved them right. That trauma was as difficult as the health problems she experienced.

(Four years after my 1978 interview, the state of Missouri discovered that Bliss had sprayed dioxin-contaminated oil on roads and lawns in many locations around the state. When a significant number of samples taken from the streets of one of these places, Times Beach, showed concentrations of dioxin at 100 parts per billion and some as high as 300 parts per billion, officials from the Centers for Disease Control and the Environmental Protection Agency (EPA) advised an evacuation of the town. In February 1983, the EPA offered to buy out all homeowners and businesses from a fund of $33 million. This response was much faster than that made to complaints of dioxin poisoning among Vietnam veterans.)

During our interview, Piatt unknowingly provided an intriguing connection with the veterans. I began to list some of their symptoms: "They are complaining of a general feeling of ill health, weight loss, diminished sexual activity, and—"

"Numbness in the ends of the fingers, I have that," she interrupted.

It was the same response we got from veteran Michael Adams of Evanston, Illinois. "I sometimes have no feeling in my hands or arms," he told us. "You just feel like they are not there. You know, like there is no blood in them. It scares me because I have to find out if they really are there."

Adams had won two Bronze Stars and a Purple Heart for his service with the Americal Division in the Mekong Delta. His description of exposure to Agent Orange revealed a new fact: Adams (and others we later talked to) had been sent into areas sprayed with the defoliant immediately after the spraying. This contradicted Department of Defense accounts that troops were kept out of sprayed areas for six weeks after application.

"In the Mekong," Adams said, "we had a lot of elephant grass and rice and heavy foliage, triple canopy, you know. You would have to go through all this, and sometimes the white fog was still hanging on it. It was a normal thing for somebody to come down with a rash—all types of rashes, everybody was breaking out with different things. It was small blisters, like a burn with tiny bumps on the outside."

I thought Adams and Piatt provided one of the strongest elements we had, these two people who had never met but who had similar medical problems and believed dioxin was the cause.

Moscow Mills, with its snow-covered midwestern setting, had moved us a step closer. The second incident that mirrored the exposure of Vietnam veterans to herbicides, and which seemed even more important, had taken place in Globe, Arizona.

Near this small town of 6,000, a helicopter had been spraying the herbicide Silvex, a chemical variant of 2,4,5-T, on the slopes of the Pinal Mountains in a manner that was a carbon copy of the spraying in Vietnam. One day in June 1969 the helicopter pilot made a pass down a valley lined with homes and small farms, either through serious miscalculation or deliberate mischief. White mist floated down the V-shaped valley, clumps of herbicide that settled on people and animals alike, just as they had in Vietnam.

Brian Boyer and I found Robert McKusick and his wife, Charmaine, still on the same farm almost nine years later. Like Judy Piatt's, their lives had been twisted by the incident. They had found almost no scientific research to support their claims that herbicides caused health problems. And because the Globe physicians could find no medical answers to their complaints of irritability and loss of appetite and sex drive, the McKusicks were called "the crazy people up the valley."

Robert and Charmaine were both academics with advanced degrees, uniquely qualified to document their experiences of nearly a decade. According to Charmaine, after the spraying, "All the women in the canyon ended up in the same doctor's office with vaginal bleeding." Many of them later had hysterectomies, she said, and among their immediate neighbors, there were about eight miscarriages. "People have had to move out of the area before they could bear live children," she added.

We walked among trees whose twisted shapes the McKusicks attributed to the spraying. They had turned their small stony farm into a living exhibit of what, they charged, dioxin and 2,4,5-T could do. I thought Charmaine had overstated her case a bit until she showed me some ducks born on the farm with inverted wings. This was a dramatic example, the McKusicks claimed, of how dioxin remains in the soil and enters the tissues of animals who walk on it, deforming their offspring. They offered as further evidence a goat with a deformed lower jaw that had prevented it from suckling. Charmaine and Robert hand-fed it as a baby.

At the time, I viewed the McKusicks as a hard-working, sincere couple whose lives had been damaged by one stray pass of a helicopter. But I also harbored certain doubts after seeing their farm, the same kind of skepticism exploited by attorneys representing Dow Chemical and the spraying company against a multimillion-dollar lawsuit initiated in 1970 by these families.

The farms affected were no more than a few rocky acres with a house and some buildings to keep several animals. None of the families seemed to make a living off them, and they would hardly qualify as farmers of the year. While not poor, their husbandry seemed only marginally proficient, giving rise to charges that malnutrition was the cause of the animals' deformities instead of the herbicide. When physicians failed to turn up explanations for the plaintiffs' symptoms, they began to be viewed as chronic complainers trying to get rich off a lawsuit.

But in the course of our research I saw several other farm families in four different parts of the United States who had been exposed to dioxin under exactly the same set of circumstances, who had provoked identical reactions from neighbors, and who had precisely the same symptoms. I felt that all were suffering a similar kind of chemical poisoning and had become the unlucky victims who had to fight back years before the scientific community had developed any proof of what dioxin could do to humans. They knew they were right, but they had to stand up to the ridicule of neighbors who didn't believe them.

The most widely publicized case at Globe was that of Billee Shoecraft, a poet who dedicated her final years to crusading against 2,4,5-T and trying to establish its link with human problems. She was

the ramrod who inspired the canyon residents to join together in their massive lawsuit.

Seven months after the 1969 spraying, she had a California physician, Dr. Granville Knight, test for the presence of 2,4,5-T in her body fat. He tested her again in 1977, just before her death. In both instances he found it.

We left Arizona with information that helped our own investigation immensely. One finding concerned the life span of dioxin in the soil. The research supplied by soil scientists, which had been compiled ten to 15 years earlier, held that dioxin broke down and disappeared in the earth in between six months and a year, sooner if it was in sunlight. But the McKusicks claimed their animals were producing deformed offspring more than eight years after a spraying. Other data we had seen about the Seveso and Moscow Mills incidents showed that dioxin remained in the soil much longer than the agricultural studies indicated was possible. We concluded that these studies, conducted without Drs. Meselson and Baughman's 1973 method for detecting extremely low dioxin levels, were deficient.

More important, if 2,4,5-T could be stored in the fatty tissues of Billee Shoecraft for eight years after the spraying incident, it could also have been stored in the fatty tissues of Vietnam veterans for years after their exposure in Southeast Asia.

Dr. Barry Commoner of Washington University, an environmental expert knowledgeable about dioxin, was in complete agreement. "It may well be true," he told us, "that soldiers who were exposed to dioxin in Vietnam had it accumulate in their body fat with no symptoms, except for the immediate skin symptoms and then, let's say ten years later, they become sick and lose weight. They would break down that fat, releasing the dioxin into the body, and the symptoms would appear."

Dr. Irving Selikoff of Mount Sinai Hospital in New York City, probably the foremost occupational-disease expert in the country, told Rose Economu that dioxin's effect on the enzyme system was important, for this in turn could cause changes in the immunological system. An attack on this system would make the body vulnerable to a variety of problems at its weakest point. That could explain the broad range of seemingly unrelated symptoms peculiar to dioxin poisoning.

At the end of our investigation, we had compiled what may have been the best dioxin overview to date in the United States.

As we embarked on writing the script, we realized that the documentary would have to satisfy two audiences: the general public, including the veterans, who would be the most affected by the report; and the scientific community, which would be examining our data as painstakingly as a physician reading a medical journal. After all, our transcript would be distributed as the most up-to-date summary of the dioxin problem. It must also be able to withstand the scrutiny of chemical companies that would have their experts try to tear it apart—with their teeth, if necessary. To weave our information into an interesting, accurate story was a considerable challenge for television, which is much better at conveying emotion than facts.

We titled the hour-long documentary "Agent Orange: Vietnam's Deadly Fog" and in it traced our search for answers to our three original questions: Were the veterans' symptoms real; had the veterans been exposed to Agent Orange; and did dioxin, contained in the herbicide, have the potential to cause such symptoms?

To speak to these questions we presented the eloquent testimony of people who claimed to have been harmed by exposure to dioxin—veterans Milton Ross, James Simmons, and Michael Adams, as well as Judy Piatt and the McKusicks.

We had an imposing arsenal of opinions from the country's experts to confirm the possible effects of dioxin, including statements by Dr. Selikoff and Dr. Val Woodward.

Dr. Meselson noted that there is suggestive evidence that dioxin is cumulative, each little bit causing damage that remains in the body. Dr. Allen addressed the veterans' problems when he said, "Low-level exposure may not produce obvious effects today or tomorrow—it may be ten years, it may be 20 years. Thus, you may be exposed to the compound and suffer no ill effects,

but you may have damage done that will manifest itself years and years later. Now, we are talking about the possibilities of cancer, the possibility of mutagenic effects."

Both Dr. Commoner and Dr. John Moore, a leading dioxin researcher from Research Triangle Institute in North Carolina, called for full testing of those men exposed to dioxin to try to prevent future health problems.

Representing the view that Agent Orange was innocent of any damage were Dr. Lewis Shadoff of Dow Chemical and Capt. Alvin Young of the U.S. Air Force.

We concluded the broadcast by stating editorially: "After researching this report and listening to the recommendations of the leading dioxin scientists in the country, we feel there is a need for immediate testing of all Vietnam veterans who handled Agent Orange or went into the sprayed areas—not only for the sake of those who have told us their symptoms but for the countless others whose lives and whose children's lives could be blighted by the dioxin in Agent Orange."

We were ready for broadcast. WBBM-TV gave us a slot at 10:30 p.m. on March 23, 1978. Friends are often surprised when I remind them that the first broadcast did not appear in prime time. One reason, in addition to the difficulty of finding programming holes, was the secrecy of the project. We managed to hold any word of the story until we had completed the documentary; then we had to sit on it for a week until March 23. This was one of those nervous periods when you fear someone else has been working on the same story and will beat you to publication.

We also faced another reality. Our broadcast "gun" wasn't as large as that of "60 Minutes." If their audience was 20 million people, ours was closer to one million at best. When we spoke, only the late-night viewers in Chicago would see it. So we devised a strategy to extend our reach.

We printed transcripts of the program and sent them to every congressman and senator from Illinois, including a videotape if we found he was not going to be in Chicago that night. I telephoned each myself to explain the focus of the program,

emphasize its importance, and alert him that he would probably be receiving calls from veterans in his constituency. The congressmen appreciated the tip and were ready when the broadcast hit the air. It gave them a feeling not only of getting a jump on the story, which would allow them to sound informed, but of being on the "inside" when an important story was breaking.

The day before airing, we screened the program for television critics and science reporters from the local newspapers. The *Chicago Sun-Times* saw the importance of the story immediately, and general assignment reporter Phil O'Connor wrote it up for his paper. The *Chicago Tribune* muffed it somehow. Casey Bukro, environmental editor, prepared a story, but it failed to make the early editions and was "forgotten" for the later editions. We have always felt it was a bias against television news that held the paper back.

To say the least, it was unusual for a local television news organization to break a national story of this magnitude. It was also extraordinary to present it in such a way that the powerful chemical and agricultural interests couldn't immediately knock it down.

In fact, the VA tried to dismiss the program as just a broadcast by a local television station, implying that nothing serious should be expected from such a small beginning.

But with the broadcast of March 23, a journalistic snowball left the hands of WBBM. It would gather momentum from a chorus of veterans' inquiries, and be joined by reports of complaints in communities all across America until it grew into the largest products-liability suit in American history and the most important issue concerning veterans since the end of the Vietnam War.

To help the story along, we responded to inquiries for information and quickly became a clearinghouse for veterans and journalists alike, sending off transcripts of "Deadly Fog" so someone else could join us.

Congressman Abner Mikva of Chicago was particularly impressed with the broadcast. In an important turning point in the distribution of the story, he invited us to screen the documentary in

the committee room of the House Committee on Veterans Affairs, chaired by Congressman Donald Edwards of California. Mikva persuaded Edwards to schedule the screening within a month of our original broadcast, and although none of the committeemen had seen the program, they were very aware of the issues it raised. Interested parties, including representatives of the VA, the EPA, and several chemical companies, jammed the paneled room. CBS installed several special television monitors so everyone had a clear view.

It was a small group compared with a television audience, but it was a concentrated sampling of the most important people who would ever receive the message. The high ceilings and the somber atmosphere of Congress made the occasion suitably august. I must admit to being nervous, but afterward I could see that the broadcast had a strong effect. At the end of the screening Congressman Mikva took the floor and criticized the VA for not beginning an investigation and thereby responding unsympathetically to the health problems of the veterans.

A VA representative in the audience quickly denied any foot-dragging. He listed a full schedule of actions that the administration planned to put into effect, some of them already under way.

The VA medical authorities, he said, had instructed all their hospitals across the country to treat veterans immediately and to report symptoms that might be traceable to Agent Orange. They had instituted a central file system so that every veteran who told the VA of special symptoms would receive additional information when it became available. Using the file as a tracer, the government might conceivably contact these men later to pay them benefits if a link was established between exposure to Agent Orange and their problems. And a scientific task force was being established to form a strategy to find the answers.

I was impressed but, as it happened, terribly misled, as were the veterans who believed the VA's statements. Unfortunately, this swift reply probably was intended to impress the congressional watchdogs more than to help the veterans.

An inside source later informed us that despite all these public declarations of help, the VA's medical authorities believed the Agent Orange issue was a fraud, promoted by malingering veterans out for a free ride. Some of their attitudes reached the press. One VA doctor said that the toxicity of the defoliant was no higher than that of an aspirin and that no evidence existed to link it to any known health problems among humans. Another VA spokesman was quoted as saying that the claims that Agent Orange caused birth defects were the primary source for what had been North Vietnamese propaganda during the war. We of course had mentioned the propaganda use of these claims but not to discount the possibly harmful effects of Agent Orange.

At the same time, Dr. Gerrit Schepper of the VA's medical staff was telling the press, "We've gotten the process going and want to make sure no case is regarded as frivolous or pushed aside."

As the veterans began responding to the public invitation by the VA to report symptoms, I started receiving reports that no one at the hospitals had been notified of this plan or knew anything about Agent Orange. When doctors finally got the word to hear complaints, a few at Hines VA Hospital, outside Chicago, made it clear the VA belief was that alleged Agent Orange symptoms were nothing more than psychological problems magnified by the press. The VA hierarchy had failed to provide its medical staffs with any research data that would give them background on the issue to help in examining the veterans. Once again, doctors were told, "There is no evidence to link exposure to Agent Orange to human problems."

I gave the VA the benefit of the doubt, hoping that such a huge organization just needed a little time to get its act straight. Sadly, it later turned out, I was wrong.

Among the Illinois congressmen who had seen the "Deadly Fog" broadcast was Ralph Metcalfe. On April 10, 1978, he was the first to ask the Comptroller General of the United States, the director of the General Accounting Office (GAO), to review the Department of Defense's use of herbicides. Metcalfe died before seeing any of the reports, which were released periodically over the

next few years and made public government records that showed more men had been exposed than anyone originally believed. Each report recommended long-term studies.

Senator Charles Percy soon followed Metcalfe's example and asked for another GAO investigation, which shocked many when it revealed that at least 40,000 Marine, Army, and Air Force personnel were sprayed with Agent Orange.

In the late winter of 1978 there seemed to be enough new elements of the story to warrant a follow-up, something rare in television news. General Manager David Nelson was enthusiastic about it, so we prepared for another foray into the world of Agent Orange.

By now, other reporters had joined the case. One notable effort was by Richard Severo of the *New York Times,* who was preparing three articles to be published in May 1979. The ''newspaper of record'' always has an impact, and the sight of Severo's well-documented accounts of veterans' complaints must have sent new shock waves through those officials hoping the furor started by that television station in Chicago would just go away.

Certainly any follow-up broadcast should state what reaction there had been to the issue among Vietnam veterans. To say the least, it had been explosive. Paul Reutershan, who in 1968 had flown spray missions in Vietnam, founded Agent Orange Victims International in 1978 and made the statement that would galvanize a movement: ''I died in Vietnam and didn't know it.'' Reutershan died of cancer in mid-December 1978, but the organization he started would grow into a large and effec-

This hunger strike was one of many protests veterans staged to demand government treatment and benefits for symptoms they believed had been caused by exposure to Agent Orange.

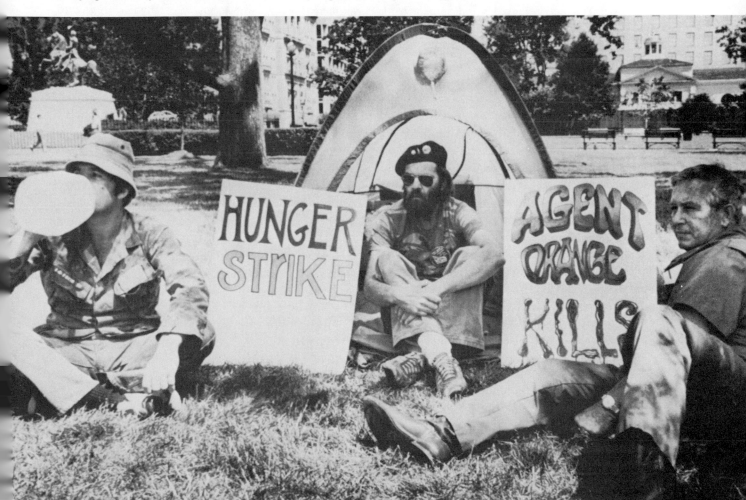

tive veterans' group under the leadership of its president, Frank McCarthy. In the Chicago area, Ron DeYoung formed Concerned American Veterans Against Toxin, and Dr. Gilbert Bogan established Veteran's Hotline to continue study of health issues. These groups and many others were aided along the way by the Veterans of Foreign Wars and the American Legion.

In effect, the veterans were helping themselves, establishing "outreach" groups to distribute medical information to those affected and providing legal advice for others interested in joining lawsuits.

Another such group, Citizen Soldier, of New York City, led by Tod Ensign, sponsored a survey of several thousand veterans in 1979. In the first 536 questionnaires analyzed, 35 cases of soft-tissue cancer turned up, along with 77 cases of children with such congenital problems as missing or deformed fingers, heart defects, and unusual skin disorders. The directors of the cursory study, Drs. Steve and Jean Stellman, admitted their methods were "self-selected" and subject to debate within the research community, but they emphasized that there was enough interesting data to warrant further study.

With the formation of veterans' groups and publicity about them, the number of veterans who identified with the issue began to grow. Those who had suffered alone, isolated, believing there was no explanation for their variety of strange afflictions, welcomed the suggestion that Agent Orange was the cause with the eagerness usually accorded a medical breakthrough. Most of these veterans had been told their problems were psychological. Agent Orange offered an answer that, even if inapplicable to their own case, at least legitimized the complaints. To wives and friends they could say, "You see, I'm not alone. Other veterans are having the same problems. I'm not crazy."

The Agent Orange issue triggered emotions that had been suppressed among many veterans for years. They saw as the ultimate irony of the whole conflict the fact that a government that had involved them in an unpopular war would be responsible for the last blow against its own veter-

ans by creating long-term health problems through chemical warfare.

In the painful examination of Agent Orange, the nation also began discovering other problems suffered by veterans, such as a delayed psychological syndrome peculiar to Vietnam and high unemployment among black veterans. As the media looked back at the Vietnam era, they discovered a generation of men who had served their country proudly but who had been forced to carry the blame for the war too long.

Besides looking at veterans' responses, we wanted the second documentary to take a step into an area we had purposely avoided to concentrate on the veterans' complaints—the domestic use of 2,4,5-T and 2,4-D. The EPA upstaged us on March 1, 1979, by announcing an emergency ban on the spraying of 2,4,5-T on forests, pastures, and rights-of-way based on studies suggesting a link to human miscarriages.

Our follow-up documentary, entitled "Agent Orange: The Human Harvest" at Brian Boyer's suggestion, was aired March 28, 1979, at 10:30 P.M. It chronicled veterans' reactions and the current domestic use of and restrictions on 2,4,5-T and 2,4-D. I also felt compelled to mention what we perceived as a pattern of problems caused by dioxin. Our unique perspective, derived from investigating isolated incidents around the country, led us to observe that cases written off as empty complaints of eccentrics, when seen together, possessed unmistakable similarities.

These cases involved humans and animals. Horses that died from dioxin poisoning in Missouri exhibited the same kind of skin reaction we found in Dr. Allen's laboratory monkeys that were fed dioxin. Ducks born with twisted wings in Arizona, and chickens with twisted feet in Wisconsin—both were from farms that had been sprayed with 2,4,5-T. A small calf from an Oregon region exposed to 2,4,5-T, born without hair on its face and in a weakened condition, had the same deformities as one of Dr. Allen's monkeys.

A year after his first comments to us, Dr. Allen stressed the toxic manifestations of very small amounts of dioxin: "They may be very subtle

effects, such as reproductive abnormalities—inability to conceive, inability to maintain pregnancy, high instances of early abortions. These are some of the complications that may not be tied in directly unless you are really conscious of dioxin exposure.''

As in our first broadcast, we tried to distribute the latest scientific information as well as follow the developing domestic controversy. Those who heard of the first program were eagerly awaiting the second, especially the congressional members who had taken up the cause on behalf of veterans in their states and districts. Everyone interested in the issue was waiting desperately for new data, hoping someone would find the magic link between human problems and dioxin. But at the end of March 1979, it had not been discovered.

I received an interesting letter after the ''Human Harvest'' broadcast from an attorney who pointed out that it took the scientific community 40 years to establish a connection between lung cancer and cigarette smoking. Tobacco interests argue that researchers never did find a ''magic link'' to cigarettes in the cancer itself; in part this was true because the cancer takes years and years to grow. Only by vast epidemiological surveys of thousands of smokers did they find that smokers had a higher incidence of lung cancer than nonsmokers.

Similarly, only epidemiological surveys would provide the answers about Agent Orange, and in that first year little progress was made toward any studies. There was much talk but little action.

At the time of the second broadcast, veteran Brian Quinn was receiving his third radiation treatment and fourth injection of chemotherapy, and was going into his second operation to cut away more tumor. He could see his six-foot, 200-pound physique shrinking away. He had been following the Agent Orange issue, and in the many hours he had to ponder the reason he was gripped with terminal cancer, he became convinced it had something to do with his exposure to the defoliant. So Brian filed a claim with the VA, as much to test the process as to collect any money. The claim was denied, so he appealed. The VA informed him

there was ''no body of medical or scientific evidence establishing any connection with medical problems and exposure to herbicides.'' On several visits to a VA hospital he was told the staff had lost his file. ''Come back another day,'' they said. He characterized their attitude as hostile.

Now 35, Brian knew he was dying, but he wanted to know why. He also believed that if his case could lay the groundwork for benefits, others might find the going easier.

When the second anniversary of ''Deadly Fog'' approached in the early spring of 1980, we fully intended to sit it out, letting more time and research pass before we tackled another update. Ed Joyce, the new general manager, wisely counseled against getting too deep in the story and running the risk of becoming advocates.

Then a windfall came our way. It was an invitation to visit Vietnam from Dr. Ton That Tung, Vietnam's leading physician and a man highly respected in international scientific circles. He had done considerable research on the effects of herbicide use and was anxious to show us the results of an epidemiological survey he had undertaken in North Vietnam. He had visited the States a year earlier and was familiar with our documentaries. A trip to Vietnam would not only give us the first look at the effect of the spray on foliage and humans there since Saigon fell, but would make us the first Americans in the country for an extended stay since 1975.

All roads into the new Vietnam begin in Hanoi so that visitors can be properly indoctrinated in the Communist way of doing things.

Our arrival was particularly poignant, for as the Thai Airlines jet liner banked steeply to begin its approach we could see bomb craters in the rice fields, the result of U.S. bombing seven years earlier. Farmers were using the large holes as irrigation reservoirs and ponds for watering their fields and oxen.

Hanoi hardly seemed like a city that had won a war. The grand French architecture was sagging, its paint peeling from the walls. Nothing looked as if it had been painted in 30 years. The wide boule-

vards were filled with bicycles, not cars. Downtown Hanoi was as quiet as a country road.

The people were friendly but terribly poor. There wasn't enough food: The average Vietnamese existed on 1,300 calories a day, and a family ate meat once a month.

We found Dr. Tung at Viet Duc Hospital in the middle of the city. The old French building was clean but outmoded. Dr. Tung apologized for its condition and explained that the country was so poor that the hospital could afford only secondhand French medical books. Very few modern drugs made their way into Vietnam, so the doctors had learned to depend on native treatments and herbal medicines.

Dr. Tung had perfected an operation for liver cancer, which we videotaped for the University of Chicago Medical School. He had published articles in the early 1970s proposing that an increase in liver cancer may have been caused by U.S. defoliation operations. After a recent scientific exchange trip to America, where he learned of Vietnam veterans' complaints, he returned home to conduct studies on his own veterans. That was what he wanted to talk about.

Overjoyed to see us, Dr. Tung hurried the introductions with his assistants so he could take us to a room where ten couples were waiting with their children. Several children had been born without eyes. One had a cleft palate. Another was born without the lower left forearm. At the very end of the little stump, where the elbow should have been, five tiny growths stuck out of the skin like fingers interrupted in embryonic growth.

The couples came from Yen Bai, a town northwest of Hanoi. Dr. Tung explained that they were among 670 cases studied by the team he had assembled. All the men had been sprayed with U.S. herbicides in the South and had returned north to marry women who had not been exposed. After comparing the number of birth defects with those in a control group that was not sprayed, he found double the number he would consider normal in Vietnam.

The doctor was anxious to have us understand the study but at the same time admitted its short-comings. Shrugging his shoulders, he indicated in French that it was the best he could do in a country as poor as his. But he had no reservations about his findings that exposed men had produced deformed offspring, still a controversial concept elsewhere. Most studies look to the mother as the source of birth defects caused during the development of the fetus.

We flew to Saigon on a Soviet-made jet liner as foreigners, partitioned off from Vietnamese citizens. Our assigned guides were extremely friendly and helpful, arranging for us to travel four days and survey areas that had been targets of U.S. herbicides.

To reach the interior of the Saigon River Delta, we used an old river patrol boat that American forces had turned over to the South Vietnamese and that, in turn, had been taken by the North Vietnamese.

A botanist from former Saigon University extended his hand toward the horizon and said, "As far as the eye can see once was filled with mangrove trees." Now there was only mud and the withered stumps of a few trees left to rot in the sun. A Vietnamese environmentalist, Dr. Bui Thi Lang, told us dioxin was still present in soil at the very heart of the delta, but since their testing procedures left much to be desired they were unable to study the problem thoroughly.

Dr. Lang said they had tried to replant some small mangrove trees, but it was very difficult. Each time the scientists would sink the trees into the mud, the tidal movement of the water would wash them away. The American NAS team had studied this area in the early 1970s and estimated it would take a hundred years to regenerate the mangrove forest. That estimate appeared optimistic.

Tay Ninh province, northwest of Saigon, had been heavily sprayed to remove cover along infiltration routes from Cambodia. Only a few lonely trees stood at intervals throughout miles of empty land. What once was a thick forest was desolate scrub, a monument to the effectiveness of 2,4-D and 2,4,5-T.

I joked that maybe we had done the Vietnamese a favor—after all, farmers in the United States

Top: Bomb craters near Hanoi, now used as reservoirs, dot the landscape. Bottom: Dr. Ton That Tung performing an operation for liver cancer in Viet Duc Hospital in Hanoi.

paid money to clear land like this for cattle pastures. There were no smiles. The botanist replied, "The Americans said the land would eventually grow back and it has, as you see, but with the wrong grasses. They are like weeds to us and the land is therefore useless."

Our third report, a half-hour documentary titled "Agent Orange: The View from Vietnam," finally made it into prime time, airing at 9:30 P.M. on April 21, 1980. By now the Chicago viewing audience was sensitized to the Agent Orange story and seemed anxious to get the latest chapter. The broadcast enjoyed excellent ratings, and it was screened in Washington for Congressman Albert Gore, Jr., of Tennessee, who was particularly interested because of the complaints by veterans from his state.

It had been helpful to visit Vietnam, the country where the controversy began. The trip was beneficial in another respect, for during it I had discovered yet another legacy of the war, the Amerasian children left behind in Saigon. This is the subject of another chapter.

The Agent Orange issue was growing so quickly by this time that it was impossible to follow every development. Each time things seemed to quiet down, a new report would cause the story to flare up again.

On September 23, 1981, Secretary of Health and Human Services Richard Schweiker reported that his task force on Agent Orange (an outgrowth of a White House task force formed under President Jimmy Carter) had uncovered evidence from military records indicating that substantially more Vietnam veterans might have been exposed to the defoliant than previously thought.

Schweiker said some exposures occurred when thousands of gallons of herbicides were dumped over bases and other populated areas after spray missions had to be halted due to hostile fire or mechanical failure. The spraying of base perimeters also exposed many soldiers, he said. Veterans, who had known of these things years earlier, took yet another "official" report in stride.

In October 1982, more than four years after our original broadcast first alerted the VA to the pos-

sible harm of Agent Orange, the Comptroller General reported to Congress that the VA's Agent Orange examinations were "not thoroughly conducted"; "The VA provided veterans little or no information on Agent Orange or their health"; and "VA personnel were not well informed about the examination program."

The report contained a startling discovery. The Agent Orange registry designed to keep track of the men who had responded with problems—89,000 by that date—didn't even include the veterans' addresses. Thus the VA could not notify the men of new test developments or follow up at a later time.

In a final and classic Catch-22, the GAO report found, 93 percent of 14,236 Agent Orange–related disability claims filed by veterans as of July 1982 were denied, at least half of them because there

Dr. Bui Thi Lang showed us newly replanted mangroves in the thick mud of the Saigon River Delta.

was no evidence in the veteran's medical service records that the disability was diagnosed or treated during his service. Of course, cancer symptoms wouldn't surface for years, and health problems in the field weren't even entered in medical records during the Vietnam War.

It was clear the VA-initiated studies had been delayed, but action on another front—the legal front—was not.

Although many lawsuits were filed by veterans in the Chicago area, where the story started, most of the attention focused on a massive class-action lawsuit against the U.S. government and the chemical companies that manufactured the herbicides. New York attorney Victor Yannacone directed a legal assault which asked that $4 billion be set aside to benefit those veterans who had been exposed to Agent Orange.

The most important development in the establishment of a link between dioxin exposure and human health problems came in late 1982. A lawsuit was brought by 47 railroad workers who had cleaned up a chemical spill near Sturgeon, Missouri, on January 10, 1979. A train had derailed, rupturing a tank car and spilling 20,000 gallons of orthochlorophenol, a chemical manufactured by Monsanto Chemical Company. After the workers developed symptoms very much like the veterans' complaints—a similarity they would only learn of later—they hired attorney Paul Pratt to represent them in claims against the railroad and Monsanto.

Pratt remembered those early days after the spill. At that time, he said, no one had any idea that dioxin had been contained in the spill. But Dr. Bertram Carnow, an occupational-disease specialist

Two children in a field left bare by Agent Orange, part of the 5 million acres of South Vietnam that were sprayed. Efforts to turn such areas into rice paddies have failed because the soil is not suitable for farming.

from Chicago hired by Pratt, testified that the men exhibited classic signs of dioxin poisoning.

I asked Dr. Carnow about the significance of his work to the Vietnam veterans. In the Sturgeon railroad workers, he said, "we have now a group of individuals with a strongly documented history, the number of days and hours they worked, a detailed medical history before and after the spill. It gives us a profile of dioxin poisoning, a profile that can be applied to the veterans."

This trial was not a hearing before a bureaucratic board. For the first time the evidence was put in the hands of 12 men and women who could decide whether dioxin had caused human problems. They said yes, it had, and in August 1982 the jury awarded nearly $58 million in damages to the 47 workers. Monsanto settled its part of the lawsuit for several million dollars, at the same time denying any responsibility.

Reaction in the Agent Orange community was one of triumph. The cast of characters who started with us in 1978, as well as those added along the way, all waiting for data that would put the controversy to rest one way or the other, were overwhelmed at the verdict. Attorney Yannacone said, "The jury in Sturgeon, Missouri, was a cross section of the American people, and they decided that dioxin is the molecule of misery, the molecule of death. The verdict is the opinion of the American people. . . . It is now time to compensate the veterans."

By the end of 1982, just a few months after this victory, the *New York Times* reported at least 50 studies related to Agent Orange finally under way, at an estimated cost of $100 million.

An Air Force study of Operation Ranch Hand will follow for 20 years 1,200 men who handled the herbicides in Vietnam to keep medical histories.

The Centers for Disease Control will study 7,500 babies with congenital defects in the Atlanta area to determine whether those children with a parent who served in Vietnam have more problems than others whose parents were not in Vietnam. It is being called the largest case-control study of birth defects ever conducted.

The National Institute of Occupational Safety and Health is compiling a registry of workers exposed to dioxin to determine the effect on mortality.

The VA will analyze 500 to 700 pairs of identical twins, one of whom served in Vietnam and one who didn't. The VA will also conduct a mortality study that compares Vietnam veterans and veterans who served elsewhere.

And the health of 6,000 or more ground troops with a high risk of exposure to Agent Orange will be compared with that of a control group whose exposure risk was low.

They are all ambitious projects, but already scientists are warning veterans not to expect too much from them. Accurate surveys have built-in limitations.

So where does that leave the approximately 100,000 Vietnam veterans who registered with the VA by the end of 1982, complaining of health problems related to Agent Orange?

It leaves them still waiting. While officials from other government agencies scurry to solve environmental problems caused by dioxin, such as the contamination of Times Beach, Missouri, the veterans continue to hear a familiar refrain: "There is no evidence that links exposure to Agent Orange to human health problems."

Unfortunately, it won't matter at all for veterans like Brian Quinn, who died April 7, 1981, when the metastatic tumor finally constricted his intestines and prevented their function. After ten operations, radiation, and chemotherapy, he succumbed to an enemy he couldn't fight. He weighed only 130 pounds when he died.

In those final hours, Brian and Carol still talked about Agent Orange and its possible role as the cause of his cancer. It was one of the few things he still really cared about.

Just as Brian's struggle with his illness symbolizes the veterans' complaints, his experience with the VA is also emblematic.

After his death, Carol received a letter from the VA advising Brian to report for a physical examination. They were ready to grant his request for another hearing.

Saigon revisited: finding the American faces

The question of what to do with the letters was growing larger every minute. If we kept them, it could mean real trouble at the airport. Should we destroy them? Perhaps, if that was the last resort. But how would we do it without creating suspicion? If it took the active minds of criminals or spies to find a way out, we were turning out to be candidates for some other line of work.

By 1980, everything had changed in Saigon and nothing had changed.

The name was Ho Chi Minh City—actually, Thanh-Pho Ho Chi Minh—but only when written. Even the Communists found it too much of a mouthful to use in conversation.

The futuristic Presidential Palace still seemed out of place against the jungle setting, but it served no single resident anymore. It had become a museum for viewing the "excessive" life-style of the past. Hours marked on the iron gates in front offered times when tours would be allowed to meander the halls.

U.S. military jeeps, uniforms, and weapons whirled around us in an afternoon's traffic jam just as they had during the American presence, but they were now the tools of Communists, not GIs.

The bougainvillea was as bright. Its colors still spilled over grayish walls surrounding French gardens. Even the old club for Saigon's elite French

One of Ho Chi Minh City's many street children sleeps unnoticed on Le Loi Boulevard. Their world was restricted to a few blocks in the center of the city.

plantation owners and the favorite haunt of high military commanders and their families, the Cercle Sportif, was intact. Its rooms no longer enjoyed the smell of French perfume and Courvoisier brandy, however. The decor was native Vietnamese, and it had been turned into an art gallery.

The Caravelle Hotel had changed not a single table or chair in its rooftop dining room, but the Vietnamese bellman at the front desk now spoke Russian instead of English.

Vengeance appeared to have been reserved for the Continental Palace Hotel across the square along Tu Do Street. Her elegance must have symbolized the decadence of the American influence. The new occupants had let the salt air and humidity tear the paint from her sides. The fabled louvered shutters hung at angles. The open veranda bar where French Foreign Legionnaires had lingered, where American officers and foreign correspondents had watched the beautiful Asian women ride motor scooters sidesaddle down the street with their brilliantly colored *ao dai* dresses whipping in the breeze, was a Vietnamese restaurant. Its storied view was filled in with cinder blocks. The inviting sound of ice tinkling in glasses of gin and tonic had been silenced, and the room was redolent of fish sauce. Worst of all, the once magnificent mahogany banisters that curled between floors were now dry and cracked from lack of attention.

This was the Saigon we found five years after it had fallen to the North Vietnamese. Although a few other Westerners had been allowed to stay the night in Ho Chi Minh City, we may have been the

These Vietnamese women on their bicycles, their *ao dai* dresses draped behind them like banners, were a common sight before the Communist takeover. To me they seemed the essence of exotic Asia.

first to walk its streets with any amount of freedom. What would we find? How would Americans be greeted? What had happened after the fall of the city on April 30, 1975? Had there been a bloodbath? What was life now like under the Communists? All of these questions added a sense of drama to our reentry, but even with high expectations we were not prepared for the surprises that would follow.

Our official business was Agent Orange. The new government of the Socialist Republic of Vietnam had invited me to bring a camera team into the country to videotape the aftereffects of the defoliant on the forests of South Vietnam. And Dr. Ton That Tung of Viet Duc Hospital in Hanoi was anxious for me to visit so he could show me his own findings from a study of the effects of Agent

Orange on North Vietnamese veterans who had served in the South.

Ho Chi Minh City was intended to be only a place to stay the night as we spent four days in an area that ranged from Vung Tau, a resort town on the South China Sea, to Tay Ninh province near the Cambodian border. Cameraman Skip Brand and technician Don Coleman muscled the delicate electronic equipment with herculean effort and lost not a single opportunity to record the trip in a style that would meet the highest standards. But Agent Orange would be overshadowed by another story on this trip, one which I would find as close as the sidewalk outside our hotel.

Most nights we would travel back into Ho Chi Minh City—accommodations were lacking in the countryside—and with each arrival came the labo-

rious unloading of equipment. The sight of huge shiny boxes sliding out of a blue Ford van attracted clusters of children who watched and shouted as the small Vietnamese bellmen wrestled with the heavy gear. Another irony, I thought. These were the children who had populated Saigon's streets for decades, perhaps forever. As if they never aged, here they were again, jumping for our pockets, darting a hand inside our trousers for spare change, all the while chattering for money or gum. The high pitch of their collective voices and the flailing of their arms created the sensation of being caught in a piranha feeding frenzy, and we would look nervously around for help, then run for cover inside the hotel lobby, where they were banned.

Street urchins had always been part of the Saigon landscape, skittering from the curb to an American GI, always a sucker for the kids, but there was a new element. One child about 7 years old, dressed in baggy shorts made of what might have been old army trousers, carried the limp body of his 2-year-old brother over his shoulder. He balanced the body with one hand and reached for money with the other. It seemed so deathlike I was sure the child was gone. His arms were dirty and covered with sores; I actually wondered why the body hadn't decomposed. It absolutely took my breath away, and I produced several coins. The youngster stared blankly and then carried his brother across the street, where he placed him on a towel beside a woman selling pencils. The "body" miraculously came to life, resting in the shade until needed again.

After enough of these encounters, I began to recognize individual children in the groups that roamed the streets. They would wave back to me and when they realized I was not forthcoming with change, they would happily resume their stations at the curb or romp into the park. I could imagine Fagin watching all this with sadistic pleasure.

One afteroon I walked alone down Le Loi Boulevard toward the former National Assembly building. As if on cue, a group of street children rushed around me, their voices jabbering and their arms reaching upward. As I examined their faces for one familiar, I came upon an extraordinary discovery. There, gazing back at me from the olive-brown flurry of movement, was an American face, as sure as if I had been looking in a mirror. In fact, he seemed to be thinking the same thing, that he had just seen his reflection. My stare may have startled him, or he may have sensed at that moment that he was not so strange after all, that somewhere there were others who looked like him—and here was one of them.

He was about 12 and had the broad magnificent smile of innocence as yet untwisted by an adult world. He too wore baggy shorts and a shirt made from army fatigues. His dark hair curled down his forehead and blew wildly as he ran across the

I had seen beggars before, but never one like this. The seemingly dead child he carried over his shoulder set him apart from the other pleading street children.

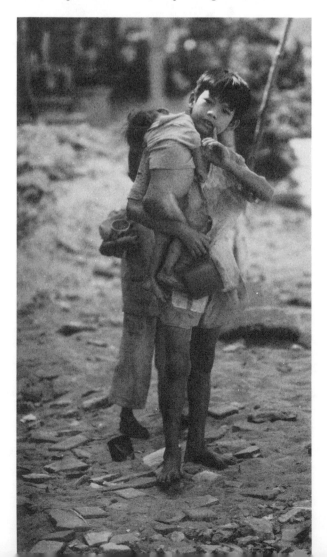

street toward a woman selling cigarettes from a large flat tray on folding legs.

He was a bit unnerved to see me following him, and he pressed closely to the woman for protection. I tried to smile at her, and asked, "He had an American father, didn't he?"

"Yes," she said. "American MP."

She spoke in broken English and tried to answer my questions until I probed too long. Her eyes shifted from side to side, looking in fear of the police or someone else. With a nervous smile she said, "I would like to answer your questions, but I be careful, I be careful."

I understood and backed away, half-spinning across the street. The event had an incredible impact on me. Thousands of Vietnamese-American children had been left behind in the final chaotic months of the war, many of them the legacy of prostitution, but others the legitimate offspring of U.S. citizens. There had been great concern about what might happen to these living reminders of war. Now I had just met one.

There must be others, I thought as I crossed the street.

Within seconds, I found a small girl about 10 years old selling steaming rice cakes from a stand of coals on the corner of Le Loi and Tu Do streets. Her skin was brown but her eyes were as round as mine and her hair fine, straight, and light brown. She shuffled back and forth between the stand and her mother, who was sitting in the shade of a building.

"American?" I asked her mother.

The woman's eyes became brighter as she returned the question, "Are you American?"

I nodded and watched her expression change. She regarded it as good news. I even detected tears in her eyes.

"Linda is her name. Her father was American soldier. He left here at end of the war. She can't speak English."

I was talking faster than normal, partly because of my excitement at such a discovery, and also because I realized the situation was precarious. I didn't want to jeopardize the woman and child in any way, and I saw a crowd begin to form around our conversation. So I thanked her and walked up the street.

Was I really that surprised? I asked myself on the walk back to the hotel. I was particularly sensitive to the story, having wondered for years what happened to these children. This interest went back to 1975, two weeks before the fall of Saigon, when I spent five days covering the collapse of South Vietnam for WBBM-TV, Chicago.

I had watched the last baby loaded onto a C-123 Air Force cargo plane, part of the U.S.-sponsored Orphanlift, an attempt to save a few Vietnamese orphans from the Communist onslaught headed for Saigon. It amounted to saving only a handful among the 1.5 million orphans estimated to be in South Vietnam, but it made the United States feel good. As small as the effort was, it was at least doing something at a time when we had to watch helplessly as a country into which we had poured billions of dollars and 58,000 American lives fell to the Communists.

I had come to the airport that day directly from Go Vap Orphanage, run by a group of Roman Catholic nuns, which cared for children who would never be leaving Vietnam. They played in a compound some 20 feet square, about 50 of them ranging in age from 3 to 8. According to the mother superior, they would probably not leave the orphanage for several years because there was no one to take them out, even for a walk. She was sympathetic and very caring but pragmatic as well. She must care for 200 youngsters. It was up to her to make sure they were fed and clothed. There was very little time for holding one child to her breast. Better they learn quickly the ways of the compound, that if they cry no one will come. The older children had learned by experience and they exhibited a rough and aggressive manner, the product of institutional living where love is parceled out to a hundred at a time and very little trickles down when one is lonely at night.

The nuns had painted the smooth cement in bright colors. They washed the hard floor often to take away the smell of urine and concentrated on preventive measures—trying to teach the smaller children to use buckets instead of the floor.

Top: A boy I photographed at Go Vap Orphanage in 1975. His face was a haunting mixture of Occident and Orient. Bottom: Whenever we left our hotel we were besieged by crowds of children, begging for money.

The nuns offered me a window from which to observe the compound, and I could see that it was wise not to go into the courtyard. The children clamored around any adult who entered, begging with outstretched arms to be picked up.

Their voices and faces were not easily forgotten and undoubtedly played with my subconscious thoughts as I walked the city five years later, vaguely wondering what had become of the children who were left behind. In these few startling minutes, I had found out what had happened to some, especially the half-breed children, those with the American faces. They had become the street children of Ho Chi Minh City.

By evening I had outlined the story for Skip and Don, and they were as excited as I. We left the hotel for a walk, intending to search out as many children as possible so we could begin to lay plans to get them on film.

Saigon nights had changed the most. The sidewalks teemed with sober-faced Vietnamese who were not enjoying the evening. In fact, most were busy watching over their shoulders, always looking right and left as if they shouldn't be there and someone might find out. There were few stores for the local population, only the makeshift black market that existed on hundreds of brittle folding trays, which could be set up and taken down in seconds. It gave the appearance of a floating market, at one moment a kaleidoscope of hats, lacquerware, and hot soup, the next moment an empty sidewalk.

There was one shop near our hotel that sold exclusively to foreigners. A constant crowd of Vietnamese gathered at its windows like children looking into a candy store. There were French perfumes and radios made in Communist nations, which gave it the appearance of a 1950 J C Penney department store.

No music wafted into the streets, there were no elegant French restaurants with their smells of garlic drifting into the night, no neon lights to create gaiety, things that had once earned Saigon the name Paris of the Orient. Now, there were only the putrid smell of garbage and fish sauce and the col-ored lights of Ho Chi Minh City's central fountain.

It didn't take long to realize that word had spread among the street population around City Hall of the Americans staying at the newly named Ben Thanh Hotel. Children handed us notes of paper. Sometimes they stuffed them into our pockets and then ran back to their mothers. When we examined the papers later in the hotel, we found they were pleas for help to get out of Vietnam. Most had pictures attached to carefully filled-out forms issued by the United Nations High Commissioner for Refugees.

One woman pressed something into my hand and disappeared into the crowd. The note said, "Come to my apartment for more information about the children," and included her address. At another place and time it would have been quite funny, but the stakes were too high. These desperate people were presenting us with a dilemma that could affect human lives. Should we confront the authorities on their behalf and risk censorship, or should we remain silent and wait until we were out of the country and tell their story to the free world?

A whistle cut sharply through the night, scattering the motley assemblage into the shadows. Two young militiamen dressed in the white uniforms and pith helmets of the North Vietnamese swung AK-47s from their shoulders and swaggered past. Within seconds the street was empty. Only pieces of paper turned over slowly in the wind that swept the ghosts of Saigon into the back alleys.

We stashed the letters and papers in our hotel room and half an hour later were walking toward a street that ran next to a bicycle parking lot. Good fortune materialized in the form of a young street peddler who rushed from a dark doorway to ask for money. "Of course," we said, "if you show us where this address is."

He read the tiny piece of paper and seemed to recognize it. So into the night we went, totally in the hands of a 12-year-old Vietnamese boy.

Soon he cut down a short half-block and turned into an unlit neighborhood street. As we walked along in the middle of the street, I realized we were

passing residential buildings. Then I noticed there were men watching us. They were dressed in white shirts and appeared to be standing guard outside the apartments. One approached and spoke in Vietnamese. We were trying to converse, asking about the location of the address, when a young girl whom I had seen in the park came alongside. She had a look of alarm on her face. "You must leave this place," she said. "There is much danger here."

In other circumstances I might have argued, but her simple communication caused a rush of panic that sent me running from a dead start to full stride within the space of a breath. All I could see was the shining of a streetlamp ahead, and I rushed for the proverbial light at the end of the tunnel.

My companions were within arm's length when we slowed to a trot, panting our relief to have reached the relative safety of a lighted street. A quick look around—no one was following, and there were no sirens. Our young guide was nowhere to be seen. If we were lucky we'd be taken for some stupid tourists looking for the past pleasures of Saigon.

Next morning there was another crowd at the doorway of the hotel. It seemed larger. As we pushed our camera gear toward the waiting van, little hands stuffed more letters into our pants pockets. I wanted to say "Stop! Someone will see!" But there was no stopping the children. In full view of the crowd they openly filled our hands, oblivious to the witnesses. Even our North Vietnamese guide looked away in an embarrassed attempt to avoid having to say something.

I was climbing into the passenger seat when the woman we had tried to visit the night before came so close her hair touched my cheek. She gave the impression she was trying to collect her children, but her real reason was to speak to me. "This afternoon at the zoo," she whispered.

Sitting inside the van where no one could watch me, I scribbled a short message. "Wait for us at Tu Do Park at four."

It was hard to keep my mind on Agent Orange as we bounced along the macadam roads into Tay Ninh province northwest of Saigon. Our guide

Nguyen was chatting enthusiastically about "points of interest." Cu Chi, for instance, was the location of a vast tunnel system dug by the Viet Cong to hide from U.S. forces. The tunnels had been turned into an attraction for Eastern bloc tourists, displayed as an example of the ingenuity that had defeated the "puppet" government of the United States. Charts above the tunnel complex diagrammed the intricate interlocking system beneath the ground. A Vietnamese tour guide fit the model of any National Park Service guide describing Pickett's charge at Gettysburg.

Along the road we also noticed a large number of veterans' cemeteries, each built around a shrine to Ho Chi Minh. "It was the first thing we did," Nguyen explained. "It is very good to show our concern for the men who paid the price for our freedom." His words carried my thoughts back to the United States and our treatment of veterans at the other extreme.

Near the Cambodian border the war seemed much closer than it had amidst the untouched buildings of Ho Chi Minh City. Trees stood like skeletons, stripped by B-52 bombing and Agent Orange. Occasionally, a rifle shot could be heard in the distance—farmers hunting for food while they waited for their rice crops to come in. We stopped at a helicopter base, now abandoned, and were greeted by a thin, older Vietnamese. He was the district chief who would lead us through the former firebase. This excursion lent an eerie cast to our trip and heightened my feeling of being one moment in the present and the next in the past.

A single strip of asphalt was in the center of a clearing a full mile in diameter. Old bunkers still stood guard around the flight line where Huey choppers once parked. Testimony to the effectiveness of the defoliant Agent Orange, there was no weed, tree, or plant that stood taller than shoulder height within the perimeter. Smoke rose from distant trees, farmers burning and clearing land for crops, and it gave the sensation of a firefight in the distance. Then the old district chief began to recall the past as well.

"I fought here for 20 years of my life," he said. "We lived in the jungle and ate rice balls while the

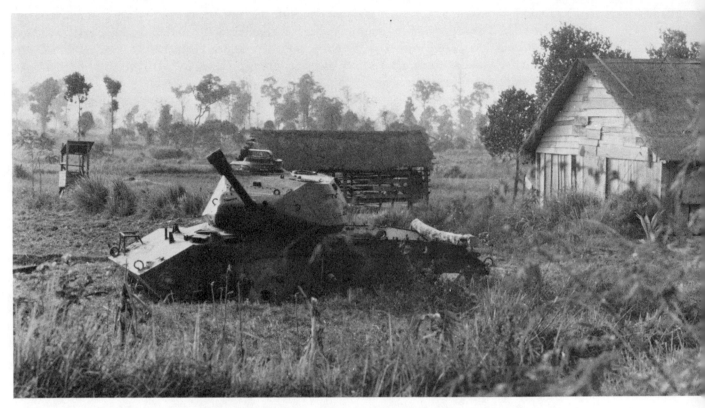

This tank in Tay Ninh province was a reminder of a war that seemed far less distant in the countryside than it had in Ho Chi Minh City. The landscape still bore the scars of bombs and defoliants.

Americans drank beer and listened to music all night.''

"Weren't you afraid of the power of the United States, the weapons, the helicopters, the B-52s?'' I asked.

"Of course, at first. But Ho Chi Minh told us that we would prevail because it was our land and our fight was right. I remember the sky would turn black from the many helicopters.''

"And the B-52s, the bombing?''

"It was not so bad. We would either go very deep in our shelters or get as close as we could to the American troops. We knew they would not bomb them.''

His skin was drawn very tight, allowing his bones to show. It was difficult to believe that this frail creature had been able to defeat the power of the United States. His smile opened upon a glittering array of gold fillings, which flashed in the sun as he answered my questions.

"We would sneak up close to the base at night and watch the American soldiers take showers. We could see them naked,'' he said, laughing.

"So why did you win and why did the U.S. lose the war?''

"We lived here. We slept with the animals and existed on almost nothing. The people fed us. It was our life. The American soldiers fought from eight in the morning until dark, then they went home. These men did not want to be here. That's why we won.''

Dust rolled up in a cloud and blew across the airstrip, and I could imagine the backwash from the rotor blades of a Huey filled with green-uniformed GIs. The copter might have lifted at an angle, then dipped toward a distant firefight and the promise of death. Such were the memories of a war lost in Vietnam, and the memories of a gener-

ation who fought it.

We reached Ho Chi Minh City by late afternoon, in time to make my appointment in Tu Do Park. I told Nguyen we were going to take the rest of the day off, and fortunately he was more interested in pursuing the city's female population than in babysitting three men from the United States. We were relatively free. Skip and Don shouldered their equipment, and we were off.

Tu Do Park was just a block from the Continental Palace. Tropical flowers surrounded a small fountain in the middle of the park. Several swing sets stood at one end, filled with children. This was not a respite for an occasional wandering child. It was the entire world for children whose mothers worked the black market in the city's center.

They were all there waiting for us, gathered on steps near the entrance. The children were dressed well, probably in their best clothes, as were their mothers. Some wore pretty polka dots, others sundresses that tied over the shoulders. Their tanned olive skin was attractive against the bright colors of their Western-style clothes. Here again, one could easily feel the presence of the past, when Americans walked arm in arm with Vietnamese women along the sidewalks of Saigon.

The occasion, however, allowed no time for nostalgia. We were grabbing these pictures as quickly as we could, shooting and talking at the same time. The women were taking an incredible risk, gathering together in defiance of laws that prohibited groups larger than three at a time. A crowd was already beginning to build, and I knew we had to work fast.

"What kind of life is it for the children?" I asked.

"It no good," one mother said. "They don't go school. We can't have jobs. There not enough food. We need help."

Their English had not been used for five years and it was a little rusty, but they had practiced for this moment and wanted it to be right.

Four boys knelt alongside one mother, their faces shining examples of the blending of Occident and Orient. The mixture seemingly took the best from both races and produced beautiful faces of dark skin and sparkling eyes.

Another pretty woman spoke up. "We need help to find our husbands. It is no good here. The children aren't wanted. It is very hard. We want to go to United States."

One of the oldest of the children began reading a letter that had been prepared by his mother, and his choppy reading was quite moving. "My name is Joey. My father was American and my mother Vietnamese. My father killed by VC. Now my mother take care of we. We have no way to go school. Please help us get out of Vietnam."

Another woman, so thin her bones appeared birdlike under a soft pastel dress, spoke with a better knowledge of English. "We have no food, do you understand? We have no place to live. And we live very hard here. The children don't go to school. I am a mother, and I feel very sorry that my children don't go to school."

I leaned forward to ask, "What kind of life will they have if they stay here?"

She looked nervously around and replied, "We're afraid of people if someone finds out we have talked with you after you leave, you know? So better you find out for yourself."

It was a clear sign the crowd had grown too large behind us. I stood up and trained my still camera on the crowd, and a number of white-shirted men quickly turned their faces. They were undoubtedly "monitors" who would report us and the women who spoke out. It was time to go. I thanked them all, promising to do what we could, and watched them scatter down the streets with their small children skipping behind them. I could only hope they would not be punished.

We had done it. Despite the oppressive restrictions of this Communist country, we had videotaped the testimony of the women themselves and their children, the best evidence of what had happened to those we left behind. But we still faced the challenge of getting it out of the country.

That challenge would dominate my thoughts until we left Vietnam, for it was a safe assumption that the new regime would regard any publicity exposing their treatment of these children and their mothers as extremely embarrassing, espe-

cially when they were trying to present a positive image to the world. Since the United States had not shown a great deal of success in forcing Vietnam to do its bidding, we could hardly expect the U.S. government to come in after us if we were stopped from leaving. At the very least, we were risking confiscation of our equipment, our 60 videotapes, 200 pages of notes, and 50 film canisters. Not only would we lose our story, but the women and children—and other individuals who had told us in confidence about life in Communist-ruled Vietnam—could be placed in extreme jeopardy.

I was convinced that the authorities would not hesitate to take repressive measures against us after a long conversation with a former professor at Saigon University, an environmental scientist who accompanied us to the Saigon River Delta to view the remains of a rare mangrove forest. She had been educated at Scripps Institution of Oceanography in La Jolla, California, she informed me with pride. The Communists apparently value an American education over any other. She had been in Saigon from the first day of the North Vietnamese takeover and was able to observe the meticulously planned invasion. As we traveled the Saigon River, she spilled out the details with a mixture of amazement and pride, for although some of her brothers had been in the South Vietnamese Army, she had been sympathetic to the Viet Cong. The following is a distillation of her account.

When the last American helicopters lifted away from the platform atop the U.S. Embassy, the hopes of most South Vietnamese left as well. Some people stood on the steps, looking into the sky for hours, waiting for the rescue planes that never came, unable to believe their American friends would not or could not get them out. Mobs stormed the embassy and threw stacks of personnel files into the streets. Some of them contained names of Vietnamese who had worked for the Americans, and they would prove to be damaging in the days to come. A severe depression descended upon the crowds that had gathered outside the wrought-iron gates. There was little hope left, defeat was inevitable, their lives had ended.

As some individuals stumbled home, they met others pushing baskets of personal goods in front of them. "Where are you going?" they would ask. The answer: "I'm getting out!" They had not yet realized they had nowhere to go. North Vietnamese divisions surrounded the city. For the next few days, a quiescent calm gripped Saigon with the stillness of death. Most of the people remained in their homes, afraid to go out on the streets.

The professor said she was listening to the government radio station when the program was interrupted for about 15 seconds. A different voice came on, announcing the takeover by the new government of the Republic of Vietnam. There was no explosion, no laughter or cheering, just 15 seconds of dead air before marching music was heard. That was the dread transition of power between South and North. The calm, reassuring voice soon came back to advise everyone to remain at home and wait for further instructions.

During the next several days, there were no screaming hordes killing and raping in the streets. The conquering army took the important buildings, the Presidential Palace, the hotels, the U.S. Embassy, and the Armed Forces television station, and periodically soldiers would drive through the city streets. But there was no cause for panic; it was planned that way.

This was not exactly a typical foreign army interested in plunder for its own sake. Accompanying the divisions from the North were Viet Cong and National Liberation Front fighters from the South. Any widespread program of vengeance would have injured the families of these loyal guerrilla fighters and risked more civil war just at the moment of victory. The professor herself was an excellent example. Her own family was divided between Communists and non-Communists, brothers in the South Vietnamese Army and brothers in the Viet Cong.

Then, too, the students of communism were drawing on the lessons of revolution learned in the universities of Cuba and the Soviet Union. You don't need a bloodbath to control the masses.

Workers at the important city utilities were the first to receive instructions to continue working, so the city could operate normally. The entire tran-

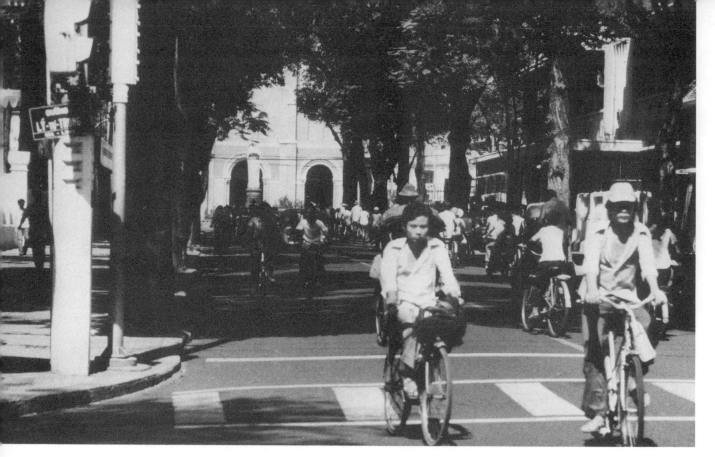

Once known as the Paris of the Orient, Saigon had changed dramatically since my last visit. Nightclubs, French restaurants, and most cars were gone, leaving only the hum of bicycle traffic.

sition was carried out according to a prearranged plan. Even the cadres who took over the Armed Forces television station had been sent to Cuba to learn the American system of television two years before the invasion.

With continuity of daily life assured, the new Communist society began dividing into cells at the workplace and in the neighborhoods. The smallest unit, upon which the entire structure rested, was created in the residential areas. Groups of as few as a dozen citizens gathered together in the home of a member of the Communist party. These party members were called monitors and were described as "first-class citizens," fine examples of what a citizen should be. A monitor, in their words, was a kind of "priest," a person above suspicion who would set an example for everyone else. If the street needed sweeping, the monitor would be the first to volunteer.

The cell meetings were extremely friendly at first, a celebration of new freedom from foreign oppression. They were portrayed as opportunities to build a new government according to the wishes of each citizen. The task of each cell meeting was to obtain an essay describing the governmental preference of each person. Also, each cell member was asked to write an autobiography to help the new leaders place them in positions that could best help the new nation. The whole thing had the feeling of a Tupperware party and must have been quite seductive. Most of the people took up pen and paper and poured out their personal histories with an enthusiasm that, if not totally endorsing the new regime's representations, at least reflected a belief that it was better than being dead.

It was a brilliant trick, of course, an example of sophisticated control of the masses worthy of a graduate degree in the school of revolution.

Once the cell monitors had a complete picture of the individuals within each group, they had total

control. They knew which had worked for the old government and which had had American boyfriends. They knew which still believed in democracy and which might be good risks for a new order. They knew which should be punished and, more important, they knew how they thought.

These building blocks of the new system continued meeting for three weeks, sometimes listening to government radio's morning lesson from Hanoi and sometimes entering into group discussion of Communist theory. Finally, an ominous announcement came from the new government. All former army personnel and employees of the puppet government of the United States were ordered to report to designated areas for "reeducation."

Labor camps were waiting for those considered the most dangerous elements of the old system. The majority were members of the armed forces who possessed the ability to make real trouble. They were instructed in the beliefs of Ho Chi Minh and how one lives in a Communist state. Those who responded well during this rehabilitation were eventually released to return to their families in Ho Chi Minh City. Some, however, remained in the camps for years, working in squads of laborers who moved throughout the country. Some estimates put the number of persons still in the camps today at 100,000, but Vietnamese authorities deny there are that many.

The second wave of reeducation involved those individuals sympathetic with the old regime who lived within the city of Saigon. They were targeted as having participated in its decadent lifestyle of prostitution, graft, and corruption, in contrast to the ascetic way of the peasants, considered the true fathers of the revolution. Thousands, indeed hundreds of thousands of city residents were sent into the countryside to new "economic zones" and told to make their way in the fields by learning to grow rice. They were given supplies that would last six months, time enough to grow a rice crop. For merchants and shopkeepers, salesmen and white-collar workers who had never known the ways of the land, it was tantamount to a death sentence.

The third form of reeducation involved young girls labeled prostitutes. In addition to thousands of women who truly practiced the world's oldest profession, they included girl friends of American soldiers, daughters of employees of the Americans, and family members of old political groups designated for punishment. Their education lasted for three to six months, depending on their rate of acquiescence to the Communist way of life.

During our stay in Ho Chi Minh City I visited such a camp and found the girls learning embroidery and native Vietnamese crafts with the aim of being able to support themselves doing something other than selling their bodies. Prostitution had existed within the Vietnamese culture long before the French and Americans availed themselves of it. Young girls were commonly sent into houses of prostitution to support the family, and it was considered a rite of manhood for a young Vietnamese man to visit such a place before earning his maturity. But it is easy to imagine the liberal interpretation applied to defining which girls were prostitutes. It underscores the immense power in the hands of the monitors. In the pattern of Alexander Solzhenitsyn's Gulag Archipelago, the mere listing of a name could banish one to a labor camp. Such power makes violence superfluous.

The movement of citizens was also under absolute control. One needed permission to spend the night at the house of a friend or travel beyond one's block or street, from one part of the city to another, and especially to another town. Without showing a pass at various checkpoints, travel was impossible.

Against this perspective, the tiny men in white shirts who were watching us in Tu Do Park became quite intimidating.

That evening I gave a party for our Communist hosts, at the urging of our guide, Nguyen. "It is customary," he observed. The place I chose was the Caravelle Hotel, and it was yet another indulgence in nostalgia.

On our way to the rooftop dining room, Nguyen stopped at the third floor and asked if I would like to see the old CBS News offices. I was delighted, and followed him to the corner room,

which looked out upon the National Assembly building—now a theater—and infamous Tu Do Street, flanked by the Continental Palace. The old offices were marked by a plaque, the kind of marker you might find at some historical site in the United States. The plaque noted that the space had been used by a news-gathering organization during the war waged by the puppet government of the United States until Vietnam was liberated by the freedom fighters. The room had not been changed; its quaint French decor still opened to the city like a window on history.

The rooftop bar and dining area also seemed frozen in time, untouched by the same five years that had been so difficult for veterans in the United States, during which most of the country had exorcised the memory of Vietnam from its thoughts. Like a lost world, the Caravelle still existed unchanged, anchored in the past. The memories were still fresh, the conversations hardly had time to have faded into history.

It was not the first time I had felt those emotions. Two days earlier we had stayed the night at Vung Tau, a seaside resort town where the Saigon River meets the South China Sea. The hotel had been renamed the Red River after the powerful tributary that runs through Hanoi. Everyone there was South Vietnamese, working under the watchful eyes of a Communist party member who held the threat of expulsion over them.

We walked into a hotel bar filled with the sound of records from 1968, and the scratchy sound cast a strange mood, linking us to that time 12 years past. There was a young Vietnamese woman behind the bar, probably 25 years old, dressed in a magnificent *ao dai* with silk panels that dropped like shiny banners across her black trousers. Her long black hair framed delicate features. She was truly intoxicating and triggered memories that easily spanned those turbulent times.

Her eyes opened wider when she heard our American accents, but she said nothing and went about her business serving bottles of Vietnamese and Japanese beer.

The music was too loud, which seemed normal.

The bar soon smelled of spilled beer and the room fogged up with cigarette smoke, all of which, aided by our own exhaustion, transformed the setting into an R and R base, lacking only the dipping khaki uniforms on the dance floor.

The hour grew late and the other members of our party went to their rooms, leaving me alone with the Vietnamese girl behind the bar. She had hardly spoken all evening and was a bit startled when I said, "Are you from Saigon?"

She only nodded.

"I'll bet you had an American boyfriend."

She stopped what she was doing and looked directly at me, holding the stare for a few seconds, then looking toward the door to see if anyone was watching. Then her eyes went down to the glass she was washing.

"Do you hear from him?"

Afraid to speak, she said quietly, "I send him letters with the Italian oilmen who come in here." They were drilling wells in hopes of finding oil along the continental shelf of Vietnam.

I asked, "Have you thought about leaving on the boats?"

She reacted like a frightened bird. "I have thought of it," she said, "but it is very dangerous."

We sat alone until I asked if she could come to my room and talk further. She glanced toward the door and said, "No, I'm not allowed to."

The music ended with an uncomfortable tick as the needle caught in a groove. She extended her hand, holding mine for a moment. With her eyes as much as her words she told me, "I don't know why, but I feel better having seen you tonight."

This was Vietnam, 1980. Everything had changed and nothing had changed.

The Caravelle party lasted two hours, filled with French wine and explanations of the Vietnamese dishes before us. We had all been together for nearly a week, and friendships had grown despite our political differences. In the spirit of those friendly moments, a young woman attached to the Ho Chi Minh City office of television relations suddenly volunteered a request.

"Mr. Kurtis. We know you have been given many letters from those desperate people on the streets. Please don't try to take them out of the country with you. Customs is something we have no control over, and if they find them it will be difficult for you to leave."

In the context of the evening, those words had a sobering effect. Others expressed similar warnings. "Yes, we have had such a good and fruitful week covering your Agent Orange story. It would be a shame to spoil it with an embarrassing situation at the airport."

Yes, it certainly would, I thought, especially if it would mean staying in-country on a permanent basis.

I thanked them for their advice, distributed some gifts, and left. Skip and Don had also heard the admonitions and seemed as disquieted as I.

Our hotel room overlooked the park in front of City Hall from the fourth floor. It had a small balcony with a pair of French doors, which I covered with curtains.

Spreading the letters out on the bed, I realized even through the veil of French wine that the question of what to do with them was growing larger every minute. If we kept them, it could mean real trouble at the airport. Should we try to force our way out of the country? That didn't seem very smart since the United States hadn't had much luck muscling its way around Vietnam, even with 500,000 troops. Should we destroy them? Perhaps, if that was the last resort. The letters, the pictures, the personal pleas to leave the country had a haunting quality. They might well be regarded as treasonous by this repressive government if they reached the authorities.

Quietly, for our suspicions were running wild, I asked Skip to set up the videotape in the shower stall so the bright light from the portable lamps wouldn't alert anyone watching the room from outside. We pasted the individual letters and pictures to the shower-stall wall and recorded as many as we could before the oppressive heat drove us out. Sweat ran into our eyes until none of us could maintain focus on the camera.

If we did destroy the letters, how would we do it? That was the topic of discussion. Should we burn them? Where, and without creating suspicion? Throw them in the river? That would mean a walk to the river, packaging them in something that wouldn't float. And what if it were retrieved after we were spotted throwing it in? If it took the active minds of criminals or spies to find a way out, we were turning out to be three candidates for some other line of work. Was there anyone around we could trust to destroy them for us? The women? we wondered. Perhaps.

Nguyen knocked on my door promptly at 8:00 A.M. I was ready, after a sleepless night, to try the first option we had finally adopted. I offered him two letters, one with no pictures attached and on which the information was sketchy, and another with the picture of a small boy, taken several years earlier. Before I handed them over I expressed my thanks for allowing us to have such a successful trip, embellishing his role in it, and said I also wanted him to have a personal gift from me, the final items I had to offer. I gave him a small pocket calculator, impossible to get inside the Communist countries, along with a copy of Frances FitzGerald's *Fire in the Lake,* also highly prized in Vietnam. As one last gesture, I gave him some U.S. currency, as much cash as I had, I think about $50, which would be worth many times that after it was exchanged in the Vietnamese black market. We had found the Vietnamese still wanted good old American dollars.

By the time I got around to giving him the letters, he acted as if he would have accepted empty envelopes. They seemed to satisfy his need to have something tangible to show his superiors, evidence that the Americans had complied with the request to leave the letters behind. As we embraced to say good-bye, my only thought was what to do with the remaining 98 letters.

In the back of my mind, I remembered the many diplomatic missions along Embassy Row near the U.S. Embassy. I had no idea how many remained, but my next step was to walk the four or five blocks and try to find the British Embassy, hoping the consular officer would take the letters and ship them to the UN High Commissioner for

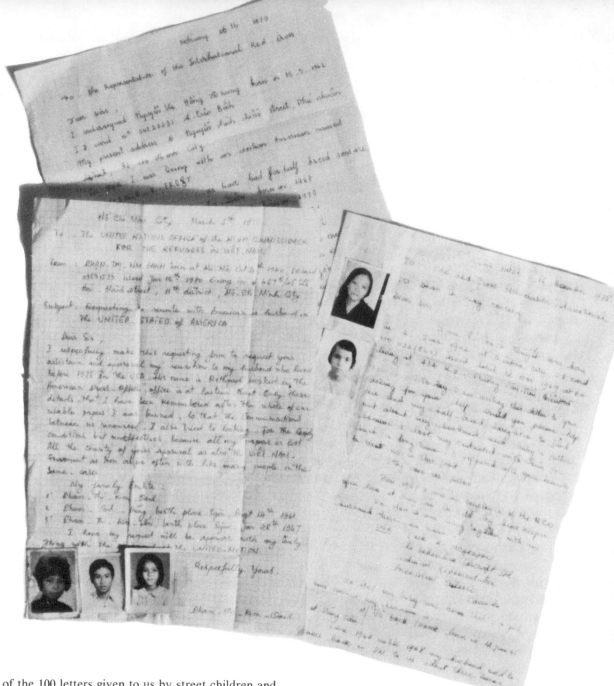

Some of the 100 letters given to us by street children and their mothers, begging for help to leave the country.

Refugees in his diplomatic pouch, which would be immune from search by Vietnamese authorities.

I packed the papers in the bottom of my leather photo bag, which had been a visible part of our equipment throughout our stay, and then put the cameras on top. Funny how much attention you can pay to detail when every movement counts.

Trying to appear casual and relaxed, I joined Skip and Don in the dining room for breakfast, making sure we kept our conversation strictly to our pleasurable time in this delightful little country. All of us were perspiring more than normal, I think, and they wished me well as I swung the camera bag over my shoulder and headed out of the hotel. We agreed that if I didn't return in two hours, they would begin looking for me.

Tourist was the watchword. Look like one and act like one. Both cameras swung from my neck, and periodically I would snap the postcard scenes—City Hall, flowers, the cathedral—working my way toward Embassy Row.

Each step I took felt leaden, and I moved along in an almost dreamlike state, as if each motion were being watched and studied.

The first block seemed easy enough. The Caravelle was quiet, although I noticed a French tourist coming out and getting in an old three-wheeled rickshaw. Someone was standing on a scaffold removing the old address from Tu Do Street and measuring for a sign leaning against the wall, which said Ho Chi Minh Tourist Office. The children we had talked with played in the park, running back and forth to their mothers, who were busy placing steaming rice cakes on their precarious trays or arranging cigarettes for the day's customers. They hardly noticed me, and I avoided drawing their attention.

I mused that in the course of a few days the old ghosts that had jumped from every corner were no longer there. They had been replaced by new ones, very real fears that lurked behind the plants and abandoned guard stands at the corners of official buildings. One such apparition materialized in the form of an old lady riding a bicycle. She wore a long coat, which seemed odd in the hot weather, and kept an even distance from her position across the street. It was a product of my imagination to think she was following me, I thought, until I watched her pause at a bus stop and stare at me while she went through the motions of waiting for a bus. I was happy to be near the corner where I could turn into the old British Embassy building and disappear into the safety of its courtyard. But it wasn't what I had expected.

The sign at the top of the stairs was for an oil company, not the British mission. In fact, some employees nearby told me, there were no diplomatic missions left except the French just down the street. Stunned, I hurried out the large gate and rushed toward the corner, my bag still hanging from my shoulder. One chance now—the French. My pace picked up to match my heartbeat.

Bicycles passed lazily across white pedestrian crosswalks that seemed freshly painted, preserved in the marvelous climate. To add to my quickening pulse was the sight of the old woman, pedaling her bicycle parallel to me across the street.

The high wall of the historic French consulate hid a magnificent building, a vestige of grand colonial affairs. The wall provided protection only on one side until I got to its gate and past a uniformed French guard, who actually seemed pleased to allow me to enter.

"Of course, *mon ami*," he said as he pointed to the entrance of the building. With soaring spirits I bounded up the steps to get inside, closing the doors quickly behind me.

Large rounded porticoes opened onto a tropical garden in front, beyond a graveled driveway for official vehicles. The hum of activity as clerks carried out their business down the hall was comforting. The movement and the windows gave it the feel of Rick's Cafe in the movie *Casablanca*. I asked for an appointment with the official at the desk, and he informed me that the consul general himself was expected momentarily.

Sure enough, only 15 minutes passed before a well-dressed man of about 50 led by a Doberman pinscher on a leash came through the doors to the greetings of his staff. I could see several heads turn in my direction, and he came toward me with his hand extended. "Welcome and come with me," he said, leading me up the wide stairs.

His office was impressive. Behind his desk was a huge siege map that had been used by French generals during the Indochina War. It showed Saigon from the city's center to the sea, each ditch and forest cluster carefully drawn. It hung like ancient history over the room. Here, too, large portals opened into the upper reaches of palm trees, with bamboo shutters shading the sun. There was a refreshing coolness to the room. Leave it to the French, I thought, to extract the most livable advantages from any location, even this one. One friend had told me the French were particularly fond of the Vietnamese because they felt the little people were able to make a good sauce. It seemed to fit.

We talked for half an hour. "It's a prison here," he explained, detailing the inability to move anywhere within the area, even with diplomatic immunity. "The hardships these new Communists have imposed leave very little freedom for these people. No wonder the boats are full."

I asked if he would take the letters off my hands and make sure they reached the UN High Commissioner, and he quickly consented. "We get so many of these ourselves, you know."

Never had I felt such relief. The burden of responsibility lifted, and I left with a feeling of freedom and clear conscience.

Along the sidewalk I felt like challenging everyone who might be a Communist party member watching me, whether waiting for a bus or walking down the street. I went out of my way to shout greetings in English so I could watch their heads turn in surprise when they realized I was American and not Russian, which would be more common. The sun seemed brighter, colors fresher. Even the little puffs of smoke that poured constantly from the motor scooters seemed more an exotic trademark than choking pollution.

I had even forgotten about the old woman, until I rounded a corner less than two blocks from my hotel. She was standing astride her bicycle, waiting for me. This time there was no effort to disguise her actions. She stared directly at me, her eyes fixed with laser-straight hardness. She was obviously planning to make contact of some kind. Was it an arrest? I wondered. Could it be worse? That sent the images racing. Should I run? I was so close to the hotel, so near to getting out of the country. All our movements seemed to slow to half-speed, and I studied each one carefully.

I took this picture at Go Vap Orphanage in 1975 after seeing the U.S. Orphanlift fly away with its last cargo of Vietnamese children. The 200 youngsters at Go Vap would probably never leave Vietnam.

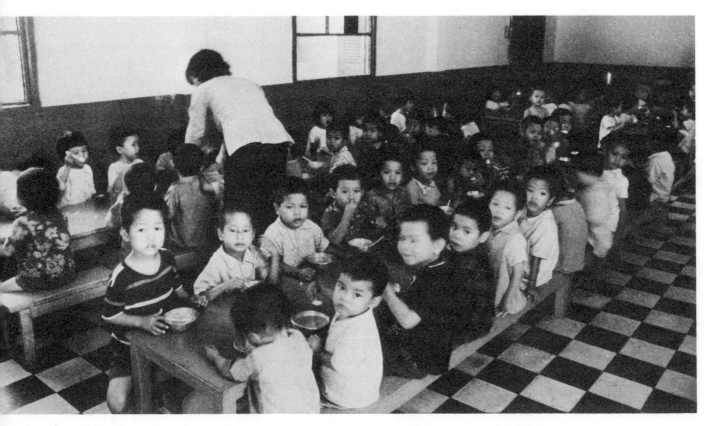

I attempted to look away slightly and slide past her on the sidewalk, but she would have none of it and moved to cut me off. From the corner of my eye I saw her hand dip into her purse. "Christ," I thought. "I've come so close, why does it have to end like this?"

In that slow motion, her arm began to move upward and I dreaded to see what was in her hand. We must have been within five feet of one another when her hand cleared the top of the purse and I could tell she held—a letter.

"Would you take this, please?" she asked. "And be very careful. It is not safe here."

In Bangkok, I called the U.S. Embassy from my room in the Oriental Hotel. "We've discovered American children," I told them. "What appear to be hundreds on the street." I'm sure I sounded much too excited. "I have them on videotape!"

They came to the hotel room within an hour, two men connected with the frustrating job of sitting outside the Communist country unable to look inside, relegated to debriefing refugees who escaped. With the videotape they could see clearly what was happening inside Vietnam, and their reaction was enthusiastic.

Richard Milton at the Bangkok embassy headed the U.S. reunification efforts for families caught in the middle of the Vietnam debacle. The United Nations had worked out what it called the Orderly Departure Program so that families could be reunited, Vietnamese and Americans who had been separated by the sudden end of the war. There was only one shortcoming: None had been reunited. Politics had intervened. United States diplomats weren't even allowed to land at Tan Son Nhut Airport to interview prospective participants in the program. After Milton saw the Amerasian children on videotape, he pulled from his files a list of nearly 80 American citizens among the children left in Vietnam who could have entered the United States immediately if only the barriers did not exist between the two countries.

The children were pawns, caught between Vietnam, which could recognize some value in holding them as a bargaining chip in the struggle to reestablish relations with America, and the United States, which wanted to minimize relations.

Beyond the U.S. citizens, there were some 600 other youngsters whose parents had failed to register their birth with the U.S. Embassy but who could trace their relations to the United States, mostly American GIs. In all, there were an estimated 8,000 to 12,000 Vietnamese-American children around Saigon.

When we returned to Chicago, the report on Agent Orange was clearly of less immediate news value than the story of the Amerasian children, which quickly reached a variety of media. In addition to news reports and a documentary on WBBM-TV, CBS News distributed the story. Imagine my exaltation one morning when I got a call from an assistant editor saying the *New York Times Magazine* would like to put it on the cover. When I came down off the ceiling, I dug into the copy and worked with editor Glenn Collins, who nursed me through revisions. We expanded the story slightly to examine the full scope of the Amerasian problem in Southeast Asia and found there were approximately 100,000 children fathered by American soldiers in Vietnam, Thailand, Korea, Japan, Taiwan, Cambodia, Laos, and the Philippines. Their story was not a pretty one. In most of the countries the children were denied citizenship. They were obviously half-breeds, marked by their faces, and in those Asian countries where one race dominated the culture, the discrimination against the half-breeds was more serious than any we have known in the United States. Most of the children did not go to school and were denied basic rights. They faced a bleak future as they grew up.

The Vietnam experience provided a slight twist to the historic pattern of "soldier leaves war baby behind." In contrast to the closely controlled occupations during World War II, many American GIs lived with Vietnamese women during their stay in-country. It was a practice called bungalowing, and it offered a weary soldier the joys of female companionship beyond the one-night stands of Tu Do Street.

Of course, thousands of men left the women

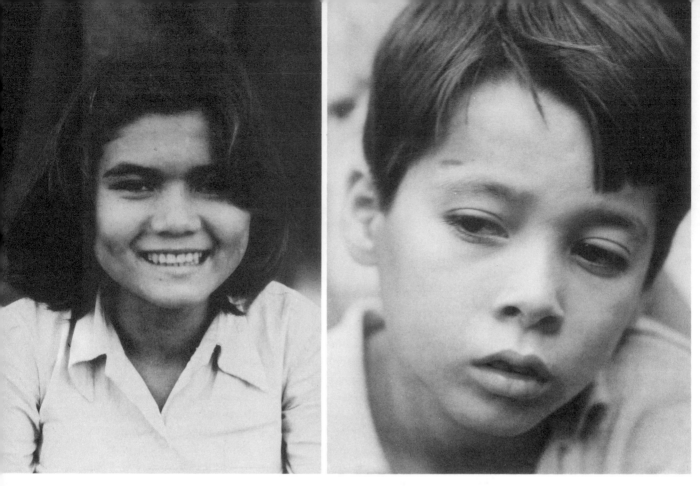

Two of the Amerasian faces: Linda, left, who helped her mother selling rice cakes; and a young boy who wasn't allowed to attend school because of his mixed parentage.

behind with little remorse, but many others became emotionally involved. Among those were fathers and husbands who were later separated from their Vietnamese families when the North Vietnamese divisions entered the city. When I reached Ho Chi Minh City in 1980, five years had passed during which men and women on both sides of the bamboo curtain had tried to find each other.

Among the letters we photographed in the shower stall was one from a Vietnamese woman trying to reach the man with whom she had lived. Once in the United States, I telephoned him. A woman answered; she said she would have her husband call me. Within ten minutes I received a call from the man, whose name I will keep secret. After asking anxiously, "What do you know about Nguyen?" he told me his story.

In the late 1960s this Vietnam veteran had found himself in a country at war. He was lonely, afraid, and most of all young. Tu Do Street's exotic bar girls were more intimidating than exciting. He was not long out of high school and was slightly embarrassed by it all, hardly the combat-hardened grunt of Vietnam folklore.

One Sunday afternoon some Vietnamese friends introduced him to Nguyen. Love stories are seldom simple. She had a child by another American soldier, but he didn't care. He had a wife back home, but that didn't seem to make much difference either. The two were living together in short order. Their relationship grew deeper, and when the young soldier was discharged, he got a job with a defense contractor, so that he could be with Nguyen.

He was out of the country on business when Saigon fell in April 1975. Getting back into Viet-

nam seemed hopeless, leaving few options except return to the States and attempt to get his Vietnamese family out.

His American wife had never learned about Nguyen. She thought he had wanted a divorce for other reasons, and the veteran slipped back into the familiar midwestern family life he had tried to get away from by going to Vietnam.

When I called in 1980, it triggered his feelings and uncorked a tale of years of frustration trying to reach Nguyen. Two and one-half years later, in 1982, he was still trying. He put his feelings down in a letter filled with his emotions. Not having seen her for seven years, he still wrote, "Nguyen and I love each other and deserve to share our lives as much as anyone else. I want your assistance in either getting her out of Saigon or me in. I must personally reassure her that I am waiting and will wait for however long it takes.

"I have written to her at least once a month since you called me almost three years ago. That means some 30 letters have been intercepted plus about six or seven telegrams. As desperate as my situation seems, I can only imagine what torment and feeling of hopelessness she must be suffering. The only reason she was not able to leave Vietnam with me was that I could not marry her legally and would not marry her illegally.

"I am bitter, not only that we as a country sacrificed honorable principles because the Southeast Asian war had become domestically inconvenient. We also sacrificed good and decent people in the South Vietnamese.

"I have not seen her since 17 April 1975, but her image is burned into my brain and I have not made it through a single day without a melancholy thought of what could have been and what should be. I am basically a romantic and believe that if I love her well enough and try very hard to deserve her love, we will be united once more. But I also believe that God helps those who help themselves. I want you to help me get her out."

Another story centered on a photograph we had videotaped of an older man holding a small child. I couldn't reach the man by phone, so I sent a telegram to his address in a far western state.

Several weeks went by before I received a return call from a pay phone.

He worked for a government contractor, he said, one of those employees of American companies who spend most of their lives out of the United States. Yes, he said, he had lived with a Vietnamese woman, had a child, and when the end came in 1975, had promised to send for her from the United States. That, he regretted, had never happened. The reason was not as touching as our previous veteran's. This man had met another woman in the States and married her without mentioning the Vietnamese child. That's why he was calling from a pay phone.

Then he revealed the real reason he had responded to my telegram. He had just undergone open-heart surgery and, being so close to death, he was taking stock of his life. His thoughts had focused on the child in Vietnam. Gripped by guilt, he said over the telephone, "I may not have long to live, but before I die I want to see my child one more time."

He would not leave his telephone number but promised to contact me when his recovery had progressed. I never heard from him again.

From Oregon, a veteran called inquiring about an older child he had seen in the report on the CBS Evening News. His story was a bit different. He had returned to the United States and begun a family here; in fact, he had four children. But he remembered a child, an orphan, just outside a firebase north of Saigon. He and some other GIs had left the base often to play with the children or take them toys and gum. He thought perhaps the little girl he had known had grown up and could have listed his name in an attempt to get out of the country. He had discussed the matter with his wife, and his family agreed that they would help her if they could.

A woman called from Tucson, Arizona, where she had moved after getting a divorce. Her husband had been in the Air Force and she had lived with him in Saigon for several years. During this time she and a Vietnamese woman had become good friends, as close as sisters. She identified the mother of the first child I saw as that woman. The

lady from Tucson was positive, although she could not remember whether the woman had an American boyfriend. She suggested the woman was not the mother but merely caring for the boy, Ha. "Could you get her out?" she asked, and offered to take her in—along with her five children.

These were typical of the responses to the plight of the children in Vietnam. Thousands of men were never heard from, of course, and who could really blame them? They had started new lives and had put the Vietnam experience behind them. But from these other men—well, they had fallen in love with Vietnamese women. That chapter of the war never made it home to the United States. After all, Vietnam was, in the words of the eloquent American soldier, "another world."

The last part of this story is still being written. It provides an excellent example of how journalism can inspire action, or give encouragement to those already trying to solve a particular problem.

The discovery of the problems of the Vietnamese-American children splashed across the country through television and print media, falling upon sympathetic eyes and ears. Among this fertile audience were people who had long been interested in the problem. The Pearl S. Buck Foundation was established in 1964 strictly to help Amerasian children. In fact, the very term "Amer-Asian" was coined by Pearl Buck in 1930 in her first novel, *East Wind, West Wind,* to describe what she felt was the most beautiful blend of races in the world, God's mixture of the best of the Occident and the Orient. She felt these children had much to give the world and was deeply hurt at their troubles in Asia. Her foundation became part of an interlocking network of concerned individuals and groups who began independent efforts leading toward the release of the Amerasian children of Vietnam.

Legislation was introduced in the House of Representatives by Congressman Stewart B. McKinney, Republican from Connecticut, to allow Amerasian children special preference among the immigration quotas. He was working to build a list of cosponsors to insure passage. The Vietnam reports helped immensely to raise public awareness and encourage telephone calls and letters to congressmen. Also effective were lobbying efforts by the Pearl S. Buck Foundation; by Father Alfred Keane, a Roman Catholic missionary who traveled the country on behalf of Korean-Americans left behind by American soldiers in that country; and by Jodie Darragh and her husband from their home in Marietta, Georgia. After reading my article in the *New York Times Magazine* and seeing the documentary, Darragh, a former stewardess, established Americans for International Aid to provide support for getting the children out. Aided by Vietnamese-American Dr. John Levan of Skokie, Illinois, the group raised money, sponsored flights into Saigon, and supported Father Keane in the United States so he could make appearances on television and in parishes across the country. The story was percolating.

By July 1982, activity was strong enough to convince the Vietnamese that there was sufficient interest in the United States for them to make an offer, one we couldn't refuse. Foreign Minister Nguyen Co Thach announced that his country was ready to let the 8,000 children fathered by American GIs during the Vietnam War move to the United States. "I mean all of them," he said.

The Vietnamese motivation is unclear. Perhaps they thought this gesture of goodwill would be an excellent way to signal their desire for renewed relations with the United States. I think it amounted to that. I suggest the timing was brought on by the Vietnamese "paranoia" concerning China. Their differences with the Asian giant clouded all their actions, and it was a good time to play their Amerasian card.

The first release, of 11 children, took place on September 30, 1982, and representatives of private agencies happily flew to Ho Chi Minh City and then accompanied the children to Bangkok. It was just the beginning. The U.S. Embassy in Bangkok has files on 3,740 Amerasians who still want to leave Vietnam, and it estimates that the total number who want to get out is between 8,000 and 10,000. Some estimates put the number closer to 25,000.

I wish them all Godspeed.

The Rice Lift

The most frightening experience I can recall was also the most exhilarating. Time has a way of smoothing near-disaster into adventure.

It began as one of the hundreds of stories played out during Saigon's final days, in April 1975. American cargo jets were transporting rice from Tan Son Nhut Airport, near Saigon, to the Cambodian capital of Phnom Penh, under siege by Khmer Rouge Communists.

Like the Berlin airlift of 1948–49, the effort was keeping a city alive. There were some differences. The modern jet liners could carry 50 tons of rice apiece and were landing under hostile rocket fire, certainly a far cry from the air bridge into the German city. And unlike the much-heralded Cold War defeat of the Soviet Union's attempt to isolate Berlin, the rice lift into Phnom Penh would soon be forgotten as a futile attempt lost in the Communist sweep of Southeast Asia.

It took two long evenings at the Caravelle Hotel bar drinking with the flight crews of the rice planes to persuade them to violate company policy prohibiting ''ride-alongs'' on the dangerous missions. But finally I managed to talk myself aboard one of the DC-8 jets and get a seat on another plane for my father, who had accompanied me to Saigon.

The main object of my attention was a flight engineer named Salty Walls from Hammond, Indiana, who along with the other volunteers aboard Flying Tigers, Seaboard, and World airlines seemed to be enjoying the danger. Most of the old-timers were chasing the ''high'' of combat experienced during World War II. The younger ones were trying to garner some seasoning of their own to match the veterans over coffee during those cold layovers at Chicago's O'Hare Airport.

I found the Flying Tigers jet moored on the Tan Son Nhut flight line, riding the heat waves shimmering off the concrete ocean at high noon. A Vietnamese crew of cargo handlers was laboring with large wooden pallets packed tightly with sacks of rice, lifting them aboard spinning rollers, then pushing them far inside the seemingly endless cargo hold. They called these DC-8s Stretch-Eights because their silver fuselages seemed to extend forever.

It took more than an hour to load the rice, an amusing fact when compared with the unloading time—nine minutes. The difference was motivation. The workers in Phnom Penh lost one man a day to exploding shrapnel from enemy rockets lobbed toward the airport. The longer it took to unload the longer they were exposed.

Salty's crew seemed glad to have my company and jovially handed me a flak jacket and steel infantryman's helmet. It suddenly put everything into a combat perspective. Salty flashed a big grin as he tried to snap a protective vest over his large protruding stomach. The vest was short by

Salty Walls, at right, in the cockpit of the Flying Tigers jet headed for Phnom Penh with a cargo of rice. He was one of many World War II veterans who volunteered in 1975 for these missions to the Cambodian capital, then under siege by the Khmer Rouge.

about six inches. He shrugged and said, "Things have changed since World War II."

The whine of jet rotors turning over sent the handlers scurrying out of the plane. We were under way before Salty had even closed the side hatch.

American air-traffic controllers had left Tan Son Nhut, and the result was a mess. It wasn't that their Vietnamese counterparts were that bad, but even the most experienced would have been challenged by the various kinds of aircraft making demands on the airspace. Giant C-5A air transports were followed by fully armed propeller fighters heading north to support South Vietnamese troops, which were trying to hold off the inexorable North Vietnamese advance.

Into this chaos we ventured, all eyes searching the skies for stray aircraft. Pilot Don Edwards pushed his right hand forward on the throttle and the plane lumbered forward like a battleship on wheels, trying to pick up speed but having a lot of difficulty. She shook and rattled and protested with disquieting noises of metallic strain until she finally allowed her nose to lift into the air. Then, with the greatest reluctance, the rest of her aching body followed.

Green palms passed under us, then sampans on a river and the brown of harvested rice fields. We were up to stay. There were a hundred pictures to get, and I was schizophrenic trying to adjust the exposure on my film camera from the harsh f-16 of the outside light to a wide-open 1.6 f-stop inside the cockpit. I wanted to get the droplets of sweat that poured down the copilot's temple.

Salty put a hand on my shoulder and shouted above the engine,

"Should be OK for a while, 'bout half an hour."

The scars of war were visible below in the miles of crater-pocked landscape that followed the Mekong River northwest to the Cambodian border. That was our reference path as well, our highway into Phnom Penh.

"Takes about as long as a flight from Chicago to Peoria, about 30 minutes!" Salty yelled. His steel helmet bounced with emphasis as he spoke, his chest full of hair heaved and struggled between the zipper edges of the protective jacket. "We were told to watch for a SAM missile base up north, but we've had no trouble so far. But every trip, we keep looking."

I needed close-ups of the pilots, and pictures of the terrain and the cargo hold packed with rice sacks. I let a tape recorder take in the ambient sounds of the cockpit and flight radio.

It seemed only a few minutes before the pilot was cutting power and banking to the left over the Mekong as it cut through the center of the capital. "That's the palace over there," he pointed, "and the racetrack." He gestured with his head toward a large blown-out bridge and one of its spans lying in the water. "That last span went the other day," he said. "Sappers got it." Near the banks of the river, a freighter lay on its side, exposing its rusted iron bottom to the sun. I zoomed the lens down toward the ship and could pick out frail brown people moving in and out of the stern.

The pilot leaned back to tell me, "We don't want to abort this first approach. That exposes us to ground fire on the other end of the runway. The Khmers advanced last night and we don't know but what they just might be near those trees," he said, pointing to a stand of eucalyptus and rubber trees at the far end of a strip of white pavement.

Flaps were hydraulically extended. Wheels lowered. The air drag cut our forward speed until it seemed we were hanging in the air waiting for the landing strip to come to us. I peered over the pilot's shoulder and felt the heat from his perspiration. We were all wet with sweat, and my eyepiece needed constant wiping. The seconds were suspended as we waited for the familiar screech of tires on pavement. Instead, the radio spit out the news that the plane scheduled to leave before we landed hadn't been cleared yet. "Damn," went the cry. It meant another pass. We were so close, just a few hundred feet off the runway. Full power.

We seemed so vulnerable, our huge bird turning slowly in the sky without the security of speed or altitude, awkwardly sliding into another lazy circle around the airfield, all the while exposed to ground fire. It didn't come.

Within 60 seconds we were again dropping rapidly toward the earth, landing roughly with an impact that threatened to tear the plane apart. The copilot turned around, professionally embarrassed, and said, "It may not be pretty, but we're here."

We taxied past a burned-out cargo plane that had been hit by rocket

fire several days earlier, then turned toward a small hut of corrugated iron barely peeking out behind a hill of sandbags. A tall American in a purple jump suit stood with his hands raised, waving us in as the Cambodian workers rushed to unload.

"Bravest men we'll see today," Salty said, referring to the skinny young men who clambered inside the aircraft like buccaneers raiding a brigantine. The pilot added, "That's the Purple People Eater," looking at the smiling giant behind sunglasses who was holding both thumbs in the air. "He's a crazy son of a bitch, gonna get the hell blown out of him one of these days. He just keeps standing out there. There was a rocket in here just five minutes ago."

The pace was fast. Both pilots kept their hands on the controls and the engines fully powered. That was one reason our position was so dangerous: The sound of incoming rockets couldn't be heard over the high whine of the jet engines. "Don't get off the plane, unless you want to stay," they yelled at me. "Don't worry!" I answered.

We were there nine minutes—not eight or ten, just nine minutes. The plane turned away from the man in the jump suit even before the hatch had closed.

There was a moment's delay for a Cambodian fighter to taxi by. I could see Cambodian soldiers run behind the traffic-control hut to hunch behind the protection of the sandbags.

Then, when we were only a hundred yards from the main runway,

I photographed the cargo hold of our DC-8 just after we took off from Saigon carrying 50 tons of rice. Handlers spent an hour loading these pallets in Saigon but only nine minutes taking them off in Phnom Penh, where our aircraft was vulnerable to enemy fire.

Salty shouted, ''Rocket to the left!''

A plume of dirt still hung in the air as my camera rolled. The rocket had landed only 30 yards away, eerily, without sound.

''That's what they look like,'' Salty said. ''First time under fire?'' No time for an answer. We slipped onto the main strip and picked up speed with the lightness of a Piper Cub. The absence of the 50-ton payload gave the craft new life, and she lunged forward like a stallion anxious to get back to the barn. We cleared the runway within seconds and banked to the right to avoid the run over dangerous territory, reaching for altitude to escape ground fire. I knew we were there when the pilots loosened their jackets with a holler of relief.

There's an exhilaration in cheating the devil, a cockiness that sets in with false assurance. The flight was not yet over.

During the 30-minute trip home I relaxed, taking casual shots needed to complete the story: activity within the cockpit, relief shown in the easy smiles and conversation as the three men lapsed into stories of past close calls. Before I knew it the time had almost slipped by and I still needed a picture of the empty cargo area, an ''after'' shot to illustrate going home. So I unhooked my seat belt and moved through the cabin door into the empty hold. A net stretched between ceiling and floor as a safety precaution against a loose load sliding toward the cockpit. I rested my camera in it for stability, while I snapped a few shots.

What I could not see ahead was the chaos of the Tan Son Nhut air traffic. We were seconds away from a near-collision in midair with another jet beginning its rice run to Phnom Penh. The pilots heard no warning on the radio; their first signal of anything wrong was the sight of a huge Stretch-Eight looming in front of them. Reacting swiftly, they plunged into a drastic dive.

Suddenly I was lifted into the air, suspended in a weightless state. I had no idea of what was happening, but I grabbed the cargo net and pulled myself down. Images flashed through my mind of astronauts moving weightlessly in their space labs. There were other images, too, of being splashed off the plane's bulkhead.

As I gathered my senses enough to crawl back into the cockpit, it was obvious that the crew was not thinking about me. Salty's face was splotched with red, the copilot was cussing wildly, and the pilot said nothing. It was still quiet as we landed and the jet engines whirred quietly to a stop, and probably five minutes had passed before the pilot broke the silence by apologizing for the sudden dive. ''It kinda gets crowded up there sometimes,'' he said.

Perhaps later, at the bar of the Caravelle Hotel, the men would let the conversation drift across beers to this story, and it would be embellished over years of retelling.

And sometime, during their elaboration of that moment, one of Salty's crew just might wonder what happened to that crazy journalist caught in the empty cargo hold of their Stretch-Eight.

Dateline: San Salvador

Focus: Looking for answers in a

land turned upside down

by death

The priest who walked away

From the distant perspective of the continental United States, El Salvador's bloodletting seemed almost innocuous in the spring of 1981, perhaps diluted by the torrent of violent headlines in our media-rich lives. But once I was there, the country became a horror, its tragedy truly comparable to the most savage human slaughters in history.

We found nothing extraordinary about San Nicolas de Soyapango, just a collection of pastel stucco houses crowding a few rocky streets outside the city limits of San Salvador. Women carried children slung on their backs; some shooed them away from their skirts like chickens as they weaved a day's toil preparing tortillas and beans. The men, if they were lucky, had jobs in the capital.

Until April 7, 1981, Soyapango would have easily fit the Central American stereotype in which the pace of life never moves faster than a walk and most of the excitement comes from the loud radio entertaining the out-of-work hombre fixing his car in the dusty street. But after that date, it became a place of fear where the residents spoke in whispers about the massacre of Soyapango.

I had seen the first accounts reprinted from a copy of a San Salvador newspaper, the *Diario El Mundo*. It reported that 21 bodies had been found lining the streets in the dawn. The account was terse, cloaked in the unrevealing form of an official

report: Treasury Police, an arm of the government security forces, had encountered a group of guerrillas holding a cell meeting in a home. Asked to surrender, the guerrillas refused and began shooting with police. The result was 21 dead, all civilians, their bodies left bleeding in the talcum-fine dust.

Two weeks later when we looked at the home where the shoot-out allegedly occurred, there were indeed bullet holes chipped into the wall. But when we mentioned the official report the residents suggested it was untrue.

Amnesty International later pieced together a sequence of events on that April night. According to its information, 30 uniformed Treasury Police drove up to a house in another area, the Guadalupe district of Apopa, in three Toyota pickup trucks. A group of them pushed aside a table being used as a door at the home of Luis Alonso Quintanilla Perdomo. He was asleep inside with his wife and eight children.

The police shouted insults as they dragged the father from his bed and threatened him. ''Get up, you son of a bitch!'' they yelled. ''Show us your papers! We are the armed forces.''

They accused the family of being guerrillas and demanded that they surrender their weapons. About 12 policemen ransacked the house, ripping open cushions and pillows, even searching the toilet, looking for guns. One of the young boys told his brother that he was going to escape so the entire family wouldn't be taken, but as he ran from the back door the police turned on a searchlight, which alerted those standing outside the house. A burst of machine-gun fire killed him.

Luis Perdomo and his eldest son were shoved outside into the street. The father, wearing only undershorts and socks, asked if he could put on his pants. The officers refused. His wife watched from the house as the police pushed the father and son, their thumbs tied behind them, into one of the pickup trucks. Then the trucks pulled away into the blackness.

Mrs. Perdomo huddled inside their home with the remaining six children, afraid of the two policemen left behind to guard the house. At dawn, the end of curfew, she went outside to look for her murdered son. She found his body not far away, with bullet wounds in his left cheek, nose, ear, and right leg. His brains were exposed through his crushed skull. A watch had been taken from his arm.

By evening, a friend informed Mrs. Perdomo that the bodies of her husband and son had been located in the El Recuerdo funeral home, ripped to pieces by gunshots fired into their backs. Theirs had been among 21 bodies scattered along the streets of Soyapango. The others, Mrs. Perdomo told Amnesty International, ''just as my husband and son . . . had been taken from their homes, moments before they were killed.'' Other residents of Soyapango confirmed to Amnesty International that the victims had been dragged from their homes and had not engaged in a shoot-out with the police.

Noting the conflicting accounts, the U.S. Embassy asked for an investigation.

As much as any single incident can, the massacre at Soyapango tells the story of El Salvador, a tale of wanton murder. About 35,000 people in this country of 5 million have been killed since 1980, some, of course, in the guerrilla war by rebels. But the overwhelming majority of deaths have been caused by a bizarre assortment of right-wing military groups in the name of fighting communism. These men kill without question or mercy, slaughtering men, women, children—their fellow countrymen and fellow Christians—and leaving their mutilated bodies as warnings to anyone who might think of joining the rebel movement.

So I found myself on the streets of Soyapango, having traveled to El Salvador to find out whether a government supported by the United States was responsible for such genocide.

From the distant perspective of the continental United States, El Salvador's bloodletting seemed almost innocuous in the spring of 1981, perhaps diluted by the torrent of violent headlines in our media-rich lives. However, there is a point at which we cannot ignore the stories from far-off lands. That point came when El Salvador began to

bear an unsettling resemblance to Vietnam, although incidents like the Soyapango killings made the Salvadoran government appear far more repressive and brutal than any of the regimes in South Vietnam.

Looking down at the spot where the bodies were found in Soyapango, thinking about the witnesses' accounts, I remembered the stories I had heard in Chicago, from church workers and political action groups, of bodies being found in ditches and fields every morning. When it came to assessing blame, however, without investigations or trials, a hazy question mark hung over the affair. That hesitation had drawn me to El Salvador, to find out who really was killing the people.

I had also come to get away from stress. No matter the 22,000 deaths in 16 months reported by United Press International, the guerrilla attacks, the paramilitary death squads—I wanted a vacation. I had just completed three months of intense battle with ABC News over a documentary produced at WBBM-TV, Chicago, by Scott Craig and Molly Bedell called "Watching the Watchdog" in which we accused ABC's investigative news team

of professional misconduct. They reacted with their own charges against me. It had been grueling for both sides, and I was looking forward to getting away from the tension. Even a trip into the heart of darkness was a welcome respite from the pressures in Chicago.

My producer, David Caravello, organized the trip, and we planned to put together a half-hour documentary after our return. David also arranged for an interpreter, Father Roy Bourgeois, a Catholic priest of the Maryknoll Order. David had checked with me about his qualifications, which included service in Vietnam as a Navy lieutenant and an active role in protesting U.S. involvement in El Salvador.

If I had questioned further at the time, I would have learned that Father Roy also had participated in a sit-in against the U.S. role in El Salvador at Chicago's Holy Name Cathedral in which several people were arrested, including Bourgeois. In my stupor resulting from the investigative reporting dispute, I heard only two things—that he was a priest and a Vietnam veteran. I hold both in such high regard that I immediately thought it would be

Members of the National Guard patrol the village of Suchitoto, northeast of the capital. Part of a garrison ordered to protect the town, the soldiers frequently find themselves under rebel fire.

a perfect combination. I also trusted David to make the judgment call on whether Father Roy should come along. The rest just slipped by as minor roughage in a résumé.

In the spring of 1981, David and Father Roy flew into Mexico City to check in at a headquarters maintained there by Salvadoran rebels. It had become a routine stop for journalists, and David was hoping to make contacts that would allow us to meet with and tape guerrilla factions behind the lines. As part of the screening process, he asked about the emotional climate in El Salvador and the chances for trouble if we brought Father Roy there. Priests were regarded by some right-wing groups as revolutionaries in white collars, evidenced by the murder of three Catholic nuns and a Catholic lay worker, all Americans, in December 1980.

As a further precaution, David went into El Salvador alone to check with reporters about whether there had been any recent attacks on the press or the clergy. The scene appeared calm, and he telephoned me from the capital to recommend giving the go-ahead to Roy, who was waiting in Mexico City. I agreed. Roy would fly ahead and we'd all meet in a couple of days.

El Salvador is only the size of Massachusetts, almost surveyable in a single approach of a jet liner. As we descended from Miami I saw range after range of mountains, cut by deep canyons of naked rock and dry twisted vegetation—*mala hierba*. Farther south, the crags fell away into a carpet of green that stretched its patchwork of coffee and sugar cane fields down to a white-bordered, deep-blue Pacific.

A common first impression of El Salvador is that of a peaceful and tropically beautiful country where food is plentiful and life is easy. Unfortunately, that impression is deceiving.

It was evening when David picked me up at the airport. With Skip Brown and Phil Weldon in from San Francisco, the old team from Iran was back together. We could almost pick up conversations left 12,000 miles away, in an opium district on the other side of the world.

I was surprised to learn that the capital was at least a 40-minute drive away. The airport was stuck on a chopped-off mountaintop and connected to San Salvador only by a winding road through heavy foliage, perfect for ambushes. David was anxious to get into the city before dark. I felt a Vietnam mentality settling in as we mentioned curfews and possible ambushes.

"Qué pasa, señor?" I asked jokingly from the passenger's seat as the blue van dodged gaping holes in the asphalt.

David spoke first. "The rebels will stop traffic and collect revolution fees. Usually they don't kill anybody, at least in most cases, but it's unnerving anyway."

"Any surprises?" I asked.

"I think you'll be surprised, all right. Things are much worse seen from the close proximity down here."

"You mean it hasn't sunk into us in the States yet?"

"You could put it that way," David said. "It never does, does it, until American boys start dying. We could do all the stories in the world and people wouldn't really wake up to the issues here until marine green started coming home in body bags."

I was sleepwalking through the conversation, agreeing with David but realizing I wasn't familiar with any of the issues. I knew journalists had been killed and bodies were turning up every day in ditches, but beyond that my knowledge was probably that of the average American—limited.

"So who is doing the killing?" I asked. "And don't give me the liberal line from some sixties handout."

"From all indications, at least from everyone you talk to, the military is killing the most, but since there are no inquiries made by any judicial system there is no hard evidence. And people are so scared that even if there were some tribunal to give testimony before, it would be difficult to get them to show up."

"So what do we do?" I asked.

"Well, let's link up with Father Roy and just start in tomorrow. I've got a busy day scheduled with lots of shooting and interviews; then we can

see where we are.''

''Terrific. On to Father Roy!'' I urged as the headlights cut through the dust and dimness settling upon us. We rushed by donkeys, carts, and peddlers from another age, moving on as if nothing unusual had ever happened, pacing along with one goal: to make it to tomorrow.

Most of the foreign journalists were staying at the Camino Real Hotel, a modern white structure surrounded by bougainvilleas and palm trees in the middle of San Salvador. There were so many newspeople gathered in the lobby and lounge area that it reminded me of a reporter's convention. All the major papers were covering the story, as were the television networks, which rented suites that they transformed into bureaus, complete with teletype machines with both Salvadoran and American news, and banks of electronic gear to keep in touch with the crews.

Roy was sitting at a table full of journalists having dinner when we arrived. At first I mistook him for an assistant cameraman, for there was no evidence of a priest's collar: He was wearing jeans and a knit T-shirt. His hair was curly and closely cut, giving him a boyish appearance that seemed out of character for a priest. Most of all he was quiet in that setting and let the others carry the conversation about who had been hired and fired, reminiscing about the days of Vietnam and comparing hotels. He may even have disapproved of some of the remarks, since, as Australian journalist C. J. Koch observed, at gatherings of foreign correspondents '''concern' is paraded as feeling, and in-jokes as a substitute for understanding.'' But if he did he gave no hint of it.

And there was nothing to provide a clue that within 48 hours our investigations in El Salvador would be sidetracked and our efforts focused instead on this quiet young man.

It was a short night of reunion for the old team, although a few beers were lifted in honor of being in a new country. David retired early to check his shooting schedule for the next day while Skip, Phil, and I roamed the rented suites to say hello to such old friends as Steve Patton of Bangkok and David Miller, CBS News Rome bureau chief on temporary assignment. Most of the networks had to cover the story as local stations back home might cover fires, running from explosion to explosion as terrorist bombs went off around town. Because we were putting together a special report rather than filing daily updates, we had the luxury of time and an extended deadline. Hence our relaxed mood.

As we sat beside a large swimming pool behind the hotel, the aroma of tropical flowers was strong in the sweet warm air. There was casual conversation heard between songs of a small combo playing near the pool. Yes, I thought in the peaceful setting, it was a pleasure to get away from the pressures of Chicago.

In the pattern of most trips, you start the first shooting day with the unbridled enthusiasm of a teenager (even though I've been separated from those years by a few decades). The excitement comes from a curiosity about what you're going to see, the adventure of assembling pictures to tell a story. Some days you get everything you've planned, other days you get bogged down. But you always start strong, looking through the fresh eyes of a newcomer, soaking up everything with a wonder that writes it indelibly on your brain.

Our first stop was Soyapango, the site of the recent massacre. Roy led us down the dusty streets and talked with neighbors about the shootings. Most of them had heard the gunfire that night and had run inside. But, contrary to the official report, they said that the man in whose house the government claimed to have surprised a guerrilla meeting had no involvement with the rebels.

Children played in open doors, and a slight breeze lifted the thin curtains in the unscreened windows. A large black pot of beans boiled above an open fire. Small children stopped their play to follow us until we reached the end of the street, where a young woman paused to speak with us in Spanish. Roy relayed our question and then her response.

Yes, she had heard shooting on April 7, and the next morning she saw the 21 bodies lying in the street before they were taken away. No, she did not know the people, they were not from the neigh-

borhood. Who shot them? Roy asked. The woman turned away.

The knowledge of what had happened here created a chilling fear, turning the lazy atmosphere into one of terror. Though the sun was moving toward its midmorning position, the brightness seemed only to highlight the horror of weapons and murder. Flashes of images walked with us, magazines being jammed into rifles, gunshots kicking up the stucco walls. I decided we should move on before the local police were alerted, for whatever reason.

We drove to the grounds of a seminary that the Roman Catholic Archdiocese had turned into a refugee camp. Here campesinos, or peasants, who had fled to the city huddled inside makeshift dwellings. A few who had covered their frame shelters with plastic, wood, or thatch turned toward other activities to keep themselves busy, weaving bracelets or rings to sell to tourists. Nuns cared for a steady stream of peasants who ran from the killing in the countryside.

We spoke to a few campesinos, letting the camera capture the feelings in the frightened brown faces, their skin taut against their cheekbones.

"We can read the Bible here without fear," one woman said when I asked her why she had come.

"The Bible?" I asked. "Is there a problem with reading a Bible?"

"Yes. If the security forces find a Bible in a home, they know you are Christian and could be a Catholic. They say that Christians gathering in groups to pray are political, planning guerrilla war. So because you own a Bible they will arrest you and maybe kill you."

"Who is killing the people?" I asked.

"Guardia Nacional."

Most of these people came from parts of the countryside where fighting between guerrillas and government forces had destroyed any hope of a peaceful climate in which they might raise sheep or cattle. They had seen the guerrillas but named the National Guard as the force to be feared.

I would later think of these simple people when President José Napoleón Duarte said of the left,

"They were very clever. They tried to create an image that they were protecting the people from repression when the National Guard was killing." Were these poor families in the refugee camps unwitting participants in a rebel public-relations campaign or were they telling the truth?

I had seen refugee camps in Southeast Asia, Nicaragua, and Africa. They all had similar features: a central water supply, rows of shelters in which to sleep, and a team of cooks, usually women from the camp population who took turns making the meals. Beyond that there was little that could be done except provide medical care. The only bright moments this place provided came from the children, whose smiles persisted even in the most slovenly areas, a spirit of hope emanating from the smallest.

I felt sympathetic as I walked through the camp—who wouldn't?—but I was there as a reporter, trying to record the problem so I could communicate it to others who might help. I wondered how Father Roy was being affected by the experience. So far he seemed composed, and his translations had the ring of truth; but a priest would feel a very close bond with these people, especially if he had dedicated himself to the cause of the poor, as Maryknoll priest Roy Bourgeois had done.

Skip and Phil, meanwhile, were soaked with sweat. They always work the hardest, gathering actual pictures to tell the story, and when they signaled that they had finished, we left.

It was just a few blocks' drive to the Legal Aid Office of the Roman Catholic Archdiocese of San Salvador, where a small staff kept records of the killings in an unofficial body count that was updated every day. The government also offered a running count of deaths, but few had much faith in these figures. A small cinder-block building behind the office housed a few desks and steel files full of personal records, the closest these volunteers could come to drawing a picture of the people who had been killed. Their task was to identify each body and record the cause of death. Theirs was neither an investigation nor an accusation, but simply an accounting so someone would remem-

ber. It was from this independent source that figures told the escalating tale of death: 1979—1,000 people killed; 1980—between 8,000 and 10,000 killed; 1981—9,000 deaths in the first five months of the year.

David had set up an interview with a pleasant-looking woman who was waiting for us under a tree outside the building. In her eyes she carried the moisture that is born of extreme grief, a moisture I imagined never disappeared. She clutched a white handkerchief tightly in her hands. A beautiful child of about 7 clung to her side, dressed in a soft polka-dot dress and staring at us with dark eyes the size of quarters.

Through Roy's interpretation, the woman told us how her son and husband had been taken from their home several weeks before by military forces. Her husband was still missing. She had found her son dead, his face caked with mud, his body bearing the signs of mutilation. She handed Roy the black-and-white photograph taken of him in a morgue by Legal Aid members.

The picture was among others provided by the office that showed dismembered bodies. Heads had been severed, and often left in grotesque positions along the road to frighten civilians. Limbs were cut off. Automatic weapons had been used to gouge gaping holes in the flesh, again with the clear intention of terrorizing the populace. The message was apparent: Don't even think of joining the guerrillas or this might happen to you.

Roy shuffled the pictures in his hands and passed them on to us. They were frightening, the worst I have seen.

Why had her husband been chosen for death? I asked.

"Because he was in a labor union."

"Why would he be killed for being in a labor union?"

"Labor unions confront the powerful families that own most of the land," she replied. "It's always been that way in El Salvador."

A picture of the violence was taking shape. It extended beyond the killing normally associated with civil wars or guerrilla fighting. In El Salvador, people were killed for owning a Bible because they

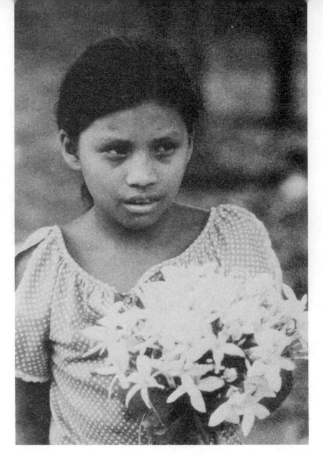

One of many children in El Salvador whose relatives disappear, victims of unexplained violence. This girl's father was dead, her grandfather missing.

were presumed to be meeting for rebellion instead of prayers, for belonging to a labor union that might represent leftist ideas, or for just being young and fitting the profile of a would-be guerrilla who might emerge from the ranks of students and youth groups. Young people were tempted to join the left, weren't they, and wasn't that reason enough for some right-wing death squads? There seemed to be no middle ground. One would assume the jails would be overflowing during such a campaign of repression, but they weren't. Most political prisoners just didn't make it that far.

Again I asked the same question, "Who is doing the killing?"

"Guardia Nacional."

Ironically, El Salvador's cycle of brutality is believed by many to be remotely tied to Russia's Bolshevik Revolution.

During the 1920s, the revolution spread its spirit around the world, even to the workers in Central America. Here, farmers worked land that had been seized from them by governmental decree some 40 years earlier and given to about 14 large families on which to grow coffee for export.

In 1930, eighty thousand workers and peasants marched in San Salvador demanding minimum wages and unemployment benefits. They gathered under the umbrella of the Salvadoran Communist party, which united the leaders of many of the local unions. Two years later, in the middle of the Depression, the party called for uprisings against the military rule, which was supported by the powerful oligarchy.

To put down this rebellion, led by Agustín Farabundo Martí, the Salvadoran Army turned its arms on the peasants in what was to that time El Salvador's most agonizing moment. Four thousand farm workers were killed when they marched unarmed into the cities. A massacre had begun. Within a matter of weeks, Army and paramilitary units killed close to 30,000 people. Peasant leaders were hanged in the squares, and the Communist party was decimated.

Through the years the dictatorship did not change, nor did the firm grip of the handful of families who controlled the export crops, although they now numbered more than 14. The military ruled the country through the presidency, and the oligarchy manned the cabinet, holding responsibility for governing the nation.

There were attempts to form political parties and even attempts at free elections, but the military was extremely reluctant to give up its power.

Fearing another peasant uprising, the regimes suppressed any attempts to organize farmers and the poor in the countryside, preserving what amounted to serfdom. The military created a paramilitary antirevolutionary organization called ORDEN, the Organización Democrática Nacionalista, a kind of military reserve scattered throughout the country. By the late 1960s it was well in place as a network of clandestine informers that covered every village and town.

The military rulers offered special privileges as enticement to join. Favorable credit, permanent employment, hospital beds, and free admission to schools were made available to ORDEN members. In many cases it was the only escape from poverty. The members, in exchange, reported any attempts at subversion and eventually began to carry out killings, taking the law into their own hands. By 1970 there were nearly 100,000 ORDEN members, enjoying what little clout they could derive from serving the military regime. A special killing machine had been created, a government-inspired mafia that operated at the whim of regional commanders of the Army or even directly for the oligarchy.

When the time came for severe antirevolutionary measures, ORDEN was ready. In 1978, ORDEN and the military factions of the extreme right wing (which also included death squads operating in collusion with the Army and National Guard, some of whose members dressed in civilian clothes to maintain anonymity) were engaged in violent conflict with several leftist groups. The number of murders and kidnappings began to escalate, as if the first tragic events dulled the senses and made even more brutal incidents possible, indeed routine.

Tales of horror mushroomed. Refugees told of babies bayoneted, pregnant women having the fetuses cut from their wombs, hundreds of peasants slaughtered in a single incident. The massacre of an estimated 600 people trying to reach the safety of Honduras in May 1980 was reported by Rev. Earl Gallagher, a Brooklyn-born Capuchin priest who witnessed two helicopters of the Salvadoran National Guard, along with ground troops and ORDEN members, cut down the refugees crossing the Sumpul River.

In April 1981, Salvadoran Army Capt. Ricardo Alejandro Fiallos testified before the Subcommittee on Foreign Operations of the U.S. House Appropriations Committee. "It is a grievous error," he said, "to believe the forces of the extreme right, or the so-called death squads, operate independent of the security forces. The simple truth of the matter is that 'Los Escuadrones de la Muerte' are made up of members of the security forces, and

acts of terrorism credited to these squads, such as political assassinations, kidnappings, and indiscriminate murder, are in fact planned by high-ranking military officers and carried out by members of the security forces.''

Yet even after the countless incidents of terror, including the public assassination in March 1980 of Archbishop Oscar Arnulfo Romero during a church mass in San Salvador, it is often difficult to establish a connection between anonymous right-wing death squads and elements of the military.

There are exceptions, however.

Sitting with relatives of victims of such terrorism in the small yard adjacent to the Legal Aid Office, I was handed some photographs that, according to the Legal Aid representative, linked a death squad responsible for the killings of two young Salvadoran men to the National Guard.

A newspaper photographer had been across the street from the Family Banking Center in San Salvador when he took the black-and-white pictures of 22-year-old Manuel Alfredo Velasquez Toledo and 24-year-old Vinicio Humberto Bazzaglia. The photographs showed the young men being arrested and questioned by the National Guard, their thumbs tied together behind their backs. In the next sequence of pictures they were turned over to men dressed in plain clothes, who put them in the back of a pickup truck and drove away. According to the Legal Aid Office, these plainclothesmen were members of a death squad closely tied to the National Guard.

Eight days later, the wife and brother of Vinicio Bazzaglia identified his body, which had been dug from a shallow grave by the side of a road in the hamlet of El Ranchon.

The mother of Alfredo Toledo confronted the director of the National Guard, Col. Eugenio Vides Casanova, with the photographs. He reportedly identified the pickup truck as belonging to the National Guard, but no prosecutions resulted.

Violence is also caused by the left, of course, but many authorities say they believe the vast preponderance of deaths occurs at the hands of rightist groups allied with the military, a legacy of El Salvador's brutal past. The National Conference

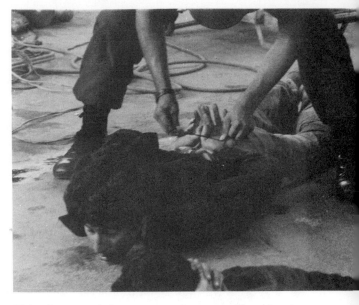

This picture and the one opposite were offered by the Archdiocese's Legal Aid Office as proof of a link between death squads and the National Guard.

of Catholic Bishops also shares this belief and therefore officially opposes U.S. support of the Salvadoran government.

The atmosphere at the Legal Aid Office, where the volunteers bent to their morbid task of identifying bodies, was funereal. Our shooting had amounted to a terribly emotional and tiring day. Father Roy had been with us interpreting at every step, in effect probing this society as an archaeologist might cut deeply into the soil, layer by layer, sifting each small shard, dusting it off to get a picture of the people and the culture in which they lived. Sometimes such a quick immersion can be traumatic, especially for someone not accustomed to flitting from story to story, extracting the essence and moving on to the next scene of despair.

For Roy, the poverty and desperation suddenly became a three-dimensional reality. In the sweat of a midday visit to refugees where the air was heavy with the smell of tortillas cooking beside pots of beans, where children ran barefoot among emergency huts made of thatch, where anguished voices over and over called to him for help, how

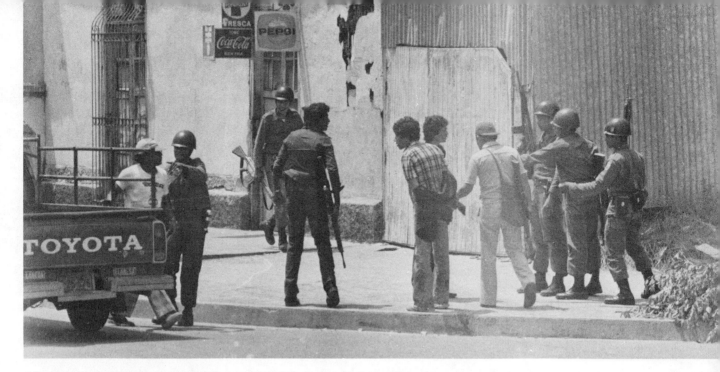

After the National Guard arrested them and tied their thumbs (opposite), two young men (at center, above) were turned over to plainclothesmen in a truck, allegedly members of a death squad. The body of one of the youths was later found in a shallow grave; the fate of the other is unknown.

could he turn his back? Roy had become a priest to help people like these, and I might have sensed that showing him the immeasurable torment of El Salvador was like lighting a fuse within him.

Back and forth we traveled that day through the streets of San Salvador until they became familiar. Some sights were strikingly American, especially the shopping center across from the Camino Real Hotel that looked as if it had been transplanted from a Chicago suburb. The name *Sears* didn't quite fit in a country recording 100 deaths a day, nor did the Hardee hamburger franchise down the street.

The hours of work faded with the sun and were followed by dinner and another gathering of journalists in the hotel, almost a ritual by now. Then came sleep, easy, welcome sleep. Although we had been in El Salvador only two nights and a day, it seemed much longer.

Each morning on the road may be a new adventure, but it usually begins in the same sleepy and stiff movements that follow a hard day's work. There are other considerations on foreign assignment. The food is different, and one of the four or five members of a news team is always adversely affected. A tropical climate saps your energy quickly, so it takes extra motivation to roll everyone out at the same time to get started. Of course, the language barrier slows things, and the constant struggling with equipment—trying to keep it dry and functioning—takes a great deal of time.

The advent of electronic equipment has created a whole new breed of technicians who possess the ability to repair and sometimes even build apparatus in the field in order to keep working. The mark of the new age of communications is the technician under pressure splicing together enough gadgets to link a videotape recorder to a satellite transmitter and send those pictures through the air.

We began that Sunday morning, as on hundreds of other days, children again at the prospect of discovery, oblivious to the trauma ahead.

Our destination was the Metropolitan Cathedral in the center of the capital and, more specifically, a mass celebrated by Bishop Arturo Rivera Damas. The small park across the street from the large unfinished church, raw in its open cement and exposed steel, gave us the best view for an

"establisher," the typical postcard picture that would fix our presence there. The shot was suddenly familiar, and we realized we had seen it on television, which by tucking those images away in the recesses of your brain often gives you the strange feeling you've been there before. In this case there had been gunfire, and people killed; it was during the funeral for Archbishop Romero. The moment played back in silence but seemed to leave screams in the air, hanging among the palm leaves that created such a disarming setting of peace.

The large cathedral was half full with the poor of San Salvador. They were kneeling when we entered, and the handkerchiefs tied over the heads of the women composed a delicate mosaic of color. In the rear, a tape recorder was positioned under a loudspeaker to record the service. Did it belong to a devout Catholic wanting to spread Bishop Rivera Damas's gospel of peace or to a representative of the ruling junta taping the words of another "leftist priest"?

Brown faces lined with the deep furrows of difficult living faced the altar as the bishop spoke. This was their final refuge, it seemed to me, the last resource of hope in a land turned upside down by death.

To the right of the altar was a chapel that extended from the main sanctuary. There was a large picture of Archbishop Romero on the wall over a small table bearing fresh flowers. Tearful parishioners filed continuously into the alcove, kneeling to pray at a small railing and clasping their hands together, often with a rosary wrapped around their fists.

Roy was dressed in blue jeans and stood against the wall, solemnly watching the mournful Salvadorans pay their respects. He stared at the picture with them, as if joining their moment of private hope and suffering. It must have been an emotional moment for Roy. Priests and nuns had gone before him in this land, into suffering and persecution and death; in fact, two of the four American churchwomen slain the previous December had been from his order, the Maryknoll. Certainly, in his mind, there was no more important cause than helping these people who lived in the knowledge that their lives might be taken in the next few seconds as easily as they might be spared. None of them knew when the next knock on the door would be the last thing they heard.

Skip whispered to me that he had all the shots he needed, and we quietly slid toward the rear of the cathedral for a final wide shot of the congrega-

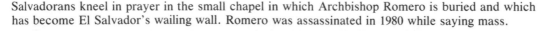

Salvadorans kneel in prayer in the small chapel in which Archbishop Romero is buried and which has become El Salvador's wailing wall. Romero was assassinated in 1980 while saying mass.

tion, on their knees praying.

It was still early as we walked to the blue van parked nearby. A few youngsters were digging their fingers into a mango for breakfast. One man in sandals and a wide hat led a burro down the street. The sun gleamed off red-tiled roofs and cut dappled patterns through the palm leaves as it shadowed the central square.

Our mood was jovial on the way back to the hotel since we felt we had already put a lot of valuable material "in the can" the day before. We had some very good footage that would provide an excellent picture of what was happening in this Central American nation. I told our team—David, Roy, Skip, and Phil—to take 20 minutes to freshen up at the hotel and then we'd head into the country toward Suchitoto, an important town in the northwest that had recently been the scene of heavy fighting.

At the hotel elevator I let Roy go up alone, mentioning that we might have to speed up our shooting schedule to allow me to return to Chicago and pick up any of the pieces still flying around from the "Watchdog" controversy. Then I paused to check the lobby for other reporters, perhaps some newcomers, before going to my room.

In the quiet morning hours 20 minutes had turned easily into 30 when Skip came down and announced he was having some stomach problems. We decided he should stay at the hotel for the afternoon and let Phil do the shooting. We loaded the blue van, expecting Roy shortly. At the 45-minute mark we called his room. There was no answer. We checked the lobby and learned that our driver, who had been waiting for us outside, had seen Roy walk out of the hotel lobby and into the parking lot.

Was he ill and trying to get some medication before we left? None of us remembered him looking ill, but I did recall that he complained slightly of stomach trouble as he got in the elevator. So we waited. When two hours passed with no word, our concern began to mount, but it was too early to raise an alarm. One possibility was that some contact that he and David had been trying to make had suddenly come through and Roy had had to leave

without alerting us. David didn't recall any liaisons, but one could have materialized. Meantime we faced rigid deadlines for shooting. If we lost the afternoon's trip into the countryside, we lost it forever. So we compromised. Skip would keep the vigil at the Camino Real while David, Phil, and I would make a quick foray into the country for some shooting.

As we drove north, we were struck by the difference between the comparatively sophisticated capital and the backward way of life just outside the city. Here campesinos lived as best they could, scratching out an existence from the rocky, difficult terrain that was left them after the powerful landowners took the rich agricultural land for their cotton and coffee.

Rusted buses connected the small villages, most of which enjoyed a solitary life in the interior of the country.

It was here that the Catholic Church faced its most difficult task. Because the priests tended these poor parishioners, people who would be most susceptible to overtures from rebels promising food and support, they became targets of suspicion for the rightist military forces. Some priests were killed as a result of this association, and almost all of them were believed by the right to be part of the Communist movement. If the outspoken Archbishop Romero could be assassinated in the middle of mass in the heart of San Salvador, certainly these front-line priests in the countryside were in far more jeopardy.

Their mission became part of the "Liberation Theology" outlined by Peruvian theologian Gustavo Gutierrez, which rejected service to the wealthy and took the Bible to those who suffered. Within that commitment was an obvious message—one that both infuriated and intimidated the ruling class—that people's poverty is not willed by God but is the result of historical patterns of oppression that cannot be overcome without popular insurrection.

The Roman Catholic Church has traditionally maintained a careful position throughout Central America, associating itself with the ruling powers in order to exist. This compromise may have ben-

efited the flock by allowing the Church to continue its mission unhindered by the government, but it also lent credibility to many repressive regimes.

This stance was shaken by the Cuban Revolution of 1959, which established an atheistic government that destroyed the comfortable relationship between church and state. The Castro administration closed many churches and discouraged church attendance. Like the U.S. government, the Catholic Church became very concerned. The not-so-quiet stirrings of change among Latin theologians appeared in 1968 at a meeting of Latin American bishops held in Medillín, Colombia. The Church, with the blessing of Pope Paul VI, dedicated itself to the poor and denounced "institutional violence," a phrase that permeated the entire hemisphere. It was viewed as a code word for the actions of repressive governments.

The new theology was not universally accepted within the Roman Catholic Church, and a debate emerged that would not cool. Some religious figures recognized and supported the declaration as a volatile weapon that could be used to incite revolution throughout Central and South America, while others feared that a more progressive approach would drive the Church into a terrible conflict with ruling governments. Pope John Paul II addressed the growing dilemma in 1980 during a visit to Brazil, urging priests to get out of politics. When he returned to Central America in 1983 he pleaded for human rights and supported his priests in their efforts to help the poor. It may have fallen short of an endorsement of the Liberation Theology, but it didn't still the passions of those who were practicing it, like the Nicaraguan priests who held political office. In countries where the press and open discussion were suppressed, pulpits became the only forums for free speech. The priests' message seemed to be that armed struggle was also a Christian struggle.

In El Salvador, although Archbishop Romero was unequivocal in his denunciation of the regime's violence, less well known priests in the countryside were going further by stirring peasants to organize. This eventually led to rural support for armed political action.

In 1977, several priests were murdered, and relations between the Church and the president of El Salvador deteriorated. Jesuits, because of their efforts at organizing the poor, were threatened with death if they didn't leave the country.

Romero emerged as the lone voice speaking out against institutional violence. Gradually, his sermons began to reflect the views of labor groups and peasants. At the funeral of a priest, Ernesto Barrera, killed in November 1978 while fighting alongside guerrillas, Romero said, "When a dictatorship seriously violates human rights and attacks the common good of the nation, when it becomes unbearable and closes all channels of dialogue, of understanding, of rationality, when this happens, the Church speaks of the legitimate right of insurrectional violence."

On March 24, 1980, Romero was shot through the heart by a sniper as he celebrated mass. His replacement, Bishop Rivera Damas, was instructed to retrench, perhaps quiet the rhetoric, and unite the Church; but he would be drawn by the forces sweeping his country into a stand against the slaughter of innocents. He too became increasingly militant.

Murders and intimidation chased priests from the countryside, and in their absence grew another religious force, the Pentecostals. Throughout Central America these Protestant evangelicals found the poor farmers and Indians fertile soil for their gospel messages, just as the Roman Catholic Church had.

We came upon such a group of Pentecostals that Sunday afternoon northwest of the capital. We had just rounded a curve on our way down a steep ravine when singing from a small building below drifted toward us. It was a touching scene, religious services on a Sunday afternoon in the midst of poverty. Yet it seemed as natural to the surroundings as the women washing clothes in a stream that meandered by the side of the road, or the leather saddle resting against a gnarled fence, or even the well-armed farmer in cowboy gear with a rifle slung over his shoulder. We spoke with him and his friends in our inadequate Spanish, and they expressed a dislike for the rebels.

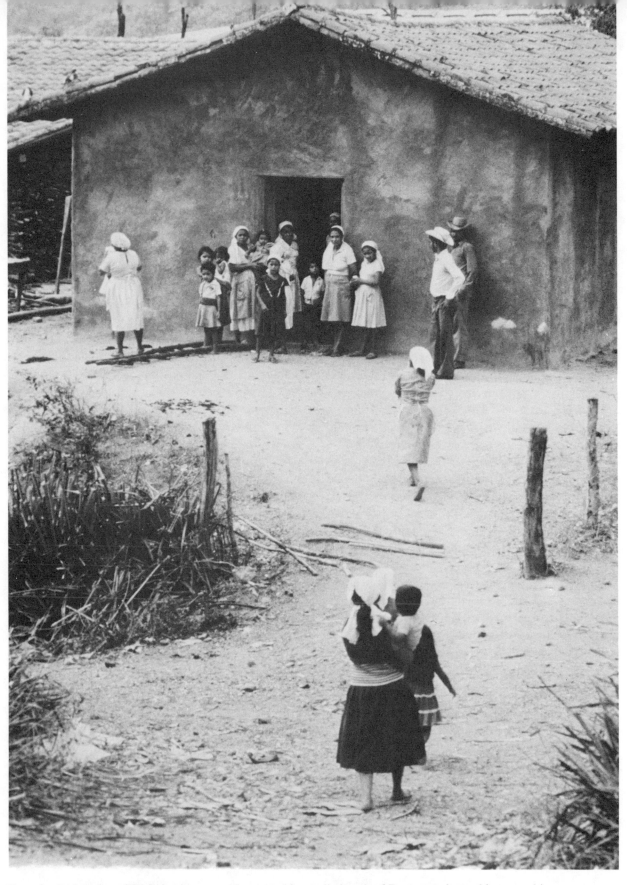

Deep in the interior of El Salvador we came upon this small church of Pentecostal worshipers seeking deliverance from their plight. "God, we are in your hands," they prayed.

"Why?" I asked.

"Because," said one, "the government has given us these guns to fight them and the rebels haven't given us anything."

"Where are the guerrillas?"

"Up there, in the hills." He pointed across the stream to the sides of the canyon, which seemed as close as a stone's throw.

Next we walked over to the small church, where the congregation welcomed our futuristic electronic gear as if they had seen it all their lives. They continued with their service while we recorded their impressive faces rejoicing in song. The picture of these people, helpless in the shifting flow of violent forces, was the most lasting impression I would receive of El Salvador, even more dramatic than the photographs from the morgue.

We were suddenly aware that we had extended too far into the interior and could be in great danger. In any guerrilla war there is little security. This became shockingly clear when our van happened upon a pickup truck loading men who were carrying M-16 rifles. They were dressed in civilian clothing, and their weapons were silhouetted against the sky. Their truck was blocking the road, so we were forced to stop. There was a long pause as our driver talked with the one man who spoke English, caressing his rifle all the while. The others stared from the pickup truck; there was not a single friendly expression among them. Finally, our driver introduced us to this "field commander," who explained that he and his men were National Guard members operating without uniforms. They would happily escort us farther if we wished, he said, but we declined. We had seen enough.

A death squad or unit of ORDEN? I realized that even government security forces might have trouble identifying who—right, left, or members of their own factions—was doing the killing.

On the way back to San Salvador, neither David, Phil, nor I conceived that Father Roy would not be there. Disappearances, kidnappings, murders—all these happen to somebody else, to foreigners in other lands, the subjects of headlines.

We rushed back into the Camino Real expecting Skip to tell us that Roy was back, maybe after a long walk in the shopping mall or with a Maryknoll priest. But it was not to be. He had vanished.

The worst possibilities now entered our minds. Reluctant as we were to consider them, we knew we had to. When men and women disappear in El Salvador there are few alternatives to murder. We had spent too many hours listening to horrible accounts to think otherwise.

We notified the U.S. Embassy, which responded with great understanding and suggested that we follow some precautions. The embassy would wait 24 hours before officially listing Roy as missing. Within that time, we should talk with Salvadoran police who would be sent to the hotel to obtain full reports.

We found some clothes in Roy's room. He obviously had not checked out, which led us to believe that he had not intended to be gone long. His prayer notebook mentioned he had negative feelings about staying in the relatively luxurious Camino Real while his brother Maryknolls lived in the hovels of El Salvador's poor. There was no clue to his disappearance.

I notified Peter Lund, general manager of WBBM-TV, of the heart-stopping news, and we both felt our blood drain away as we spoke at length about what to do. He was tremendously supportive and took over the stateside task of notifying the Maryknoll Order and Roy's parents and friends. We awaited word from the embassy and decided to follow its advice as to our next moves. Mentally, all of us entered into a death watch, anticipating a message that a body meeting Roy's description had turned up in a ditch outside town.

David and I retraced our steps on the previous days, returning first to the Legal Aid Office. No, they hadn't seen him. The cathedral. The mass. We found no one who had seen him after our visits. Two Maryknoll priests were still in the country and we called them, hoping each time that they would say yes, Roy's here. They didn't, but they came into San Salvador to help.

We hesitated at first but then with great reluctance discussed the possibility that Roy was dead. Actually, we realized it was a probability.

We were no longer covering the news, we had

become the news. Should we share what had happened with our colleagues or keep the matter within our small group, as the embassy recommended? We chose the latter, risking criticism from other reporters and the suggestion we had something to hide. There was another consideration at hand, however—the life of Roy Bourgeois. Not knowing exactly what had happened to him paralyzed us with the fear that we might tip death squads to his absence, assuming they hadn't already taken him.

United States officials expressed other concerns to us, including fears that there might be a death list that included all our names. In that kind of a situation you operate with great caution, sifting through the possible results of your actions.

Rugged mountains rise in the countryside, often providing shelter for guerrilla forces.

The embassy wanted to avoid further problems, not to mention loss of American lives, and advised us to remain close by the protected area of the hotel and keep in constant touch. It would handle press releases and any dialogue with the news media.

In addition to the serious questions about Roy's welfare, there were ethical considerations. Should we have brought a Catholic priest into El Salvador knowing other Maryknolls were regarded by the rightist forces as extensions of the left? We had taken several precautions: Roy had not worn a collar and at no time told anyone of his vocation. If anyone in El Salvador knew what he had chosen as his life's work, with the possible exception of some people at the archdiocese, it was a surprise to us. David had been careful to inquire into the mood of the country, and there had been no indication of recent attacks on the clergy.

Another reason we had brought Roy to El Salvador was that the Roman Catholic Church has often been an important link in my stories for the Chicago audience. Chicago is the largest Catholic archdiocese in North America, and its parishioners had appreciated our efforts to report on Catholic programs to combat hunger and suffering. Since the Church was more directly involved in this story than in almost any other I had covered, the perspective that could be provided by Father Roy justified our taking him as our interpreter.

We still had one contact we hadn't taken advantage of, an introduction to President Duarte from Father Theodore Hesburgh, of Notre Dame University. Father Hesburgh had taught Duarte in his first religion class, and they had developed a deep friendship over the years. It was pure coincidence that we were scheduled to interview Duarte the day after Roy's disappearance. The embassy was still in its 24-hour hold on releasing news of Roy's "missing" status, and I thought we could use the contact with Duarte to speed up an investigation.

El Salvador's president was very concerned and immediately offered his complete support, requesting investigations from the National Guard and Treasury Police. But ultimately they produced no hint of what had happened.

When the 24 hours had passed, the embassy released word of Roy's disappearance. In addition, they let us know they were very concerned about our remaining in El Salvador. Although we wanted to stay and follow the story, hoping not only to lend our efforts to an investigation but to keep pressure on the officials, we did as the embassy requested. Skip and Phil joined me for the nervous ride to San Salvador's international airport past the various ambush points, which loomed dangerously close. But the ride was without incident. David followed the next day. Rather than risk the same long drive, the embassy had David driven in an armored car to a small airport in the center of the capital, from which he took a five-minute flight to the international airport.

The next ten days were as difficult as any I have ever spent. Maryknoll priests flew to Chicago from their central headquarters in the East, and together we set up a committee to maintain a watch on the situation. They enlisted the aid of the National Conference of Catholic Bishops and visited several congressmen to keep pressure on the Salvadoran government to press its investigation.

The incident also captured national headlines because of the earlier murder of the four Catholic churchwomen. If yet another member of the clergy was killed, it could have a negative impact on the future of U.S. support for El Salvador. Among the dozens of wild scenarios we had conceived to explain Roy's disappearance was one in which he had gone on a kamikaze mission just to bring embarrassment upon the government.

For our part, we continued to cover the story every day. Our universal fear was that Roy had been killed by military death squads. But if he had only been kidnapped, we hoped the show of concern from the United States would help produce him alive. The government of El Salvador was very sensitive to public opinion at the time since Congress was preparing to vote it more aid, and President Duarte assigned a special liaison who kept us well informed of Salvadoran investigations—almost too well informed. Hardly a day

went by that didn't include a painful ritual of false alerts.

"A body has been found" was the frequent call from El Salvador, and we would notify family and friends. Our CBS news bureau in San Salvador would dutifully videotape the mutilated corpse and beam the pictures into Chicago by satellite, asking us to identify the clothes, shoes, or any marks as Roy's. But each time some article just wasn't right, and we who had seen him last could not identify the body as that of Roy Bourgeois.

As we waited, prayed, and hoped, a few of our colleagues in the profession tried to provoke an ethical controversy, alleging that we should not have taken a priest into El Salvador and that doing so compromised the safety of other journalists working there. That charge was particularly painful because I have always been careful to avoid such a situation. It was also disconcerting to have these self-righteous critics ignore the plight of Father Roy as they attempted to take some competitive advantage by exploiting the story, initiating debate before all the facts were known. We chose to let the criticism go unanswered. Roy's life might be at stake.

Parties on all sides attempted to use Roy's disappearance for their own purposes. From President Duarte's office came the charge that the incident proved a link between rebel fighters, Catholic priests, and the press.

Things were starting to get out of hand when, 11 excruciating days after we had last seen Roy, a call came from the U.S. Embassy in San Salvador notifying us that he had walked into the embassy unharmed. He appeared to be totally unaware of the furor he had caused.

We held a life-restoring celebration at the television station, as if Lazarus had arisen. Those of us who had worked together, and who had formed a network of daily communication, rejoiced.

Roy was debriefed by the U.S. Embassy and then told he must get out of the country as quickly as possible. Like David, he traveled by armored car to catch a domestic flight to the international airport. Maryknoll fathers planned to meet him in Miami and then fly with him to New York, where

they would hold a news conference for the many inquiring reporters. Roy's reappearance after so many people had presumed him dead created great interest in what he had to say. Because of our relationship, we were able to meet the group in a home in Coral Gables, Florida, for a private interview before Roy faced the rest of the press.

He was thinner than before; I could see it in his face. His priest's collar—which I was seeing him wear for the first time—gave him a serious air. This was no wild-eyed radical protester, as Roy had been portrayed by some, including fellow priests. He was studious, deliberate in his actions, and totally dedicated to the cause of the poor. We sat in a living room and listened to his story.

"Our last report saw you leaving the hotel," I said, "walking into the parking lot. Just what happened?"

"I left the hotel to go back to the cathedral," he replied.

"Your contacts were there?"

"Yes. I had made the contacts in Mexico, and when I got to El Salvador things finalized very quickly. Mind you, it was a painful decision to make. I was afraid, and I didn't know exactly what to do. I was also afraid that I might die. But when I heard you say you might have to leave El Salvador early, I knew that was my last chance to see the rebel side. I had to leave that very moment."

I wanted every detail, so I walked back over some of the same ground.

"You mean when you got back to the room, there was a message there?"

"No," he said. "I had met with them at the cathedral."

This came as a shock because I did not remember leaving Roy's side, except when he crossed the sanctuary from the alcove where Archbishop Romero's picture hung to ask Bishop Rivera Damas when the mass would begin. Even then, I thought I had followed his every move. Roy said he found his contacts back at the church and wrote an explanatory note to us that they said would be delivered. Of course, it never was. He spent ten days in the Salvadoran backcountry believing that the only repercussion of his action would be criti-

cism that he had become a leftist.

"Where did you go?" I asked.

"They took me to Morazan province." This was the area of heaviest guerrilla activity; in fact, leftist forces claimed to control vast areas of the mountain region.

"We traveled by van," Roy continued. "I wore a baseball cap that I pulled down over my face when we were stopped by government forces."

"And who was helping you?"

"There were people all along the way, in safe houses, people who are part of a network supporting the opposition to the government in different ways."

"An underground," I suggested.

"Yes. There is all kinds of resistance. Some people are messengers, some run safe houses, others who don't believe in nonviolence bear arms. The people who took me from San Salvador to San Miguel were resistance, aware that if we were caught, they might be killed. They were risking their lives for me."

Although the brutal tactics of El Salvador's military could never be justified, Father Roy's description of widespread resistance helped explain why the military often targeted seemingly innocent people.

"Did you see any evidence of foreign arms?" I asked.

"No. I asked them if they had Russian arms, and in Morazan province they said there were none there. Once I got into the province I felt safer. I was traveling most of the time, sometimes with children. One was only 12 and he carried a pistol."

"Are they Communist?"

"I didn't think they were pure Marxist, but they do have a basic understanding of the class struggle that Marxism speaks of, including the 12-year-old and other teenagers I traveled with. They are very politicized.

"I saw some training at a camp, which was very disciplined. They were up at 4:30 in the morning. Some were teaching military tactics, others explained how to handle rifles. Teams of paramed-ics went off into the countryside to give aid to the peasants just as they might help the people after they had overthrown the government."

Roy did not see any actual fighting because he was moving very quickly.

"I was literally walked into the ground by campesinos; I was no match for them," he admitted. "We traveled at night, hiking up and down the mountains. They knew everything about their land, where the water holes were, for instance. They would get information about whether it was safe to continue from people who lived along the trail. We walked from sunset to sunrise, and I felt very secure."

"No evidence of government forces?" I asked.

"Once I saw a helicopter come low over the treetops, so we took cover in tunnels that had been dug under the brush, like the tunnels I had heard about when I was in Vietnam. They would be impossible to see even if you hiked right next to them. It showed the preparations they have made.

"Since they are poor people in the first place, we didn't have much to eat. I had meat only once, I remember. We ate mostly tortillas, wild fruit, and tomatoes," Roy said.

And what was the overall impression he had gained from this experience?

"I came back more convinced than ever that the military aid we're sending down there—that is being financed by you and me, the taxpayers—is causing blood to flow on Salvadoran soil. We are inflicting grave suffering on the poor. We are doing this in the name of fighting communism. We're simply out of touch."

"That sounds just like the Catholic theology of liberation," I said, "like the left."

"Don't you see, the left is the poor," Roy answered. "As missionaries our lives are rooted in the gospel message. What was once taught as being the will of God—the poor people's plight—is now seen as an obstacle to what God wants. It's a liberation, all right, a gospel message that calls on us all to be fully human, to liberate ourselves, to be free from malnutrition, to have schools and

medical care. For the poor it's great news, but the problem comes for the rich. It's bad news for them. It means they will have to give up something: power, land, wealth.

"That's the dilemma of missionaries today. Our critics are not from the ranks of the poor, not landless peasants of El Salvador, not factory workers of Chile, Bolivia, Guatemala, not mothers having their daughters raped. Our critics are the rich in that country and this one, politicians who are out of touch with the Third World, even churchpeople who are very wealthy and would like to see life continue as it is now, to maintain the status quo, the comfortable."

Father Roy had walked among the poor of El Salvador and honed his beliefs to a sharp edge.

After his return, there were news conferences and speeches before church groups, and slowly life returned to a quieter pace for Roy. He assumed a lower profile within the Maryknoll Order in the United States, still speaking against U.S. policy in El Salvador. But his status had been tarnished by the fact that he had gone off with the rebels. By doing so, he allowed his disappearance to be used by the Salvadoran government to bolster its claim that an alliance existed between guerrilla forces and the clergy.

Our efforts to gain a better understanding of who was doing the killing in El Salvador were interrupted when Roy walked away. I went ahead with a 30-minute documentary called "The Dilemma of El Salvador" using what footage we had obtained, and the show, broadcast on June 8, 1981, was a sobering look at how the pervasive violence touches the lives of Salvadoran families. The dispossessed at the refugee camp; the bewildered, grieving relatives of the missing; the residents of Soyapango who were too frightened to tell us what they knew—all added up to a nation living under a death sentence.

On August 1, 1983, Roy disguised himself as a U.S. Army officer and, with several others, sneaked into a barracks at Fort Benning, Georgia, to pass out leaflets to 525 Salvadoran troops in training. The leaflets repeated Archbishop Romero's final plea for the Army to lay down its arms.

A National Guard patrol at Suchitoto awaits orders to begin its daily surveillance.

Dateline: Africa and Asia

Focus: Following the trail of

the world's vanishing wildlife

Witness to extinction

Looking into Cotton Gordon's face was to follow a hundred game trails at once, etched deeply in a beaten mask. The hunter represented to me an important part of the extinction story. Today the great game herds are shrinking, their numbers diminished by poachers seeking enormous profits, and the hunter, too, is a vanishing breed. Africa has become the killing ground at the start of an illicit pipeline supplying a worldwide market for animal products.

We spotted the elephant from the safari wagon. More accurately, Cotton Gordon picked it out in the dense forest. I was concentrating on the Zambian dirt road, hanging onto the high rear seat as the Land Rover lurched in and out of dried elephant tracks, shaking with a death rattle each time. The tears in our eyes came from the frosty wind and low branches of mangy thorn trees that ripped tiny cuts when they hit. But no one said, "Whoa!" God, this was the high adventure of Hemingway, following professional hunter Cotton Gordon on the trail of elephant.

Suddenly, Gordon throttled down and hit the brakes, sending us forward into a coughing-thick dust cloud. He was out of the open-topped Rover in a flash, turning automatically with a command, *"Toa bundouki"*—"Get the gun." A Kamba gun-bearer dutifully retrieved the weapon from behind the driver's seat and placed the big .470 double magnum into Gordon's hands as client Bill Miller was repeating the motion from the passenger side,

chambering a large cartridge in his .416 Rigby.

I pleaded for them to wait just 15 seconds to let Skip Brown and Phil Weldon unload their video-tape recorder. It didn't do any good. Gordon's trackers had spoor, and the small party could smell an early kill. We wound up chasing the hunters as they tracked the grazing elephant.

The setting looked like Virginia in the fall, with sunlight striking dried brown leaves, different from the tall grass we'd come through just outside camp or the mud banks of the nearby Luangwa River, which caked into irregular patterns. We made a thunderous sound as we ran along, but we had to reach the hunting party before they fired; capturing that moment of decision on tape was crucial.

Fresh elephant piles steamed in the morning's chill, telling us that we were closing in. The crackling of dried leaves underfoot was drowned by a torrent of cussing from the three of us, each trying to find the hunters with one eye and watch out for swinging tree branches with the other.

Suddenly, we burst into a clearing where the hunters stood like silent statues, staring directly ahead. The trackers were frozen as well. All eyes were trained 50 yards distant—I followed their line of sight—to a gray mass partially hidden behind a flat-topped acacia tree. We edged toward Cotton Gordon, who was whispering to client Miller.

"Too small. It's only a young bull and the tusks aren't fully developed. We'd better pull back before he charges and we have to kill him." Gordon winked at me as he waved the boys back, lifting the barrel of his mammoth gun effortlessly and handing it to the gun-bearer.

In the distance, the young giant snorted with contempt and flipped his head to curl his trunk back for a final victory blow before spinning into the woods and safety. He was lucky. If Gordon had decided to shoot, the young bull would have been dead.

Gordon's decision was the mark of a professional. He had chosen to forgo the client-pleasing act of momentary excitement in order to do the right thing, as he saw it. Few were qualified to question his judgment here in the bush. Like others of his special breed, described by Ernest Hemingway and Robert Ruark in the 1930s and 1940s, he ruled a small kingdom of black trackers and skinners, cooks and waiters, to serve men of wealth who sought the heads of animals. They were all looking for something else, of course, and Gordon knew how to help the anxious client find it without allowing him to get trampled beneath a Cape buffalo's hooves. It was the answer to a question buried in the guts of every man, as if it had been placed there by some distant ancestor: How would I react to a charging animal? Could I stand in the face of danger, or would I run?

Cotton Gordon had seen every manner of man in that situation, from presidents of corporate empires to simple natives helping with a wounded beast. He was a great white hunter of Africa, the kind of man one dreams of being as a child and—in the words of a scriptwriter describing Clark Gable—the kind you wish you had been as an adult.

The shadows still had soft edges as Gordon paused with his client. This, too, was part of the hunt, the talk of what might have been.

"We just couldn't take that one. Sorry. Wasn't worth it," he explained. "Tusks weren't long enough. We're only after big ones, for the record books at Safari Club or Rowland Ward in London. May take us a week or more, but we'll find a big tusker. Don't worry," he said reassuringly with a hand on Bill Miller's shoulder.

Miller smiled and remarked, "It's just as well, really. It could have turned out like the wounded lion across the river from Chibembe camp."

"Hell," laughed Gordon, "let's hope we don't ever repeat that one!"

"Don't keep us in suspense," I said, which was just enough encouragement for Miller to take center stage in the tradition of hunters everywhere.

"We were tracking a wounded lion, which can be a pretty scary trip, believe me. Fortunately, we were downwind most of about an hour and thought we had him holed up in a thicket of mopane trees." Miller fingered the cartridges in his belted safari

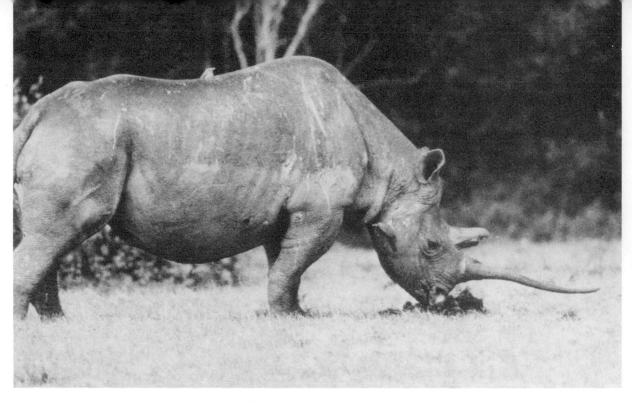

A battle-scarred white rhino with an unusually long horn. Because of the great demand for rhino parts on the black market, the animal is more valuable than a Mercedes-Benz.

jacket as he talked. We gave him all the attention anyone could ask for, even an electronic camera recording his every word and expression.

"Our tracker Sam found a blood trail that led right into the trees, and we knew that any moment the big lion could come roaring out of there meaner than anything. Cotton told me to lock and load. I remember the very words," he said, glancing at Cotton: " 'I'll go for him first, but I want you to stay five paces to my left. If I miss, you back me up. Don't worry about aiming—he'll be close enough for a chest shot.' I was plenty scared."

His narrative *did* have some suspense to it, and Skip kept rolling.

"Then this explosion came through the thorns, and all I could see was a yellow blur coming at us. I could hardly get the stock up to my shoulder, it was shaking so bad. Neither of us fired and I thought maybe something had happened to the guns, then I heard Cotton's go off, like a bomb. But the damn thing didn't stop, so I let a round go that caught him midsection, and Cotton got another one off. It flipped his head straight up, and

when the thing came down he was only about ten feet away, stretched a full eight feet in length with this huge mane. Prettiest thing I ever saw!"

Gordon could remain silent no longer and joined in, "We won or we wouldn't be telling it right now!" The boys roared with laughter, which kept Gordon going. "I told him then that he wouldn't recognize the story when I got through telling it back in camp, but damned if you didn't beat me to it, Bill."

At that moment the month-long safari was worth any amount of money Bill Miller may have spent. There was a ritualistic link between hunters—call it male camaraderie—that stretched back through centuries of common experiences. The world had become a lot more complicated since our forebears took their lions with a sharpened rock, but this hadn't changed: You got the animal or he got you. And if you won, then you talked about the hunt.

For me the moment was marked forever by what followed.

Cotton Gordon squinted, his eyes almost hid-

Hunter Cotton Gordon, who gave his clients a taste of the rapidly vanishing world of big-game hunting.

den behind folds of weathered skin, as if scanning the shoulder-high grass next to the forest for sign of more game. The laughter faded naturally as the hunters realized that, for the moment, the source of their pleasure had disappeared. That realization symbolized a much more serious problem, one that was never far from their thoughts.

The great game herds are shrinking. Their land is being squeezed by human populations that demand new fields for housing and cultivation. And the lucrative market for animal skins, horns, and furs fuels a poaching trade that is killing the game in unprecedented numbers.

Standing there with Gordon and his client, surrounded by Kamba and Kikuyu natives, I could see that the hunter is a vanishing breed, too, chased from one African country to another by governments intent on nationalizing the hunting trade or banning it in an attempt to save the animals that remain. The likes of Cotton Gordon have become their prey.

Ironic, I thought, the hunters sharing the same fate as their noble adversaries, forced into smaller and smaller territories like a retreating army with little hope of victory.

With the look of an animal that had picked up a scent in the changing wind, Gordon turned toward me. "My boys will never see it like I saw it," he said, referring to the game with a sweep of his broad palm toward the horizon. "But on the other hand, I never saw it like my father saw it and I thought it was fantastic when I was younger, so I think it's all relative. Things change and situations change and governments change, but if the wildlife is cared for and the property is taken care of, it'll be here longer than you and I ever will."

There was a wishful quality in his voice that suggested the situation might be more serious than that.

Later we spoke of the reasons for the diminishing herds. "Has hunting contributed to the problem of endangered animals?" I asked.

"Legalized sports hunting never has wiped out a species and it never will. But poaching has no limits. It's just slaughter, and no one has any concern for the eventual depletion of a species."

Stories begin like that, with an interesting phrase or new idea that crosses the mind like a breeze. In this case, the image of the hunter Cotton Gordon reinforced statistics that I carried in my traveling files, prepared by conservation groups suggesting that humans are destroying the environment at such a rapid rate that plant and animal life are being eliminated faster than at any time in our history. The director of the New York Zoological Society, William Conway, had told me that 20 percent of all species on earth will be lost within the next two decades. He was an optimist compared with conservationist Dr. Norman Myers, whom I contacted at his home in Nairobi, Kenya. Dr. Myers estimated that we are presently killing one species of plant or animal every day, and that the rate may approach one per hour by the end of the decade.

In the process of clearing new land and taking such "souvenirs" from animals as skins to satisfy our fascination with their beauty, we are altering the balance of nature in ways that may have fright-

ening results. If we continue to cut oxygen-producing greenery from the planet, if we destroy rare species of plants, if we wipe out entire species of animals in the name of quick profits, how do we know we won't kill the one species that holds the cure to as-yet-undiscovered diseases or the key to our very survival? There may not be a single magic link, but can we be sure?

That was why Skip, Phil, and I were in Africa in the summer of 1981, to pursue a story with an impact potentially as far-reaching as that of a nuclear war. Our task was to document an important aspect of the process of extermination, following the bloody trail of animal products from their illegal source, poaching, to the ultimate consumer.

Looking into Cotton Gordon's face was to follow a hundred game trails at once, etched deeply in a beaten old mask. I felt it was an important beginning to the extinction story. He represented a relationship between humans and animals that has existed since both walked naked on the savannas of East Africa. Now, one predator stands on the verge of wiping the others out.

Cotton Gordon was a front-line soldier who observed the extinction problem firsthand. He saw it in more than scientific articles and surveys. To him, it was a smaller zebra herd, fewer elephants, and rotting carcasses left by poachers at the water holes. Just as his face was carved into the memory of every client he took into the bush, he made a big impression on me. It was his love for the game that came through, and the sadness that resulted from watching it disappear.

"Go see Phil Berry down the river," Gordon suggested. "He's with Save the Rhino Trust, funded by World Wildlife in the States. It's a good start!"

The river has cut a vast floodplain between the escarpments that border the Luangwa Valley in eastern Zambia. It forms a natural ark where hundreds of species of African game thrive along the banks of the life-giving Luangwa River before it flows into the Zambezi. Hippos roar in early morning, crocodiles slip silently into the water from their sun-baked sandbars, thousands of buffalo cross the park in a single herd, shutting out the sun with the trailing cloud of dust. Phil Berry lived along the riverbank, two hours' drive downstream from Gordon's hunting camp.

Berry was tall and angular with a biting Australian accent. He had smart eyes and a wise grin, and he wore quasi-military African khaki to command respect from his small band of antipoaching recruits. If Cotton Gordon was the pioneer homesteader who encountered the Indians firsthand, Phil Berry was the cavalry riding into battle.

We arrived at his makeshift jail to find 12 poachers sitting in the shade, handcuffed together.

"Caught them carrying elephant tails and hides out of the bush," he explained. "We'll keep them here until the others come from the village to give themselves up."

Among the young men were several pregnant women who had helped carry the hides. It seemed rather harsh to punish these poor people; they were killing animals they regarded as pests, for the elephants often trampled their crops. To hold the women seemed particularly cruel, but Phil Berry was a determined man who knew what he was doing. When he sent word back to the village that the women would be released if the men gave up, several known poachers walked into the jail.

Also in the relatively small building was a room that served as a macabre reminder of Berry's principal mission. It contained more than 50 rhino skulls, neatly numbered and placed in rows for study. Poachers had killed them all, bringing the rhinoceros population to a dangerously low level. "Automatics make possible the wholesale slaughter of many animals at a time," Berry explained, showing me the Chinese-made semiautomatic rifle that had been taken from the poachers. "They just go into a herd and drop as many animals as they have bullets."

Berry was a one-man army, leading his men into the bush where they patrolled known poaching trails and even set up Vietnam-style ambushes. Several firefights had left two poachers dead and a number wounded. Berry alone had made 500 arrests in 18 months, but these efforts still had failed

to stem the tide of slaughter.

Gathering facts to tell a story is a lot like hunting for gold nuggets. You head for an area where you think they are and search until you find them, all the while hoping to strike it rich. We gather television pictures much the same way, in fits and starts, hoping for the one shot that represents the bigger picture. Phil Berry's camp by the Luangwa River gave us some important building blocks in our story, and helped point us along the extinction trail.

Berry's attempt to save the rhino also provided a tip to the most serious extinction problem in Africa, a prime example of how an animal can be pushed to the edge of existence by man's greed. The rhinoceros comes as close to a living prehistoric creature as anything we have, tracing its ancestors back 50 million years. Rhinos once also roamed Europe and North America, but now there are only five species left, in Asia and Africa. All five are on the brink of extinction, and man is directly responsible; the rhino has no natural enemies.

After some phone calls and hurried research,

we leaped from Zambia to Aberdare National Park in Kenya, situated, according to Kikuyu belief, on the kneecap of the god who lives on Mount Kenya. We could see across the foothills of that great mountain to the antelope-brown plains that sloped toward Nairobi. Looking in the opposite direction, I could follow neatly ordered coffee plantations, which stepped toward jagged peaks disappearing into mysterious clouds.

Our new guide was Sam Weller, who gripped the wheel of his Land Rover as it jerked against deep ruts left from the mountain country's heavy rains. We were in an emerald canyon rich with hundred-foot trees whose latticed vines gave the feeling of a single mat spread across the landscape. Sam spoke into his two-way radio, asking if the other cars had spotted any rhinos. His language was fluent Swahili—*"Jambo iko faro"*—and apparently received a positive response. A grin lit up his round face, which was circled with a short crown of hair that suggested a once-lush red growth.

Previously a hunter, Sam Weller managed the Aberdare Country Club, transitory home for thou-

A member of Save the Rhino Trust, Zambia, with one of the automatic rifles that have accelerated wildlife killing. At rear are captured poachers who brought down several elephants with the gun.

sands of tourists who visited the national park, including the spillover guests who couldn't get into the more famous Tree-Tops Lodge nearby. His ruddy Scottish face displayed a marvelous sense of humor until we pulled within sight of two black rhinos grazing on short meadow grass. The horn of the mother swept unusually high, and she used it with the skill of a swordsman to keep her calf in line.

"There used to be two or three hundred here," he said sadly. "Now, we're lucky if there are a hundred. Something happened to them in the last few years. Whenever a car would approach in the old days, they would charge. Now, they run like greyhounds."

Weller was trying to say that some communication had passed among the rhinos, perhaps part of an instinct for survival that associated cars with men—who were killing them.

"You should talk with Peter Jenkins," Weller suggested. "He'll tell you what has happened. He used to be game warden at Meru National Park on the other side of the mountain. Same thing happened there."

We were reluctant to leave, knowing each visit to a game park becomes a treasure among life's memories. I asked Weller to drive us to Peter Jenkins's home. The house, just outside Aberdare, was only temporary quarters, but it was in a magnificent location overlooking a coffee plantation with rows of the head-high plants rippling up a nearby hillside.

Jenkins was a William Holden look-alike, from English stock that had pioneered Kenya long before the Mau Mau uprising led to independence. His life had been devoted to the preservation of Africa's animals, as a game warden. It wasn't a job that would make a man rich, but it provided a wonderful life for his family. At the same time it was something he loved. Few men are that lucky.

Peter Jenkins was leaving Meru National Park after years of struggling with poachers and with native farmers who wanted the rich land inside the animals' domain that seemed so much greener to them. He was caught in the process of Africanization, which gave black nationals the jobs held by

whites, even white Kenyan citizens.

Jenkins's story of what was happening to the rhino was not a pleasant one. Its telling created the same sad atmosphere I had felt with Cotton Gordon. Jenkins drew deep breaths each time he described a different incident, for he had lived through the agonizing events one by one.

"In the days of '74 and '75, there was an estimated population of about 250 rhinos at Meru. When I left at the end of January '81, there were a known 36. It was possible there were a few in the thick bush country, so there could have been 35 others at the maximum."

Jenkins pointed to a scrapbook of pictures accumulated during those years, a grisly record of rhino carcasses left to rot in the open savanna after poachers had cut their horns away. That's all they took, just the horns.

At first, Jenkins said, he was able to maintain antipoaching patrols that were moderately successful against the bow-and-arrow tribesmen who hunted the rhino, but in the 1970s the problem escalated. His eyes swept the clouds that hung low on the horizon, as if he could see back to those years when the worst came.

"A series of armed conflicts went through Africa. Ethiopia was fighting Somalia in the Ogaden, and the result was an arms flow into East Africa. Rifles were added to the spears and poisoned arrows. Soon whole herds were being slaughtered, as if no one cared."

He explained that the wild animals revered by conservationists are considered little more than nuisances by the native farmers who work hard to plant a crop. When an elephant tramples months of work it's hard to view it as a lovable circus clown that should be preserved. The natives are competitors for the land and are dedicated to driving the nuisances away.

"Between October of '78 and April of '79," Jenkins went on, "50 rhinos were killed by Somali poachers, all with AK-47s, G-3s, or rifles. They cut off the horn with an ax or knife. An experienced man can remove a horn in five minutes."

As we talked about incidents that had begun nearly four years earlier, I learned that the

weapons flow had spread much farther south, past Kenya's border into Tanzania. Uganda had experienced serious warfare and contributed to the moving arsenal of weapons available to various guerrilla bands. Mozambique, South Africa, Zimbabwe, Angola, Zambia—all had been the sites of conventional and clandestine war. Scarcely an African country was free from an arms buildup.

Peter Jenkins's account, on top of Phil Berry's in Zambia, made it clear that automatic weapons had given the natives an incredible advantage in their predatory relationship with the rhino. The animal was defenseless. The rapid-fire guns had speeded up the poaching process to feed the pipeline of horns flowing to market.

Back at Aberdare National Park, to illustrate the ease with which a rhino could be approached and killed, I asked Skip and Phil to climb into the back seat of an open-topped Land Rover and instructed our driver to turn off the road toward two grazing animals about a thousand yards away. The ride was excruciating, even in the heavy-duty vehicle. The adage "When it rains it pours" is an understatement in Africa. Torrents turn the flat meadows into soft acres of mud. When the animals pass through by the thousands, their tracks dry into small craters, which make driving cross-country an act of insanity. Even with this jostling, however, our noisy approach failed to disturb the browsers, a mother and her calf, munching peacefully on clumps of thorn trees. We stopped about a hundred yards from them. They seemed so docile that I asked if we could walk another 50 yards to get a closer shot. The driver gave me the deadpan reaction to a "typical stupid tourist" before he explained there was great danger even sitting in the Rover.

"They may look ferocious with that horn, but they're vegetarians," he assured us. "But walk up to them? Absolutely not. They might get startled and charge. If they wanted to, they could take this vehicle apart like a can opener."

Our point was made, however. We were within an easy hundred yards, close enough for a killing shot, because their eyesight was so poor they couldn't see the danger until it was too late.

We had now established on videotape how the rhinos were killed, but not yet why. Fortunately, there are more animal authorities in the Nairobi area than anywhere else in the world, so we tracked down an assistant professor of geography at Nairobi University. Dr. Esmond Bradley Martin had contracted with the International Union for the Conservation of Nature and Natural Resources and the World Wildlife Fund to do some investigative reporting. He had followed the rhino parts from poacher to consumer to find out where they were going and was the perfect person to ask. We sat in the portico of Dr. Martin's fashionable suburban estate outside the Kenyan capital.

"The skin goes to Southeast Asia," he told us, "where it is used for skin diseases. The blood is used extensively in Burma, the dung is used as a laxative, the toes—or actually the hooves—those are ground up and used for the same purposes as the horn, to combat fever. The penis is used in northern Thailand for sexual purposes. The bone is used if you have a broken bone yourself, then one is tied around it as a splint. The stomach is buried in the ground. Worms crawl into it and then are removed and ground up into an oil that is used on the skin. The urine is sold as a lotion."

When all the parts are added up, the animal is worth more than a Mercedes-Benz. And because of the enormous profit to be made, it is far more valuable dead than alive. Dr. Martin said, "In the last ten years more than 90 percent of all the rhinos in Kenya, Uganda, and Tanzania have been killed, due primarily to the remarkable increase in the market price of the horn. It has jumped 20 times its level in 1970."

"You mean the horn is the primary reason the animal is killed?" I asked.

"Yes, oh yes. It's worth its weight in gold, first in the Oriental markets, where about 60 percent of the horns go for use as a fever reducer, and more recently in a little Arabian country on the boot heel of the Arabian Peninsula, North Yemen. It's a most bizarre story."

"Well, let's take the most bizarre market first, by all means!"

With his white hair spilling over a youthful

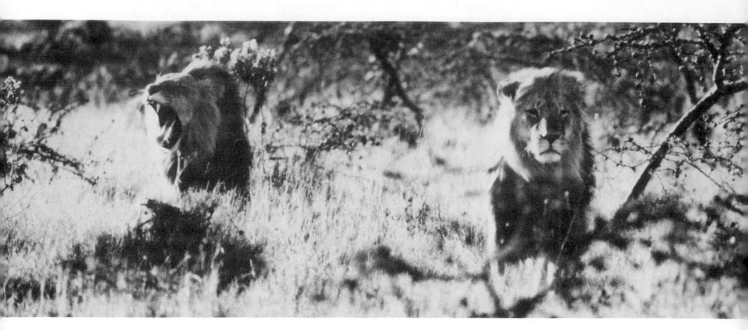

Lions of the Solio Game Reserve, Kenya, a 20,000-acre private game ranch near Nairobi. Founded by wildlife lovers, the ranch boasts 22 species, all carefully guarded from poachers.

face, Dr. Martin nearly bubbled with enthusiasm at the chance to tell someone the facts he had gathered.

"The Yemenis have no oil of their own, so the men travel north into Saudi Arabia to work in their oil fields. They become wealthy by Yemeni standards, which isn't hard, and since money burns a hole in all pockets, when they get back home they want to show off their wealth. Now, North Yemen is a spartan country. There are no roads, so one can't buy a big car as a status symbol, or a bigger house since things haven't changed for centuries. The one thing they could spend money on was a dagger called a *jambiyya*. All the men wore one, right in front, at their belt, an Arabian phallic symbol."

He warmed to the punch line. "Unfortunately, the most expensive handles were encrusted with silver and jewels, and made of rhino horn. Between 1969 and 1975, twenty-five tons of rhino horn were imported into North Yemen to meet the demand. That represents 8,000 rhinos killed in the wild, by poachers."

Dr. Martin paused just long enough to let the weight of the numbers settle, then offered, "If you would like to see a fraction of their handiwork, I'll call my friend Daphne Sheldrick."

The conservation groups overlap each other in East Africa, creating what amounts to a communications network that can provide answers almost immediately. Daphne Sheldrick, an Englishwoman somewhere in her 50s, had pictures, too, and her own special story.

Family photos in the living room of her home showed a beautiful young woman standing beside a handsome young Englishman. He wore the tan outfit of a hunter, she a flowered dress with the hem caught in a breeze that ruffled it slightly. Pictures of their honeymoon, I was told. David Sheldrick had turned from hunting to caring for the animals, assuming game-warden responsibilities at the giant Tsavo National Park in Kenya. The years, reflected in black-and-white photographs around the room, had been good. Daphne was shown holding baby elephants and lion cubs, orphans she had nursed back to health so they could return to the wild. One snapshot even showed a baby rhino. I felt I had seen the photos before,

Skip gathering footage for our documentary. Africa's game reserves are a photographer's dream, offering incomparable glimpses of wild animals acting out nature's drama.

perhaps in articles about orphans of the savanna.

Then the character of the pictures changed. The pleasant reminders of three decades were replaced by photos of elephant carcasses and tables full of rhino horns, hundreds it seemed, stacked alongside piles of ivory tusks. David had captured poacher's booty on its way out of Tsavo.

We videotaped the visual "evidence" and learned from Daphne why she now lived alone.

"David's heart was with the animals in Tsavo," she said. "As the poaching increased he stepped up patrols. He made many arrests and trained his own men well. But the park encompasses thousands of square miles, and there just wasn't enough manpower to cover it all. The poachers were draining the animal population, but David's patrols were quite effective. Then, the government took him away from Tsavo and put him behind a desk. That meant they had an interest in allowing the poaching to continue. David was doing too good a job and they wanted him out of the way."

Daphne's attractive face became melancholy as she described their final days together.

"He died suddenly, not long after he left Tsavo, torn up inside about what was happening to the animals he so loved."

"Died of a broken heart?" I asked.

She smiled sweetly and replied, "Perhaps."

We swung back into Nairobi and hunted up one of Hemingway's old bars, at the Norfolk Hotel. It was a small United Nations, teeming with the dashikis and Muslim turbans of representatives from several dozen African nations, in town for a meeting at Nairobi's modern convention facilities. Sipping on a Kenya beer as we went over our shot list, I remarked, "We're in pretty good shape, don't you think?"

Skip was euphoric about the pictures. Aside from the rhinos, which were the heart of our story, we had seen some of the most magnificent country in the world. We had stayed for a couple of days at an Abercrombie and Kent lodge in Kenya's Masai-Mara Game Reserve, where we watched migrating wildebeests moving across the border separating Tanzania and Kenya. From afar they appeared as a glistening black cloud against golden hills. At the

edges of the herd of jumping, breeding animals were always the predators. Through our telephoto lenses we followed a cheetah on his rounds looking for a young or sick wildebeest. At first it seemed he would be in heaven, able to pick easily from the vast herd. But the wildebeests were very aware of his presence, and when he got too close the larger bulls would draw together and face him, an intimidating sight even for the fastest predator in the world.

Several times we watched the cat patiently hunched on a small anthill to get a line of sight above the grass, his small head surveying thousands of potential meals. Then he would effortlessly slip into the brown vegetation and disappear from the wildebeests' view. Our telephoto lenses were reaching as far as they would extend, 200 mm, 400 mm, even farther for the electronic camera, and we saw a yellow blur moving like lightning through the grass, then a scattering of animals, some jumping in fright. Once he brought down a small calf, but it wriggled free and the cheetah returned to the shade of a tree to rest.

Witnessing the natural play of these plains is incomparable, unless there are too many witnesses. Sometimes there are so many minibuses following a cheetah's hunt that the wildebeests are tipped to the presence of a predator. Man interrupts nature's drama.

We also saw a lion pride feasting on a freshly killed wildebeest, the cubs allowed to gorge themselves before the parents dug in, perhaps to let the kids tear the tough hide from the more desirable meat inside. The mother, who probably had done most of the work in bringing home the kill, sauntered lazily into the scene to push her face deep into the belly, then raised her whiskered head, now red with blood.

When they had eaten fully, the family spread across the landscape in varying forms of collapse, looking like fraternity members after a drunken brawl. Several hundred yards away, as if he didn't want to be disturbed, the grand patriarch let the flies crawl over his nose and through his mane, too tuckered to lift a paw to shoo them away.

Now, in Nairobi, it was late afternoon; we had stayed in the crowded bar for several hours, reviewing what we had seen and taped. This wasn't hunter's camp talk about the day's kill, but we were just as thrilled. Our "shots" were more than tall tales or heads to hang on a wall. They were electronic images that we would edit to illuminate the problem of extinction so others might do something about it. Yes, extinction; the word drifted in and out of the conversation over the beer-soaked tabletop.

Phil challenged our thoughts. "So we know how the killing is done and why, basically, but why should we care?"

It was one of those questions so fundamental that a quick answer is hard to come by, like why should we care about a sunset's color.

"What kind of world would it be without them?" Skip asked. "And would you want to live in it?"

"Most of the experts say," I offered, "never mind the secrets all these species of animals and plants might hold, unknown cures to diseases we don't even know about yet, these animals have a right to live. Out there on the plains, the predators take their prey only to sustain their own lives, not to butcher for sport or decoration. Just because we have the ability to wipe out every living thing on earth doesn't mean we have the right to do it, in vengeance or for the money to be made."

"What worries me," Phil continued, "is that once these life forms are gone, they're gone. We're killing species that took millions of years to evolve, and our kill rate is so fast that we're not giving new life forms the evolutionary time to replace them."

I sent the conversation on a different tangent. "I guess I would say that for me the strongest argument for trying to prevent animal extinction is the elephant."

"I thought we were covering the rhino," Skip protested.

"Oh, we are, and we'll stay with him, but the elephant is the animal that fascinates me the most. It's mysterious, you know. We were in Rhodesia in 1977 doing the guerrilla war and flew down from Victoria Falls to Wankie National Park. It's not as

pretty as the Masai-Mara but a lot bigger.''

The story came back easily in the dim setting, and the group knew they were in for a long one.

''They have more elephants than you've ever seen down there. One afternoon there must have been a couple of hundred at the water hole, and we heard one trumpet sound. All of them stopped what they were doing and trooped off in a kind of formation, moving through the trees big and small with sentries out on the sides for protection.

''It's a matriarchal family group. The females take care of the youngsters until they're able to move out on their own, while the adult males live largely apart. They come in for mating and when there's danger, but for the most part they forage for themselves at a certain distance from the main herd.

''In fact, I got into trouble with that. Again, I was trying to cram as much shooting into our schedule as I could and wound up on the last morning with about an hour and a half to get some final shots. So the guide puts us into a small jeep and heads for the nearest elephant droppings.

''We're hauling ass down a dirt road when he points to a massive elephant over by a water hole and says, 'A mother and her calf.' He should know, right? He pulls off the road to get closer. It's not hilly in Wankie but we have to stand on the seats of the jeep to see over the brush. Sure enough, about 100 yards in front, they're still there. The guide motions silently with his hands for us to get out, and my cameraman Bill Burke has this look in his eye that says, 'Something tells me this isn't Kansas.' Our tech is Ron Terrazoff, who follows right along behind the guide and me. The guide is carrying an M-16—which, he admits, won't stop anything that big—but it gives us a little more confidence.

''We come out of the brush about 40 yards from the elephants, but there's a big surprise: It isn't a mother, it's a bull! Well, at that point I know about as much about elephants as diddle. I've got two Nikons around my neck, the 105 lens up to my eye, and it's a great shot. What I don't know is that everybody else has dropped out. The crew is back about 20 yards and the guide is nowhere to be

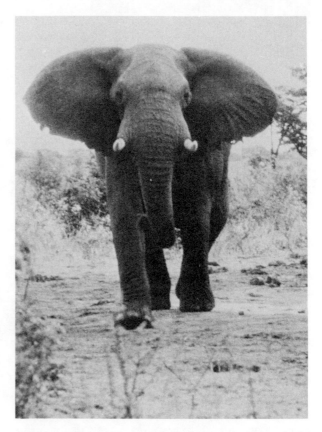

This young bull lowers his head for a full charge at the brash human who has invaded his territory at Wankie National Park, 1977, in what was then Rhodesia.

seen. We're all used to people hanging over us to prevent getting the shot, right? No one wants you to get hurt, right? Well, here I am, just as if I were shooting at the Bronx Zoo only there's no fence.

''The big guy sees me and turns around. I'm on his turf, and I can just imagine his thoughts: Who is this joker walking up on me out in the middle of nowhere? I think he's going to run off, so I'm actually *hurrying* to get closer before he does. Except he doesn't move, and it becomes pretty clear he's not going to. I get to about 30 yards of him when he turns full face and mean. He throws his head up and trumpets like you wouldn't believe. Well, I take one more step and all I see is the head go down, the two huge ears go out like windmills, and here he comes.

''I'm turned and running when I hear the M-16

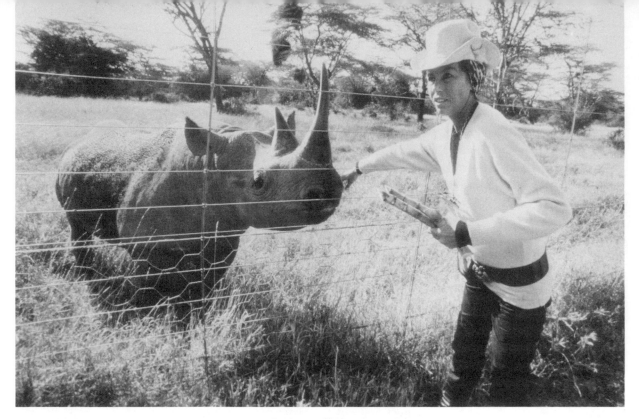

Claude Parfut feeding sugar cane to an orphaned rhino at Solio Game Reserve. Sadly, the round-the-clock protection offered here may be the only way to save the rhino from extinction.

fire, which sounds like a cannon out there in the quiet. It hits in front of the bull, enough to make him pull out of his charge and trot off, trumpeting or laughing at those crazy bastards who invaded his territory. I get back to the jeep, and the guide apologizes for not seeing it was a bull. And the crew, they held on the shot like heroes, but it was one of those moments you couldn't talk about for a while, not until we got on a plane and someone broke the ice. Then, we couldn't stop talking. I guess that's what they call being scared spit-less.''

The sun had gone down. Nairobi's streetlights were creeping through the windows of the bar into our little cluster. We were all tired. To wrap things up for the night I said, ''Last shot in Africa tomorrow, gents. Back to rhinos and a place about three hours north of here called Solio Ranch.''

The highway climbs slowly from Nairobi toward Mount Kenya. The mountain was showing its broken-tooth peak and looked like part of another world. About halfway up the foothills was

the spot where American businessman Courtland Parfut had bought 60,000 acres of grazing pastures in 1966. When we got there in 1981, he was raising between 10,000 and 12,000 head of cattle.

His French-born wife, Claude, was an uncommon lover of wildlife, and she had persuaded him to set aside 20,000 acres for a private game reserve, right in the middle of the ranch. To the chagrin of the ranch foreman, who saw his prime pastures taken away, Solio Game Reserve was created as a private home for 22 species, among them the densest population of white rhinos and black rhinos in all of Africa.

Courtland Parfut made sure it would stay that way. He hired one of Kenya's finest game wardens, Rodney Elliott, remembered by Robert Ruark when he was hunting the Samburu Game Reserve as a man of uncompromising reputation whom Ruark feared as much as a wounded buffalo. Elliott also made a name for himself during the Mau Mau uprising as the toughest fighter against the rebels in the country. At Solio, he runs anti-

poaching patrols along a 22-mile-long fence that stands 11 feet high and is reinforced by a 4,000-volt electric wire to keep the elephants out.

We accompanied Claude Parfut in a yellow minibus that she uses every evening for a private drive to see ''her'' animals. I saw at least a dozen rhinos from the road, grazing and browsing comfortably in thickets, under mimosa trees, and in open savanna. In the afternoon we even observed five of them silhouetted against crystal-blue skies, fencing with each other as several males courted a female in heat. A rare opportunity had been provided by this private setting, an example of what one family had done to create a Noah's Ark for this prehistoric beast.

On the drive back to Nairobi, I realized the true significance of Solio Game Reserve. Although a positive step, it underlined the sad state of the rhino, emphasizing what an effort was needed to provide the species with any security. It was a stark look at the future, when the only rhinos left will be in private reserves where they can be protected with high fences and 24-hour antipoaching patrols.

Most of the poachers who kill rhinos are Africans, but the wanton killing satisfies a foreign market. Few Africans attach special medicinal or spiritual powers to the animals; many Asians do, as Dr. Martin had documented. Although 40 percent of the rhino horns go to North Yemen to make dagger handles, the remaining 60 percent fill the Asian market, where Oriental physicians and pharmacists use scrapings from the horn to treat fever. Some cultures must at one time have also used it as an aphrodisiac, because that belief seems so common. Our next step was to find rhino horn being sold, to capture the practice on videotape. Establishing the market demand would complete our picture of the animal pipeline. Eventually, when our electronic images were added to the facts already gathered by World Wildlife and others, knowledgeable officials might be influenced to think of some way to stop the flow.

Bangkok comes close to being my favorite city, despite its smog-choked streets, because of the river and canals that reach its exotic heart. You can travel back hundreds of years with a single boat ride. It's almost like riding through a giant communal bath, for people are always washing in the canals, wrapping towels around their waists as they dip themselves in the muddy water. Children jump at your boat in friendly games, swimming like water rats to grab hold for a ride. Small dugouts carry steaming hot dishes for the homes along the bank or the latest fashions so the ladies won't have to go out. And long commuter canoes drive through the narrow waterways powered by noisy automobile engines mounted on the bow, leaving behind waves that smash against the wooden pilings of the dark houses.

Five million people have jammed a city immortalized for Westerners by Joseph Conrad, Somerset Maugham, and the musical *The King and I*. This was once the capital of Siam, the fabled land of palaces and temples, and a king who was so loved by his people that they gave every succeeding king his name.

Thieves Market in Bangkok's Chinatown was no bigger than an alley. It was so crammed with exotic fruits, vegetables, and Oriental dishes that only a narrow walkway remained through the center of the chaos. The smell of sweat and the buzzing of flies joined a cacophony of street sounds, including high-pitched Oriental voices, to create a mental barrage that left us feeling almost drugged.

We were looking for pharmacies to see if rhino horn was indeed stocked and sold. There were plenty of the Oriental herb shops; every other store, it seemed. It took a few minutes to adjust to the assault of new sights and select what we were looking for. We found glass cases displaying coiled tiger penises (for sexual potency; instructions were to boil them into a tea) and deer antlers, which were scraped to create a powder used to treat nervous tension. An extremely plentiful item was the gallbladder of the black bear, which was boiled into a broth to be drunk as a cure for blood problems. Placentas from various animals were also abundant.

At first I had to ask for rhino horn. The phar-

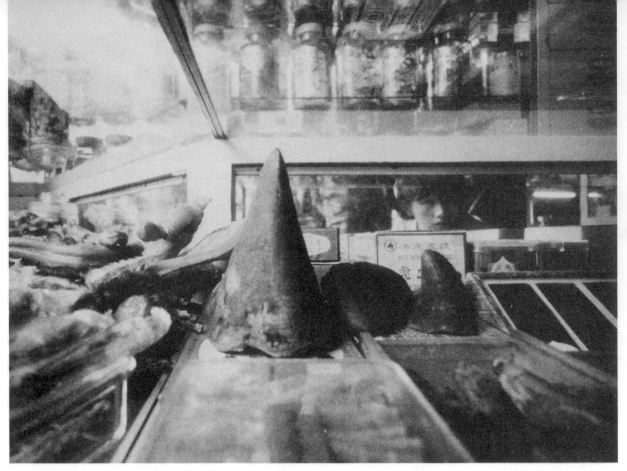

Like almost every other display case in Bangkok's pharmacies, this one had a rhino horn prominently positioned next to ginseng roots, bear gallbladders, and other unusual remedies.

macist had trouble understanding English, so Skip drew a picture for him, quite a good likeness of a rhinoceros, and then pointed to the horn. The man behind the counter disappeared up some wooden stairs. When he came down he carried a perfect specimen, a large brown rhino horn split down the middle to allow scrapings that would then be boiled into a tea. The whole process was performed in front of the customer so he could be sure no other kind of horn scrapings were substituted for the "real" thing.

"Aphrodisiac?" I asked.

"No, no," he replied as he handed the horn to his daughter. He noticed Skip filming him over my shoulder. Pointing to his head, he said in painful English pronunciations, "Headache. For fever."

It seemed much more sensible than a sex potion but still stretched the bounds of reason, for the horn is made only of keratin, a protein that forms the basis of toenails, claws, and hair.

In the next store no one spoke English, but we counted the now familiar items used in Oriental medicine that were thought to possess special qualities for healing. Our eyes carried us through the display cases until we came to the end and a conical object, a gray-black rhino horn.

The horns came in rapid succession, another in a shop not far away. Then, in one glass case that had been positioned to catch the attention of sidewalk customers, we found three horns, each representing an animal killed and taken from Africa or Asia strictly so its horn could be displayed like this and sold.

This was Bangkok, only a small part of a market that stretched throughout Asia, in similar pharmacies of Singapore, Taipei, Tokyo, Hong Kong, Peking, Jakarta—hundreds of towns and cities throughout the Orient.

We learned some new details. Asian rhinos were more highly regarded than African because the horns were smaller and their curative qualities thus believed to be more concentrated. Several species of Asian rhinos had already been virtually wiped out, increasing the pressure on the African animals.

The cost also varied a great deal, from India to Tokyo. Average prices seemed to run as high as $10,000 for a full horn, although we heard talk of horns that sold for $26,000. As the horns became more scarce, the price rose, according to the law of supply and demand.

It was almost as lucrative as the drug trade and much less dangerous, because countries in Asia didn't seem to care about the depletion of rhinos in Africa. Just to keep this Asian market supplied for the next ten years will take every rhino now living in the wild.

We had come to Bangkok to document the market use that was drawing rhino horns out of Africa at a tragic rate. Through this conduit of death flowed not only rhino horns, but elephant ivory, tiger skins, and other "products." But there was even more to be learned in Bangkok, for the city is the hub of a wild animal distribution system that is much bigger than rhino horn supply. Bangkok teems with animals, killed or captured not only for their supposed medicinal qualities but for use as pets, research objects, or zoological attractions, and bought by collectors and animal lovers. In Bangkok, we saw exemplified the special relationship between humans and animals that has grown from a culture which uses animals in its religious rites, as it has in many other eastern countries. We took some time to understand it.

A soft gray light enters Bangkok's Royal Wat an hour before dawn to compete with the lighted candles that have caressed a large, golden Buddha through the night. Tiny bells signal the beginning of another day.

Outside, where the night's coolness still lingers, 60 young Buddhist monks in saffron-colored robes wait patiently for their breakfast. Believers volunteer to bring them food to gain grace in the eyes of Buddha. On this morning a happy couple have carried freshly steamed rice in the trunk of their car, and are now serving it from an ornate silver container into the mahogany bowls that the young monks carry with them.

It's an exotic scene, played underneath legions of pigeons that periodically rise in unison and spiral toward the top of the Siamese temple.

An additional character enters, a vendor carrying small cages with tiny birds inside, offering to sell them to families who have come to worship. A young girl squeals delightedly as she opens a wooden cage door and a finch flies away. Her father reflects her joy in his smiles.

Not far away, behind several parked cars, more cages are being stocked with turtles, small fish, even thin eels carried in a clear plastic bag filled with water. All will serve the wishes of Buddha, that animals should be released to the wild, ensuring a harmony between man and his environment.

Of course, times have changed since Buddha walked the earth, and the spirit of his teaching has been distorted. To increase their profits, vendors will watch for the birds that have been injured in the cages and have faltered to the ground not far away. They will recapture and sell them to another worshiper. No matter. Releasing birds and other wild animals in the middle of a large city is tantamount to killing them anyway.

This practice demonstrates clearly one role that animals play in the Asian culture, a means to an end, in this case a spiritual link with Buddha.

If these creatures are special messengers into the spirit world, it follows in Buddhist thinking that they must possess additional powers that can benefit humans. Alive, they are regarded as reincarnations of ancestors; dead, their parts are believed to contain cures for human ailments, strengths usually identified with the animal that humans can assimilate. As unscientific as such beliefs may seem, they are common among more than a quarter of the world's population.

It was midmorning when our driver turned into a city park in Bangkok. At my urging he had managed to locate at the Chinese weekend market the

highly unusual ritual in which a man of declining sexual capacity attempts to rejuvenate his potency by drinking the blood of a freshly killed cobra. Chinese joggers dressed in bright running suits and sneakers passed the car, adding a bizarre touch of the twentieth century to our anticipation of an age-old rite. The winding lane was soon filled with exotic foods steaming along the curb and dancing monkeys bouncing at the end of an organ-grinder's chain.

Our car pushed through the park's crowded streets until I saw a middle-aged woman standing behind a table lined with bottles of a thick red liquid. The signs were in Chinese and I quickly found that she spoke little English. Skip and Phil began videotaping the monkeys while I checked to see if this was what we were looking for.

A pickup truck was parked next to the display stand, and there were small boys peeking through a canvas flap. They would giggle, then run away. I pulled back the corner of the flap myself. To call the sight within shocking might be a little mild. Two handlers were sticking a pole, curved at the tip, into a deep box. Each time they pulled out a seven-foot-long spitting and writhing cobra, quite angry at being disturbed. The snake would raise its head and flare its hood to strike fear into its enemy or any human stupid enough to be looking in its direction.

The handlers seemed no more concerned than if they were playing with harmless ropes, and they mischievously let the snake rush toward the end of the truck. This sent the gathered mob scattering in all directions, terror in their eyes. I knew the feeling.

When I found Skip and Phil at the monkey dance I could hardly speak, but I'm sure the look on my face was explanation enough. They followed with camera and videotape recorder.

Customers were waiting around the truck. Skip was dangerously close to a new snake, which mistakenly thought the way out was toward the large zoom lens pointed toward it. After a quick retreat, I glanced back over my shoulder to see the handler step on the snake's tail and slip a knotted piece of twine around the hooded head. In seconds the head was tied to a brace that supported the canvas tarp, and a second man was holding the body of the snake to stretch it tight.

With the skill of a surgeon, the handler used a razor-sharp knife to make a slit in the cobra's belly, halfway down the body from the head. Exchanging the knife for scissors, he snipped a fleshy tube and drained the cobra's blood into a stainless-steel cup, then cut out the gray heart, about the size of a quarter, and let it fall into the cup. One more slit and a curled object the size of an appendix dropped into the blood. I was told it was the snake's penis.

The handler's legs bent to allow his body to edge out of the truck without spilling the valuable liquid, which he delicately carried to the waiting Chinese woman. She could have been a priestess judging from the solemn look on her face as she

In hopes of restoring his virility, an older man gulps down the blood of a freshly killed cobra at Bangkok's Chinese market.

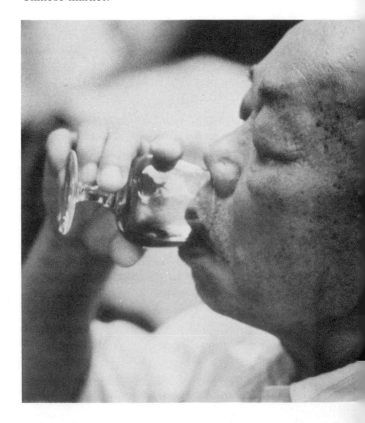

Opposite page: The tomb of Archbishop Romero rests in a chapel in San Salvador's Metropolitan Cathedral, El Salvador. It never lacks for fresh flowers, burning candles, or tearful prayers of hope.

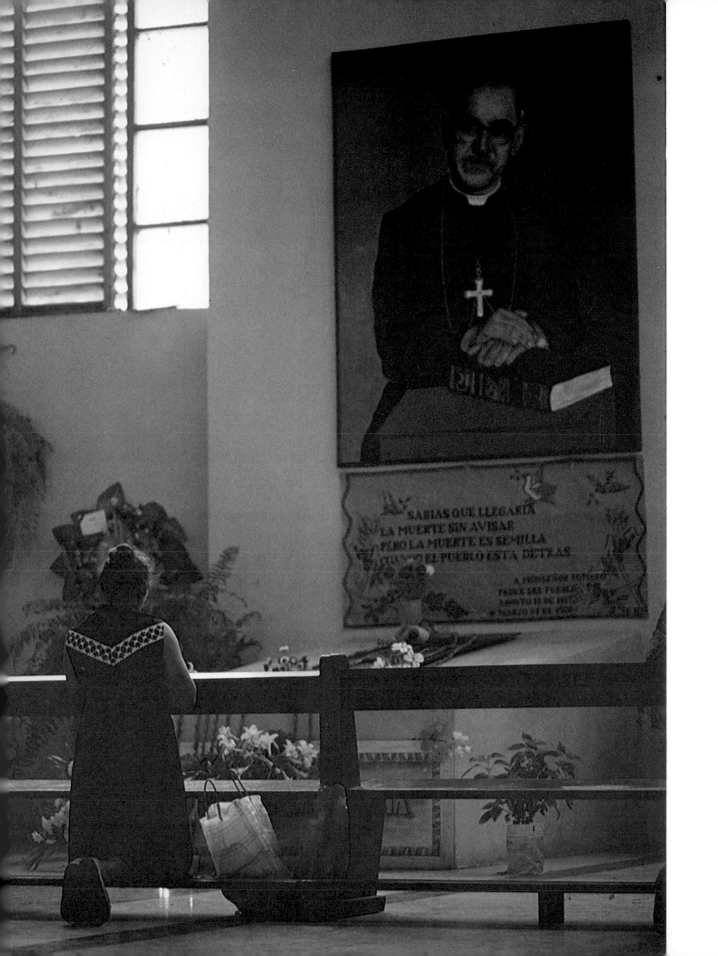

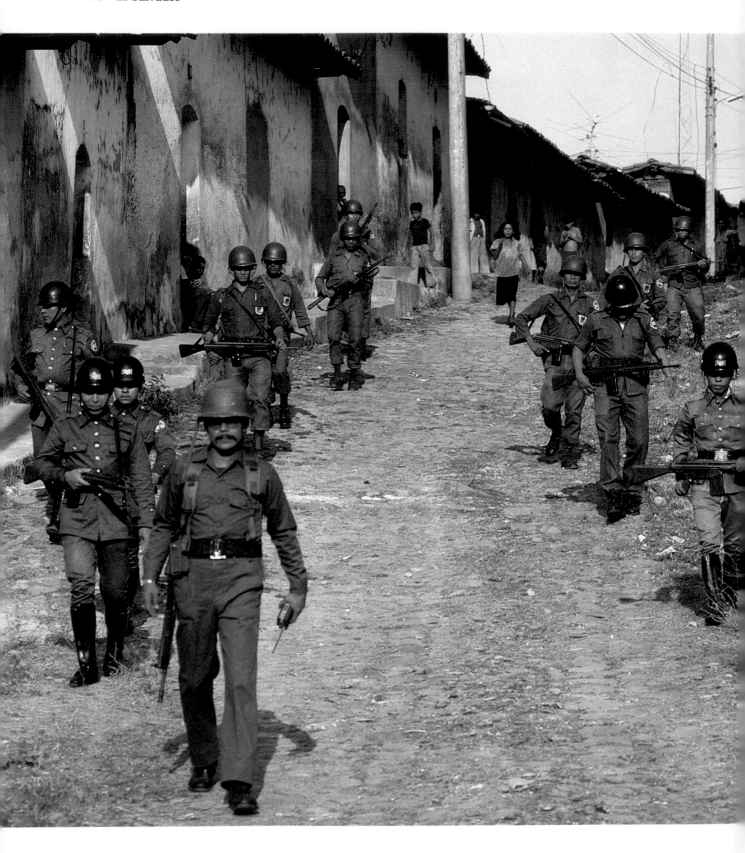

Opposite page: A government patrol in Suchitoto, in the north of El Salvador. Below: A vigilante squad armed by the military as a local defense against guerrillas. There are enough weapons inside the country to fuel the civil war for years without outside support.

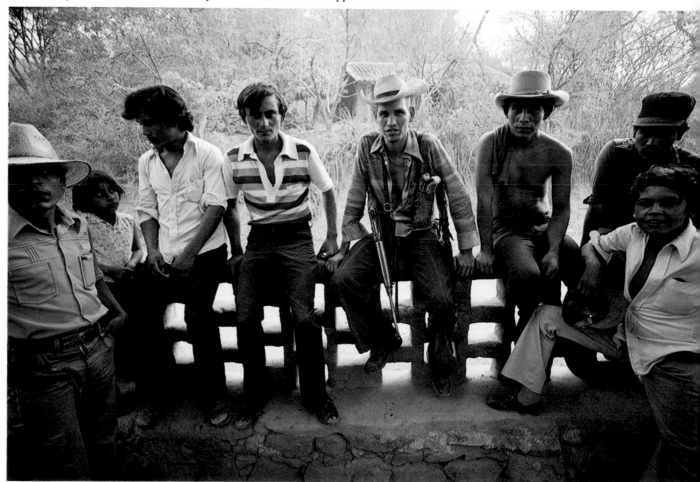

This page: The children of El Salvador are witnesses to their nation's bloodshed. Smiling or silent, all of them will be touched by the slaughter. Opposite page: Two Masai warriors cover the vast distances within the Masai-Mara Game Reserve, Kenya, the only way they know how.

Below: The Kenyan village where we viewed the aftermath of a tribal massacre. Right: The rhinoceros has been brought to the edge of extinction by man's predations, while the giraffe (far right) has grown in numbers due to the lack of demand for its skin or horns.

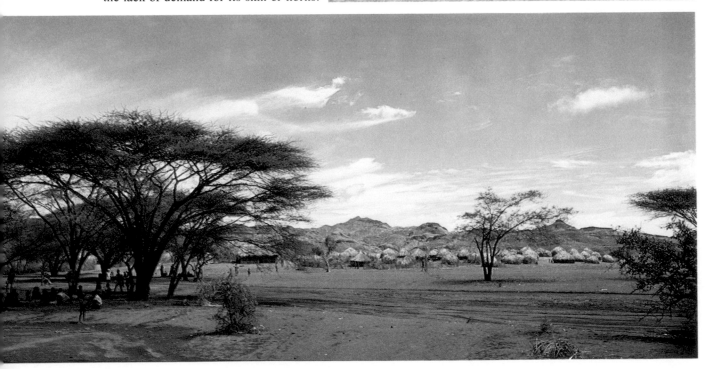

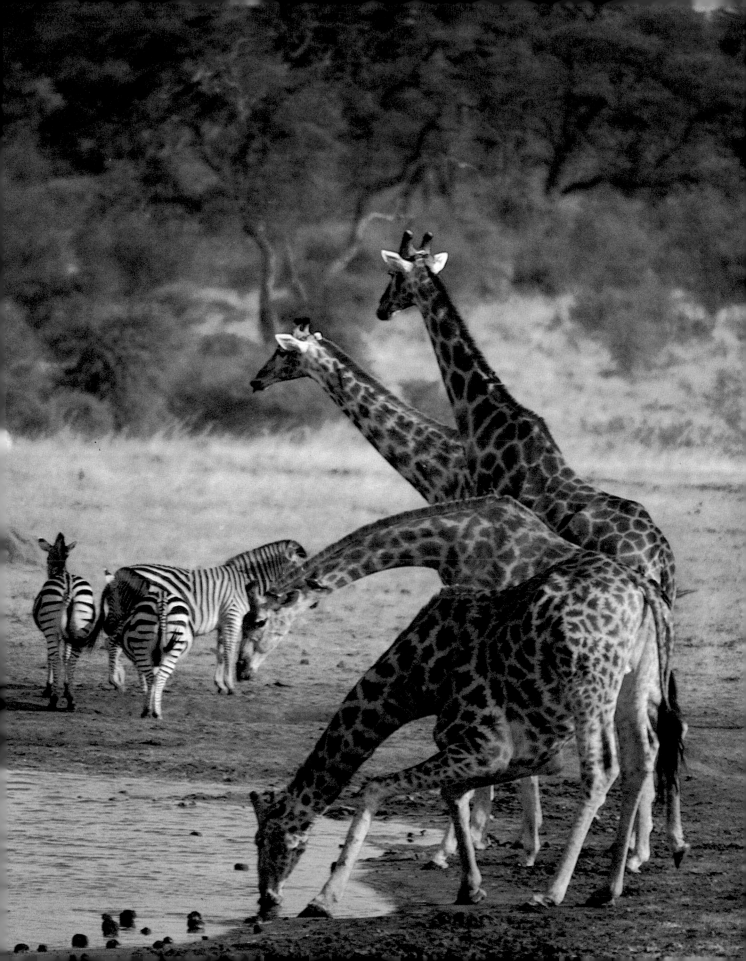

East Africa is still home
to a wonderful variety of animals—
from leopards to zebras to ostriches
—but their existence is threatened
by the growing needs of the area's
Third World nations
for food and land.

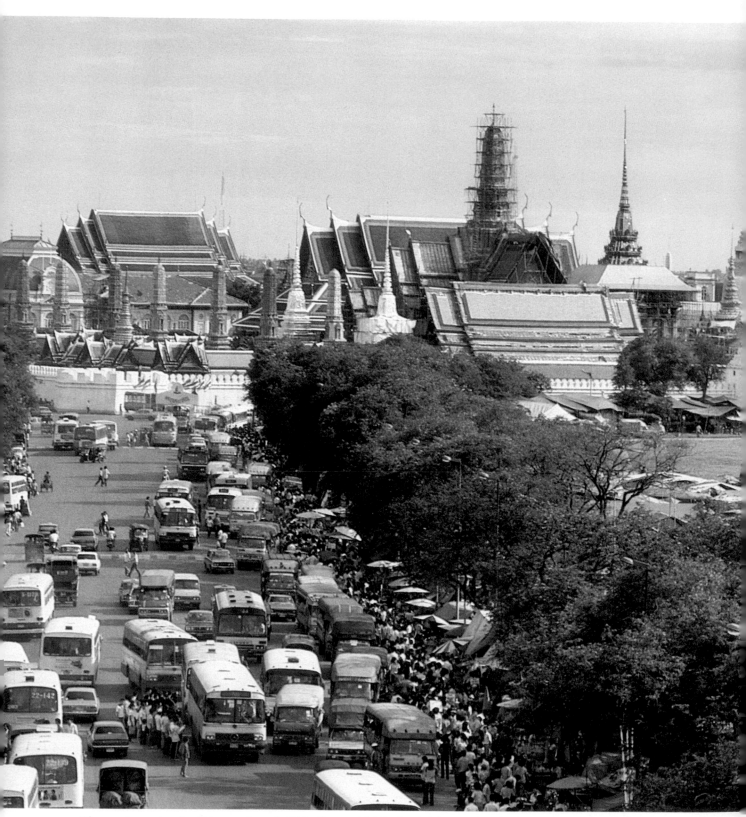

The most spectacular "farmers' market" in the world, Thailand. The weekend animal market in front of Bangkok's Royal Wat offers thousands of endangered animals for sale, draining the countryside of wildlife.

Within a few blocks
in Bangkok, Skip and Phil
videotaped (clockwise from right)
an endangered species of cat,
an array of delicacies,
and Oriental beetles, all for sale.

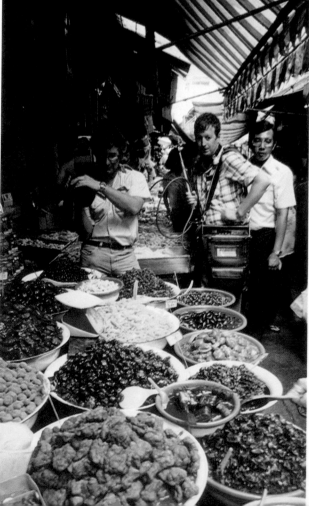

Above: In January of 1981, the spirit of Solidarity was at full flood, visible in the faces of Warsaw shoppers.
Overleaf: "Solidarnosc!" The anonymity of this massive crowd assembled to hear Pope John Paul II in
Czestochowa, Poland, in June 1983 allows these Poles to express their support of the outlawed trade union.

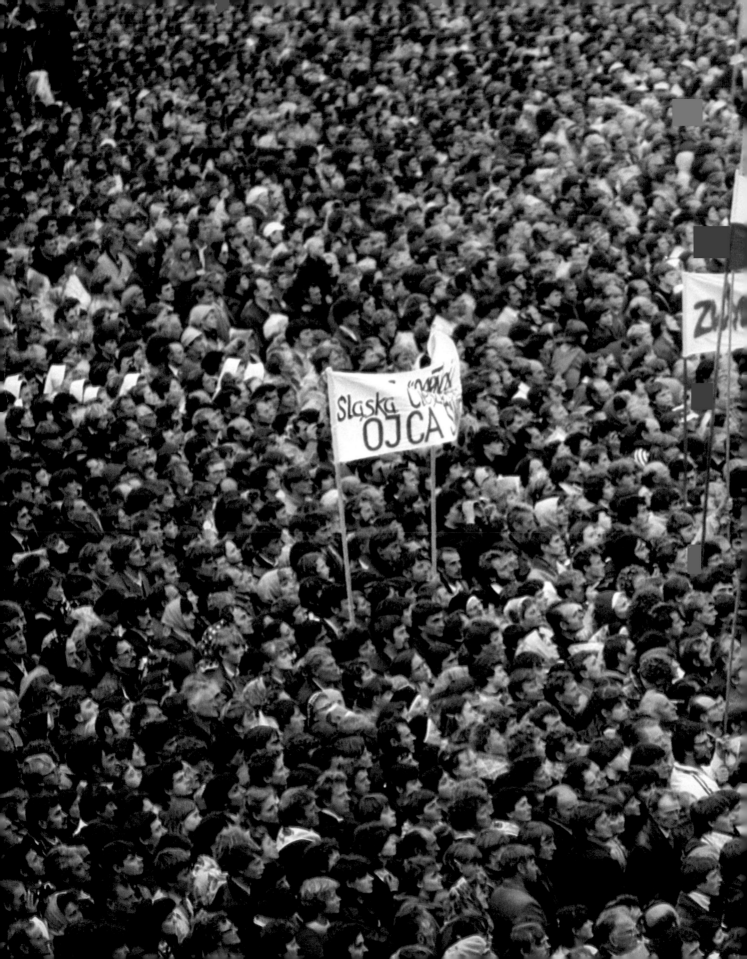

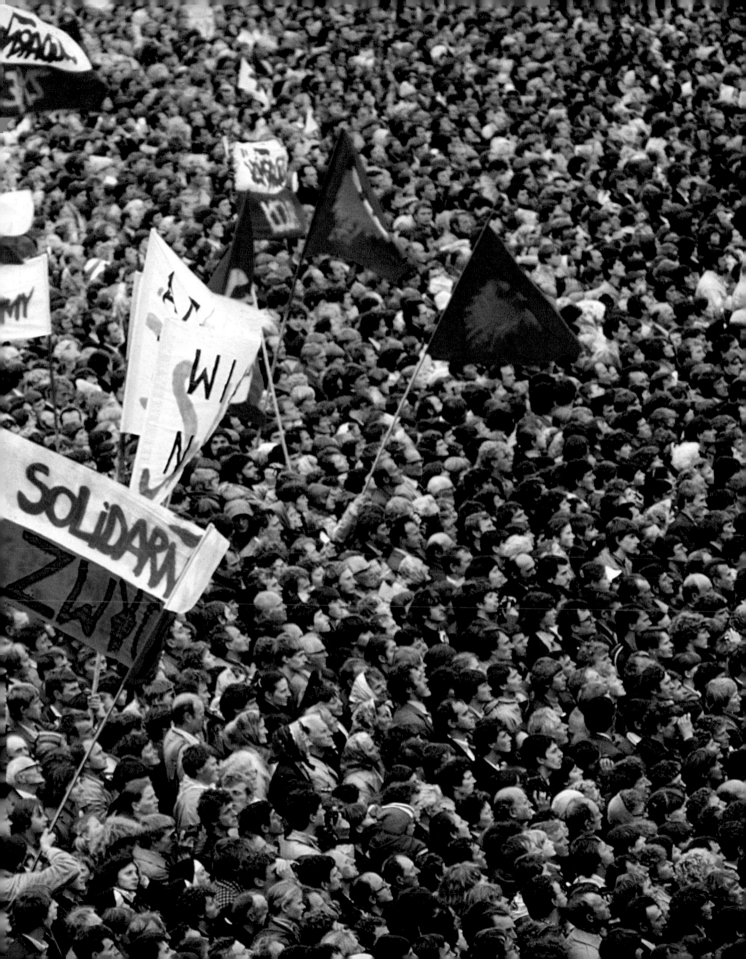

Poland celebrates the return of the Pope in 1983:
Right, a decorated church in Krakow;
below, a homelier display in a neighborhood window.
Bottom: John Paul offers spiritual encouragement
to one of the hundreds of thousands
of faithful in Poland.

mixed a jigger full of the fresh blood with wine, stirred it, cut the organs carefully into pieces, and poured the mixture into a wineglass.

"Twenty dollars," she said reverently as she lifted the glass toward me with the confidence of a physician, then handed it to a waiting customer. He was a Chinese man in his 60s, and he gulped the mixture in two swallows, his stoic face free of even the slightest grimace. I cannot say the same about my expression as I watched the sequence.

After taping for most of the morning, I felt confident we had visual elements few people had ever seen to demonstrate the close relationship between man and animal in this culture. It wasn't much of a jump to realize that Western civilization, while it lacks the supernatural connections, also practices customs that reach back to early man. We wear animals' skins, eat their meat, hunt them in the manner of predators, and admire their beauty, all of which makes them valuable dead or alive. This means someone will kill them or capture them to make money.

In Thailand, marketable animals were easier to catch than in years past, as they were driven into ever smaller habitat. I had been told that timber interests were cutting down the tropical forests so fast that there will be no forests left in Thailand within ten years if cutting continues at the present rate. I doubted the truth of that statistic until I saw vast fields of tapioca cultivated where only a few years before tropical jungles had stood. Farmers are turning the forests into rice paddies as well, eliminating one of the world's great sources of oxygen and an immense haven for birds and wildlife. The same story could be written in Kenya, Zambia, Brazil, most of the countries of the Third World.

About 60 miles southeast of Bangkok, on the road to Chanthaburi, we pulled onto a country highway that led through picturesque rice paddies and steeply pitched roofs of Buddhist temples. We wanted some rural shots and came upon a farmer knee-deep in his water-filled rice field, snapping the reins over a buffalo pulling a plow through the mud. We approached him on the outside chance that he might know something about the wild ani-mal market. I asked his wife if she had any wild animals or birds for sale.

"Yes," she replied in Thai to our interpreter, "come and inspect what we have."

The one-room house was built on thick poles, in the style of delta people, with roll-up bamboo screen walls. The large room, which was used for eating, sewing, and all family activities, was empty of furnishings, and the floorboards were smooth from wear.

Hanging outside the house was a cage bearing two beige songbirds that the farmer had caught with a big net as easily as he might go fishing. He would eat the fish, however. He trapped the birds to sell. The farmer could make as much as 20 American dollars for the pair, the equivalent of a week's income.

He showed me the long net that he used to catch the birds. It was folded underneath his hut the way someone might keep a fishing pole. The farmer hunted in the evenings after working the fields, and at night, so the birds couldn't see the 20-foot net. He would hold the net against a tree and tell his son to light a firecracker to startle the birds. If the farmer was lucky, a rare bird would fly into the net and bring in as much money as an entire year's rice harvest.

I asked what happened if he didn't sell the birds locally. He said a buyer passed by every week. The wild things captured by the farmer flowed to this middleman and eventually to the larger market in Bangkok, staged on the weekends near the Royal Palace. Our Thai farmer was clearly a prime source in the animal supply line.

Bangkok's weekend animal market is the vortex of a teeming system that harvests birds, deer, bears, snakes, monkeys, seemingly any living thing from the forests of Thailand. The setting is dazzling—the parade grounds of Bangkok's Royal Palace, a Siamese spectacular spread out in front of the gilded spires that crown ornate temples. At one end of the magnificent scene, beneath colorful canvas shades, is a menagerie, an adventure for the tourist interested in exotic sights, but a house of horrors for the animal lover.

The weekend market is internationally notori-

Some of the more than 300 species of birds that pass through the Bangkok market yearly. By the end of a typically hot weekend, the floors of these stifling cages are covered with dead birds.

ous for its exploitation and abuse of animals. In a single weekend, thousands of birds, fish, and mammals will be sold, a perfect example of how a central market that puts a price on wildlife can literally drain a nation of its valuable living resources. Over a single year, the number of birds sold will amount to 350,000, representing 350 species.

Row upon row of bird cages stood baking in the hot sun. A golden eagle was cramped into a small wooden cage, unable to turn its head. There were colorful fish by the tankful. Dogs fluffed up from their baths whined pitifully for young children to pet them, perhaps saying, "Take me away from all this."

Flying squirrels, already on endangered lists, were displayed with strings around their necks. A woman threw one up into the air and pulled it back hard to demonstrate its power to "fly." The squirrel's ability to glide through forest treetops, thanks to a parachutelike fold of skin along its sides, became tourist bait. The woman opened the small

furry animal's mouth to show that its sharp incisors had been removed so it could be safely taken home to the children.

From a cardboard box came the high-pitched squeal of something hidden from view.

"What is it?" I asked.

"A deer," was the reply.

Its plaintive scream was frightful.

Gibbons, small apes also on the endangered-species list, were chained to poles, awaiting buyers.

Animals were used for entertainment, too. Three carnival tents were spread beneath the relentless sun to shelter an audience for what a barker hailed as a centuries-old fight to the death between two of nature's deadly enemies—the mongoose and the cobra.

A badgerlike mongoose paced at the end of a rope, nervously watching a 15-foot king cobra, which had raised its huge head two feet vertically in the air. Scars on its flared hood revealed old battles, suggesting an uneven match-up, a snake

Despite being on the endangered list, flying squirrels like this one are for sale at Bangkok's market.

probably without fangs. It was all for show; the snake and the mongoose would live to fight another day.

The scenes Skip and Phil were taping were dramatic, but the pictures were not that easy to get. The keepers were wary. They had been inspected before, and some of their endangered animals had been confiscated. They were not under regular surveillance by any means, but to be on the safe side dealers kept their "rare" finds in cardboard boxes behind the stalls. They were very aware of our television camera, so we quickly came up with a strategy. The first day, Saturday, we reconnoitered and used the camera in the open. Passing in full view of the merchants, we interviewed them about their animals, then kept moving on, always moving.

The next day we did our shooting behind the stalls, avoiding the dealers' attention, which we knew would be riveted on customers passing in endless streams in front of the stalls. Our approach turned out to be a good idea. By Sunday afternoon

the Southeast Asian sun had taken its toll: Stall-keepers scooped dead birds into garbage cans, constantly cleaning the big cages, and we were able to capture all of it on tape. There was no breeze, and the oppressive heat hung like a stifling gas in the cages.

We walked by the animal dealer who had told us about the deer the day before. He seemed angry that we had come back and were taping him again, this time from the rear of his small sales area. He approached me with a sullen look, then pulled a furry animal off his shoulder and threw it onto my shoulder, upsetting it terribly. It dug its claws through my shirt to hold on, as he knew it would, and bared its teeth with a hissing noise.

"Take it, it's yours!" he yelled. "You seem to want something so much."

"We want pictures, that's all. Thank you, but no thanks," I said. I pulled the small, testy beast from my shirt. It fought to stay secure, but I wrestled it loose and returned it to the dealer, after which the three of us beat a quick retreat.

This market, with its stable supply line, also services 200 international animal dealers who sell their stock to zoos, collectors, and other customers all over the world. Not a day goes by at Bangkok's international airport that a wild animal isn't sent somewhere in the world. And if a buyer wants something that is declared illegal in Thailand, the dealer knows how to fix that as well. Here's an example.

A shipment of white-handed gibbons was requested by a buyer in Belgium. Bangkok Wildlife, one of Thailand's more notorious dealers, got the order. According to the files of U.S. Justice Department investigators working out of the U.S. Attorney's office in Chicago, the gibbons were obtained in Thailand; but because shipping clearance wasn't legal since the gibbon is an endangered species in Thailand, Bangkok Wildlife smuggled the animals into Laos, where legal shipping invoices were obtained. When the shipment came through Bangkok, all the inspectors could see was that white-handed gibbons were being sent to Belgium. It all seemed perfectly legal. However, the plan was discovered in Belgium by an alert cus-

toms inspector who realized that white-handed gibbons are not native to Laos and therefore could not have been legally shipped from there.

Similar schemes to "launder" animals and make the illegal appear legal are perpetrated on a daily basis. Airline cargo shipping has enabled the illegal dealer to enter the jet age. The result is a flying zoo that supplies traders and buyers who make animals their profitable business—until the resource runs out.

If Bangkok is the Macy's of the animal market, Japan is the Harrods. In line with the Oriental attitude toward animals, the Japanese pay handsomely for animal products, as we confirmed when we commissioned a Japanese cameraman, Kakun Sho, to pick up some pictures in Tokyo. He found that snow leopard coats sell for $30,000; tiger-skin coats, outlawed in most countries, were selling for $55,000; and a leopard-skin coat had a price tag of $74,000.

One gift dealer in Bangkok killed 40,000 pythons a year to ship to Japan as skins for purses, shoes, and handbags. Each year he killed 30,000 cobras and mongooses, which he stuffed into fighting positions and sold to Japanese gift shops. It was his most popular item, and I found his storeroom looking like hell's own fury, stacked high with the stuffed snakes twisting in vicious mock fighting.

In Japan, the sea turtle, or *bekko,* signifies longevity, so items made from its shell sell for unbelievable sums. Four species of sea turtles have been wiped out to supply the demand. We found a pair of eyeglass frames made from the mottled shell that sold for $4,000. An ornate pair of *bekko* hair combs was advertised at the sum of $23,000. Admittedly these were for a special occasion—to adorn the carefully coiffed hairdo of a Japanese bride—but some royal crowns don't cost that much.

A giant panda sat in the window of a Japanese stuffed-animal gift shop. Its price—$100,000. The proprietors pointed out that it was found dead of natural causes and then preserved for posterity. We could only hope it hadn't been killed by poachers. No animal seems to escape man's predation.

In the United States we might regard these Asian examples as extreme cases of traffic in animals, but we're in a poor position to level criticism. The U.S. Fish and Wildlife Commission estimates that 2.5 million mammals, reptiles, and amphibians are imported into the country every year. In addition, $18 million worth of fish, and 500,000 birds estimated at $7 million are brought in. It's part of a legal animal trade that amounts to $500 million every year in the United States. The commission adds to that figure an estimated $100 million worth of illegal animal business.

This worldwide animal trade, of course, encourages the killing harvests. It is also one basis for the dire prediction that within a few decades we will have destroyed hundreds of thousands of living species around us.

If there is any hope of curbing such destruction, it appears to be in the form of a treaty that more than 70 nations have signed called CITES, the Convention on International Trade in Endangered Species of Wild Fauna and Flora. It identifies endangered species and protects them by prohibiting their importation.

I learned firsthand that CITES was working in Bangkok, where I decided to test its effects by attempting to purchase a tiger-skin rug. Local laws have stopped the overt sale of tiger skins, but I surmised that this would merely cause the business to move into some back room. I was right. The clerk who greeted me at the entrance of the gift shop, open to the street, enthusiastically suggested we make an appointment to view such a rug inside the shop at a later time.

"Yes, we can get them for you," she said.

"How much do they cost?"

"One thousand American dollars."

It was surprisingly cheap, considering the product was rapidly dwindling in supply. The reason for the decline in price was the lack of demand from countries outside Thailand, even though Thailand had not signed the CITES treaty. CITES makes it illegal to transport the skin back to the United States or other member nations; it's automatically confiscated as one of the prohibited species. If a tourist can't take it home, why buy it?

This chamber of horrors is actually a storeroom of stuffed cobras, part of a Thai business that stuffs 30,000 snakes and mongooses a year and sells them to Japanese gift shops.

After traveling the world to investigate the animal extinction trail, the documentaries almost seemed secondary. We prepared two hour-long broadcasts, which aired in prime time on WBBM-TV, Chicago, under the title "Passport to Extinction"; the first part was broadcast on December 27, 1981, and the second on January 4, 1982. Donna LaPietra, Molly Bedell, and Gary Wright combined talents to produce and edit the final programs. Public response was extremely gratifying both in the personal commitments offered to stop the extinction problem and in the ratings. Both broadcasts won their time period against network competition.

Long term, we can only hope our effects contributed in some degree to the education of a public that will support action to stop the process of extermination.

Since the documentaries, there have been a few developments worth mentioning. In 1982, the government of North Yemen agreed to ban the importing of rhino horn. The African Wildlife Leadership Foundation deserves credit for the persuasive negotiations that led to that end. Now the foundation seeks funding for a mass education program among Oriental physicians to replace rhino-horn remedies with good old aspirin.

That kind of good news is overshadowed, however, by the enormity of the poaching problem. Unless emergency programs are applied by Africa's already overburdened governments, poaching seems impossible to stop.

When the circle of my journey closed back in Chicago, I encountered the most sobering footnote I can imagine, one that added a tragic perspective to the plight of the rhino. Out of curiosity, I paid a visit to Chicago's Chinatown, a community of several thousand second-generation Chinese who serve up ethnic food for tourists and maintain two Chinese herb stores for the old customers. On the chance they might have heard about a rhino-horn remedy, I stepped into a family-owned business.

"Do you have rhinoceros horn?" I asked.

At first the parents looked confused, but the daughter recalled a box recently shipped from a Hong Kong dealer marked Unicorn. She remembered a horn she had taken from the box and put in the store window. She walked over and picked it up.

"Is this what you are looking for?" she asked. It was the horn from a black rhino.

If the market reaches even to the small Asian community of Chicago, what chance does the animal have?

Our first view
was of bodies
under a bloody
sheet, with the
feet left
uncovered.

Massacre in Northern Kenya

We were flying north from Nairobi following the Great Rift Valley to a drought-stricken area near the northern border of Kenya, where two missionary doctors were tending an African tribe in the spring of 1976. Five of us, including a cameraman, a sound man, and my father, along as an extra hand, were sardined into a single-engine Cessna flown by Arnie Newman of the African Inland Mission. The mission was one of dozens of Christian organizations operating in Africa.

Above us, mountain-blue skies. Below, vast game reserves that spread raw and untouched between quilted swatches of tea and coffee plantations. Herds of elephants plodded along, in the words of Isak Dinesen, "as if they had an appointment at the end of the world."

Beyond the jagged peaks of Mount Kenya the land looked almost prehistoric, as steaming geysers puffed from seemingly fresh beds of lava cascading down the sides of the valley.

The story about the doctors had come at the last minute, and to my good fortune. It had taken two days to get our camera gear through

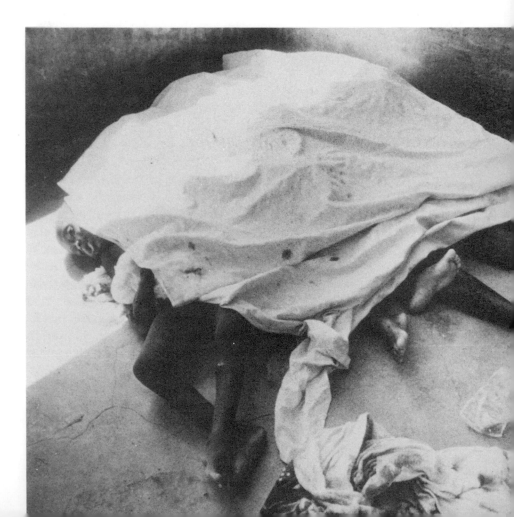

Victims of a tribal raid in Kenya. I happened to be on a plane flying overhead when the tragedy occurred, and the pilot was summoned to the scene. About 40 people were killed, most of them women and children.

Kenyan customs, and next the report we had planned to do on two Chicago seminarians in Serengeti National Park was lost when we were turned back at the Tanzanian border. This unexpected setback, the kind that makes reporting overseas so unpredictable, sent us back to Kenya and the game reserves. With only one day of shooting left before we were scheduled to return to Chicago, we had little to show for our travel halfway around the world other than pretty pictures of wild animals. In other words, I didn't have a story, which isn't the kind of message one looks forward to giving to a news director.

But my luck changed when Arnie told me about the American doctors, and we were on our way to talk with them.

Peter Bertolini, our cameraman, was videotaping the escarpment below while Chuck Meyer watched the controls of the large, early-design electronic minicam system we had carried into Kenya, the first time a camera of its kind had been used in Africa. I pulled the microphone to the front of the plane so Arnie could describe the terrain below.

"There are still bandits in those hills and various tribes who come out of the mountains to raid other villages," he said.

Suddenly he was interrupted by a squawk of the plane's radio, the timing so uncanny that a more religious man would certainly have called it divine intervention. The voice broke with hysteria.

"Arnie, is that you?"

"Roger. Affirmative. Go ahead."

"We've had quite a time down here at the Finnish mission . . . a Pkote raiding party came through about an hour ago and massacred the Turkanas. We've got 30 or 40 dead, more wounded . . . mostly women and children. Can you give us some help with your plane—take some of them to Kapedo and that hospital up there?"

There was no need to answer. The Cessna tilted into a slow downward spiral, passing rough lava formations on one side of a river swollen brown and ugly by spring rains. A village soon passed beneath us, its thatched-roof huts looking like giant beehives against the rocky soil. Bodies littered the ground between the huts.

"That's the mission!" Arnie pointed to a cinder-block building about a quarter of a mile from the village. Most of the bodies seemed to be strewn across the dirt just off the building's back porch.

The plane fell onto the crushed volcanic rock that covered the tiny airstrip. Arnie wheeled sharply toward a car pulling to a dusty halt.

"Don't have room for all of you," the driver yelled as he swung open the door, "but I'll make two trips. There's no time to lose. We've got some bad cases."

We heard the mission before we saw it. There was a strange buzzing noise, like the sound of a big crowd in the distance. As the car pulled to a stop, the buzzing became a mixture of children's screams and the death wails of their parents. The drone provided a frightful clue to what lay beyond the cool hallways leading to the rear porch.

Our first view was of bodies under a bloody sheet, the feet uncovered. The feet were either large or very small, those of adults and children.

Behind the mission, nurses washed the native hairdressing—a mixture of cow dung and grease—from the ocher-colored heads of the wounded Turkana women. Next they cut the hair down to the scalp to prevent infection. Some of the bodies flopped like dead weight in the hands of the aides, who laid them prostrate in the sun.

Other Turkanas who had escaped the slaughter stood in a circle watching the futile efforts to save their tribe. The men were wearing colored feathers, their skin ornamented with scars. The women had row upon row of bright beads around their necks, the mark of beauty among unmarried women. Their faces were not twisted in grief at the specter before them; instead they showed signs of shock, looking glazed and emotionless.

We could begin to discern the injuries. Many of them were knife wounds; spears and arrows had also been used. The nurses threw beads cut from the victims onto a steadily growing pile in the center of the yard. I suddenly realized that all of the injured were women and children. Those around me were too busy to venture an explanation.

Indoors, a lone Finnish missionary doctor was working in a stream of sunlight at a simple but clean operating table set up in what normally would have been a first-aid station. Two helpers maintained battle stations against hordes of flies, sweeping handheld fans in a grand manner across the woman on the table. A metal ring sticking through her earlobe bounced upon an ebony cheek when her body moved, creating a queer scene. Here Western man was reaching back to an ancient culture. The young doctor's blond hair fell over his glasses as he leaned toward his sutures. He had no anesthetic to deaden the painful stitches he pulled

Near right: Wounded but still among the living, a young Turkana examines us gravely as he waits to have his injury treated.

Far right: A mission doctor operates on a victim who had been stabbed in the chest, stitching the wound without anesthetic.

through the skin, but his patient made no sound.

Some patients died as we watched.

Others who seemed less seriously wounded were taken to a waiting car for the short ride to our airplane. I carried one child in my arms only to have it die by the time I reached the car. I remember thinking there was no quiver, no mystery as the life passed from the small body. We wrapped the larger adults in blankets to make them easier to carry. Too often the doctor waved us away, pronouncing the victim dead.

Two poignant scenes I shall never forget. Two Turkana women held a third as she died; they looked into her lifeless eyes and wailed their emotional good-byes. Then, within seconds, the sound cut to a dead silence. The women placed their friend's body on the ground and turned away quickly as if to escape the reach of death's fingers.

Another Turkana woman, dressed in a Western skirt, peeked cautiously into a shed that was being used as a morgue, fearful of what she might find. Her head jerked upward as she recognized a small child. She began to run in circles with her arms waving, screaming hysterically. Friends held her close until her sobbing body slumped to the ground.

Gradually, the wounded were transported to the Cessna and taken to Kapedo, 30 minutes away. Its facilities were more modern than the mission's but still nothing to compare with anything in the United States or even Nairobi.

The dead were prepared for immediate burial. Families seemed to know just what to do, using large animal skins to carry the bodies away. Children watched their elders dig the graves. There was no ceremony. The process seemed quite matter-of-fact, as if the Turkanas were much more aware than cultures considered further advanced that death is a natural consequence of life. These people seemed to be a part of nature, blending into the cycle of life and death so apparent on the African plain.

As we walked the short distance from the mission to the village, trying to re-create the scenario of attack for our camera, I asked an English-speaking mission worker what had happened.

"The Pkotes came just before dawn," he said. "They stretched a hundred in one line and moved this way," pointing toward the village. It was exactly the kind of assault tactic taught in the Marine Corps, a skirmish line designed to get full firepower up front and trained on the enemy. In this case, there were only a few guns. The primary weapons were bows and arrows, spears, and knives, the kind of war-making arsenal that had been used for tens of thousands of years.

"They went through, killing only women and children," he said, "maybe because the Turkana men heard them coming and ran away or were getting ready to defend themselves. Then the Pkotes ran into the hills, perhaps looking for the cattle or the men who ran from them."

"Why did it happen?" I asked.

"Maybe for cattle and sheep. Maybe not. Maybe because this Turkana tribe did the same thing to the Pkotes last year."

The scenes in the village were straight out of the Iron Age. Men sorted through weapons on the ground. Their arrows seemed thin and brittle, but when tipped with poison they could bring down an elephant. Warriors held their spears close as they whispered in small groups, perhaps discussing future protection or revenge.

As we were walking between the small conical huts, a tall young man appeared at my shoulder. He carried a bow and arrow and would have been intimidating if not for his smile, which revealed white teeth that were dazzling against his raven-black face. He said that his name was Isaiah and that he had learned to speak English at the mission school.

"Will the Turkanas make a raid on the Pkotes?" I asked.

He replied with the innocence of a child. "Oh, yes. You can be sure of that."

"And will you go to kill Pkotes?"

He hesitated, lowering his head before he answered, as if he were ashamed of his feelings.

"The others will kill. They like to go and kill. But I will not go, I . . . I don't like to kill."

Isaiah lived in two worlds, that of the Christian mission, from which he received his education, and that of his village, to which he owed his life and loyalty. We finished taping in the village and walked back toward the mission with Isaiah trailing us, practicing his English.

There in the blazing afternoon sun, the four of us were dazed by the experience. It would take several days before we realized just how much of an impact it had made. There was a sense of mission, of doing our job, that carried us through the incident without allowing for reflection at the time.

Weeks later, an official Kenyan government report said that new weapons—rifles—had been smuggled into the northern border area from guerrillas fighting in the Ogaden, a region of neighboring Ethiopia. The introduction of guns into these old running quarrels tipped the balance of power in favor of the Pkotes, who had obtained the rifles and who moved to take advantage of their new strength.

Looking back, the events of that dramatic day seem to have meshed together too smoothly. The flight at the last minute. The interview with our pilot, which left the camera running for the break-in on the radio. The diverting of our flight and the massacre in the middle of a wilderness we never would have dreamed of visiting. And finally, as the Cessna was gliding in on its final approach over the village to pick us up—an image that would be the final shot needed to complete our story—our last battery running out of energy just after recording the shot, leaving the camera dead.

If we didn't have the videotape we might still be wondering about what really happened on that brilliant landscape in northern Kenya, where twentieth-century man got a privileged glimpse of an ages-old struggle for survival.

Dateline: Poland

Focus: A Communist state challenged

by a grass-roots bid

for freedom

Searching for the spirit of Solidarity

For the most part the huge crowd that had gathered to hear the Pope was quiet. The television cameras did not show the ring of militia at the rear of the crowd, hundreds of uniformed police ready for any disturbance. The Poles listened to the words of hope that came from their beloved leader, but at their backs beat the heart of the Communist party—the militia.

The tall spire of the Jasna Gora monastery disappeared like an apparition into the gray rain clouds of June. I watched the mist play about it in the reflections of a small puddle near the rear gate, where priests and members of the news media were entering the grounds, their shoes clicking on the cobblestones as they passed. The mist would clear intermittently, and whipping from the statuettes high on the monastery walls I could see banners in yellow and white, the papal colors.

In just a few minutes Pope John Paul II would appear at the monastery as part of his trip to celebrate the 600th anniversary of the Black Madonna of Czestochowa, Poland's holiest religious painting. I had made my own pilgrimage to witness his visit and to see the Poland of 1983.

It had been raining for several days, and the old church was soaked through, releasing a dank odor from the white limestone upon which the monastery was built.

Security guards checked every pocket, every

piece of equipment I had, then passed a portable metal detector from head to toe before permitting me to climb an easy flight of stone stairs up toward the battlements that extended from either side of the structure. The monastery was a medieval fortress, too, and this staircase must have known the clank of armor in the seventeenth century, when Poles fought Swedes on the plains below, or a hundred years later, when Casimir Pulaski led a revolt against Russian troops.

A chest-high wall topped the 30-foot fortification, and I walked toward it wondering about the size of the crowd I would find assembled on the large lawn outside the monastery. Usually the noise—the buzz of a million voices—rises above these papal gatherings long before the people come into view, but this time was different. I was so close, yet it was quiet.

Then, as I peered over the wall, I saw a resplendent human canvas of faces, pressed together so closely they created designs of color like some finely woven Persian carpet. I put their number at anywhere between half a million and a million. People were packed together so tightly that those who might faint wouldn't fall but would be held upright until they could be passed to the edges of the vast crowd. Near the borders, latecomers were trying to force their way toward the altar, pushing those in front of them and creating waves among the bodies, like a breeze moving through a wheat field. No one fell; they simply swayed until the motion passed.

They had been standing for hours and waiting for their pastor, John Paul, and they would stand for hours more to attend afternoon and night masses. They had gathered to witness the return of the most revered man in Polish history at a time when Poland suffered.

To me it seemed that a dark melancholy enveloped the country 18 months after martial law had been imposed. The government had curtailed individual freedoms and declared the trade union Solidarity illegal, effectively bringing a halt to a movement many Poles believed had been sparked by the man they now stood waiting for.

His rallying cry to action had come during his

1979 visit to Poland. The country had unified behind its one faith and this one man; even Communist party members were part of the huge turnouts for the Pope. John Paul not only preached peace but also encouraged the people to pursue their rights of free speech and assembly. When such a clarion call came from the Polish Pope himself, it had to provoke action.

The rest is familiar. In August 1980 strikers bolted the gates of the Lenin Shipyard in Gdansk and negotiated the right to form free trade unions. Solidarity was born, and the West could sense a breath of change, all the more tantalizing because it rose from within the Marxist stronghold—labor.

As I waited with the hundreds of thousands of Poles to hear what the man who may have started it all would tell them now, I noticed again how quiet the crowd was, how the overriding mood was one of restraint. And I realized the party was over.

It had been a grand try, a glorious moment of hope that blew across Poland with the renewing strength of spring's first warm breeze. Freedom had touched on this soil in the form of one word—Solidarnosc—but just as the white dove now released from the papal altar circled the crowd and lifted toward the heavens, that exaltation had passed. The spirit had been bruised and twisted into other limited means of expression in the wake of military rule. It would undoubtedly break forth again in another shape, but the brief shining moment of Solidarity was over, its potential as the vehicle of Poland's liberation gone.

I stood high above the crowd at Jasna Gora musing about that flash of history, wondering if it was just an isolated grab for economic improvement or the seeds of something much larger, a tremor of resistance to the institution of communism itself. I thought back to the events of those August days nearly three years before that captured the world's attention and eventually brought me to Poland the first time.

The birth pains of Solidarity reached the United States before they were heard even 300 miles south

The spires of the Jasna Gora monastery, in Czestochowa, Poland's spiritual heart. In times of suffering the monastery has offered Poles solace in the form of the Black Madonna, enshrined here.

Above and opposite: Two views of Chicago Polonia. Here the latest news of Solidarity was never far from street-corner discussions like the one above.

of Gdansk, in Katowice. George Migala was preparing for his 4:30 P.M. newscast, "Voice of Polonia," over Chicago's ethnic radio station WCEV. It was August 15, 1980. As he was reading through wire copy from the Associated Press, a Gdansk dateline caught his eye. The story told of a strike by 17,000 workers in the Lenin Shipyard, which sent Migala thinking back ten years to a similar demonstration that toppled the government of Wladyslaw Gomulka and left dozens of workers dead.

"The government is just going to put this demonstration down too," he told me he thought at the time. "The Communists can't be busted up by demonstrators."

Migala's newscast wasn't even heard by most of Chicago's metropolitan population. Only the recent Polish émigrés or first-generation residents tuned in this Polish-language information service. But those people represented a larger Polish community than any other outside Warsaw.

Aloysius Mazewski, president of the Polish National Alliance in Chicago, was in his office

when he received a telephone call about the strike in Gdansk.

"I got many calls like that, some that weren't true at all, from people trying to start something," Mazewski said to me later. "I didn't think much about it until later, when I called the State Department."

The Poland desk told him the news of the strike was quite true; in fact, the strike was still going on. From that moment, he followed every word.

Accounts of what was happening in Gdansk came stuttering into Chicago through news reports and transcontinental phone conversations between family and friends until Chicago Polonia was able to piece together the astonishing story of Solidarity and its leader, Lech Wałesa.

The editor of Chicago's *Polish Daily Zgoda,* Jan Krawiec, wrote an editorial on September 2 hailing the agreement between the workers and the government as a major victory for the working people of Poland, but he harbored some doubts. It was happening so quickly.

"Deep inside I was not sure," Krawiec admit-

ted to me later. "Lech Walesa might be blinded by his success and begin trusting too much. They said they were Poles talking to Poles, but that was not so. Communists are not Poles. They think they are fighting for something great. Their loyalty is to Russia, not Poland."

In his editorial Krawiec warned against trusting the Communists, but that message went unheeded in the euphoria that greeted the news about Solidarity.

There has always been a special relationship between Chicago and Poland because of the sheer number of Poles who began immigrating to the midwestern city in the late nineteenth century. The heart of Chicago's Polish community used to be near the intersection of two great Chicago streets, Division and Milwaukee. This was the port of entry for new immigrants, and from there they could walk for blocks, get a job, and live for months without knowing a single word of English.

Gradually the Poles moved northwest along Milwaukee Avenue and were replaced by black and Hispanic families. But the Polish names remain etched in the stone buildings of the old neighborhoods, where you can still see Polish old-timers arguing on park benches and find *pierogis,* specially made Polish sausages, and bookstores where Polish biographies of Pope John Paul II dominate the displays and English titles are relegated to the rear of the window.

Sometimes the link with Poland seems to extend to a physical resemblance, especially when leaden skies hang close to church spires and hold the cold to the earth, reminiscent of scenes in Krakow and other Polish cities. To many Poles who have lived here for decades, Chicago *is* Poland, more real than the new cities that have been built over the rubble of World War II in their homeland. And to them what happens in Poland is second in importance only to what happens in the United States.

So when word of Walesa's efforts arrived, they were eager to help—and many were in a position to donate more than hand-me-downs. Within two years, Chicago's Polish community would funnel a

total of $35 million in food, medical supplies, and clothing to Poland in the name of the new spirit of Solidarity.

For us at WBBM-TV, Chicago, the situation in Poland was more than important foreign news; it was practically a local story. We wanted desperately to send a crew to Poland and report on events firsthand. But this seemed impossible, for since the Gdansk strikes the Polish government had barred the entry of any foreign journalists beyond those already in Poland due to what it termed "internal unrest."

In the end we made it in with the help of another Polish connection, Congressman Daniel Rostenkowski of Chicago. He made contact with the Polish Embassy in Washington, asking permission for a television camera crew from Chicago—myself, producer David Caravello, and cameramen Skip Brown and Phil Weldon—to travel to Warsaw. An official answered that the request would be honored. When the instructions arrived from Warsaw cancelling all journalists' applications, the embassy was left in a rather embarrassing position with the powerful Polish congressman from Illinois. Finally, Warsaw relented and granted an exception to its ban, admitting our crew.

When I arrived in Warsaw in late January 1981, it was a Chicago kind of day, slate gray and overcast to the point of being claustrophobic. The penetrating dampness and heavy-hanging ceiling would hardly disappear for the entire trip.

Entering a Communist country is leaving the light for darkness, accentuated in this case by the depressing weather. I've repeated the experience in a number of Iron Curtain countries, and each time I have the impression that communism has squeezed the lifeblood from humanity, leaving behind a gray, colorless existence devoid even of smiles.

Polish soldiers carrying submachine guns walked back and forth among the planes parked on the airstrip, contributing to the oppressive atmosphere. A further element of tension would be added to this trip by the very real threat of a Soviet invasion. Because Solidarity was moving slowly toward demands for the democratization of Po-

land—a concept forbidden under Russia's Communist system—there was a constant feeling of flirting with danger. It reminded me of the way I had tried to photograph an elephant in Rhodesia, inching my way carefully into his territory, not knowing when he would decide to say "No more!" and charge. When would the Soviet divisions massed at Poland's eastern border be ordered into the country to stop Solidarity? The question seemed to be at the back of everyone's mind.

In those first impressionable moments in the country I remember feeling very alone in the cold airport terminal. Public buildings are left unheated in Poland to conserve energy, and the result here was a crowd of people waiting for luggage, dressed in parkas and heavy woolens, and stamping their feet for warmth.

David Caravello, who along with Skip and Phil had arrived earlier, was waiting for me on the other side of customs. "We've got to hurry," David said in greeting, grabbing my bags in the same breath. "Farmers are demonstrating about 20 miles from here, asking for their own union, Rural Solidarity. I've sent Skip and Phil ahead to begin shooting. We'll join them there. Let's go."

I'm sure my lack of enthusiasm was not appropriate to the occasion, but I followed dutifully and collapsed into the front seat of a cramped Polish automobile alongside our driver, who wheeled out of the airport and onto an asphalt highway. This was the world of the traveling newsman in the eighties, I thought, dashing off a direct flight from Chicago to Paris with a layover of a few hours before boarding another plane for Warsaw. Nearly 18 hours without sleep and yet, before bed, a demonstration to cover. The adrenaline is surging, but it's flowing into a body on the verge of exhaustion, akin to pouring jet fuel into a Model T. The secret is to keep moving and make yourself think you're awake.

"So where do we start?" David asked in an effort to wake me up. "Why don't you outline some thoughts? If I don't agree, we'll rewrite this instant view of history."

This exercise may seem rather formal between friends, but it's a valuable tool for the reporter and

producer to exchange thoughts and form a common foundation from which to report a story. It's also a necessary discipline when you haven't had a chance to fully discuss a story and are thrown together to communicate "truth." The fear is always that you might miss the real story, so two heads are usually better than one, especially given the pressing deadlines of television news.

"My impression of post–World War II Poland is struggle," I said. "First the country lost 6 million people in the war—half of them Jews—as well as most of its cities, burned to the ground. Then its political freedom was seized by the Soviet Union."

By 1956, the burden of the Soviet-imposed system had grown too heavy for the Poles. In a series of events that foreshadowed what would happen in the 1980s, workers in Poznan staged a general strike for better working conditions and an end to Soviet rule. The regime answered with force. In the end, after tanks had been called out to suppress the revolt, at least 50 workers had been killed. A memorial was finally built in Poznan in their memory but only after nearly 30 years of controversy.

The incident showed the government that a change was necessary. Wladyslaw Gomulka, a hero to many Poles because he had been expelled from the Communist party in 1948 for his opposition to Joseph Stalin, was allowed back into the party as Poland's leader.

Soviet tanks were poised on the border, but Gomulka convinced Nikita Khrushchev that Poland could solve its domestic problems. In fact, under Gomulka's leadership, the country came alive with a spirit almost comparable to that of Solidarity. Some people even talked of a national rebirth, free from the crushing Stalinist practices that had followed the war.

But the cultural renaissance ran into an old nemesis—the Communist party and a trait that marks its core, the fear of individual freedom. By 1967, the party had managed to squeeze the hope from Poland once again, failing to provide promised workers' councils within the factories.

Yet the era of resistance was not over. Students demonstrated around Warsaw University in 1968, and on December 14, 1970, shipyard workers marched down the streets of Gdansk to protest declining living standards and steep food prices. What began as a march soon got out of control. Communist party headquarters was burned along with 220 shops and 19 buildings. It was enough provocation for the authorities to retaliate brutally. Again, tanks cleared the streets and left about 50 dead. Among the demonstrators was a young man named Lech Walesa, who would never make the mistake of letting his unionists take to the streets. The 1980 Gdansk strikes would be far more effective because they never left the confines of the Lenin Shipyard.

The bloodshed meant the end for Gomulka's 14-year-old government, and Edward Gierek came to power. Under his economic plan, wages went up 12 percent within two years. New industries were formed with the help of massive technological aid from the West. Soon production capacity doubled and with it Poland's debt. By 1973, Poland owed the West about $2.5 billion; the debt was more than $20 billion by the end of the decade.

Poland was scheduled to repay its huge loans by selling all its newly manufactured products to Western markets. But no one could foresee the energy crisis of the early seventies, which brought on inflation and recession in almost all economies, including that of the United States. Forced into competition with superior products on various markets, Polish goods were unsuccessful and sales quotas went unmet. The Polish economy began to decline. Its more stable products were taken out of internal consumption and exported to obtain hard currency to pay off the country's debts. Those products included food, which had always been plentiful in Poland, one of Europe's leading grain producers. If the Poles prided themselves on anything, it was eating well. They especially depended on pork, which got them through the winters. But farmers now found it unprofitable to raise pigs. Meat, vegetables, tractors, cars—all seemed to be leaving the country, making it difficult for Poles to buy even goods produced in Poland.

Then yet more bad luck. Several bad harvests required Poland to import food, which in turn

At a Rural Solidarity meeting in 1981, a speaker talks of farmers' difficulties in getting equipment. The government's policies favored state-owned farms over private ones.

required still more borrowing. Lines of people waiting to buy goods began to get longer as shortages appeared. Housing slumped, imports were restricted, and such essential items as medicine ran into short supply. So the lines grew.

In addition to these problems, Poland's agricultural policy was failing miserably. At the heart of most Communist countries is the collective farm run by the state, but not in Poland. Seventy-five percent of all the cultivated land was still privately owned and farmed. These owners supplied 80 percent of the country's food and competed directly with the state-owned farms. The result was a paralyzing standoff. The government provided its collective farms with excellent equipment and capital for investment, which were virtually wasted on only 20 percent of the nation's produce. The private farmers, who had to struggle to obtain seed, tractors, fertilizer, fuel, and spare parts—all of

which were becoming increasingly expensive— were unable to turn a profit. Some Poles believed this dilemma was part of a Communist strategy to allow the state to gain the upper hand by destroying the privately owned farms. Many private farmers did begin leaving the land, since the cost of production exceeded the prices they could get for their crops.

The inevitable cycle that led from soaring inflation and poor harvests to food shortages and rising prices touched off the most notable demonstrations in Poland's era of unrest since 1970.

"So the stage was set for revolution," I suggested to David at the close of our summation.

"Set—yes," he replied. "But there were still a few more elements to the equation this time, not the least of which was a population manning the protest line that was under 40 and had not known directly the pain of the Stalinist years, and thus

A Polish woman signing a petition demanding that Rural Solidarity be recognized.

was much more willing to demonstrate.''

As we raced toward the Rural Solidarity meeting, the countryside changed from stalag-style housing projects to open fields still dark with the ugly ground cover of melting snow. Through it all was a wet, biting cold you couldn't escape.

"When the highway was opened between Poland and the West under Gierek, a lot of things came in with the investment money," David continued. "American blue jeans and movies flooded the country; just look at the Elvis Presley movie in our hotel. And discos are the most popular form of entertainment here."

"It certainly is the stuff that inspires fantasy, and when it's cut off it can be quite a disappointment," I said.

"One other thing," David added. "When the economy faltered, so did the Polish faith in the Communist party leadership. There are still a lot of rumors about government corruption, and they eroded all trust in current economic policies."

"All this is true," I said, "but one of the most important catalysts of revolt was Polish pride. The greatest moment in Polish history may have been the 1978 selection of a Pope from within the Polish Catholic Church, which had been the refuge of the devout through all those postwar years. The importance of Karol Cardinal Wojtyla's elevation can't be overstated."

"Sure, it was a confirmation for the Poles of their faith. More than that; for many, it was a divine sign that 35 years of growing Catholicism under an atheistic system was smiled upon by God, who rewarded Poland with a papal ring."

"Enter the Pope's visit in June 1979," I said. "His message was incredibly important for Solidarity. It united the people and left them with the conviction that their struggle for individual freedoms was a just one. Two months later Solidarity was forged in a Gdansk shipyard."

Our hurried discussion of Solidarity's beginnings merged into living history as we came upon heavily bundled parishioners leaving a church set back among evergreens. A man with a loudspeaker barked instructions that directed them into marching formation for the walk to the soccer field, where the Rural Solidarity meeting would be held. At the front of this collection of ruddy faces was a large banner picturing the Black Madonna that flapped from three sticks held together by the farmers. They stepped off in front of the crowd and came toward us, heading directly for some large puddles of rainwater in the street. The hardy farmers slid their boots through without hesitation. I stood with Skip, videotaping as hundreds passed. They were silent, I remarked, as if the cold had taken their voices, leaving only the sound of boots on the asphalt.

At the soccer stadium, the farmers sat huddled together, paying close attention to speeches about their problems—the need for tools, jeeps, all the things that the state-owned farms got without asking. Then came the cry for a Rural Solidarity to organize the farmers into a bargaining unit that might demand some of the reforms obtained by

their brethren in the shipyards. The crowd responded enthusiastically.

This was Poland at the height of Solidarity's popularity. It was a movement that animated groups with the promise of a better future, and it fired up the dreams of every Pole. The trade union of the Gdansk yards was only one of many that answered Solidarity's call. Bus drivers and deliverymen who supported railwaymen on strike; workers in a ball-bearing plant; unionists in a tractor factory; newspaper deliverymen; glass workers; tram drivers; 20,000 workers at a helicopter factory in Swidnik; garbagemen in Warsaw; Silesian coal miners—all were linked together under the umbrella of Solidarity.

The movement's leaders had stopped counting membership at 10 million, which made Solidarity larger than the 3 million–member Communist party and second in Poland only to the Catholic Church. The sense of excitement Solidarity had inspired must have been the same as that which followed Gandhi in India and Martin Luther King, Jr., in America, the knowledge that truth was being spoken and would not be denied. Was Solidarity then a revolution? By almost any measure, yes, but it was wiser to call it a social movement and not invite confrontation with the party.

Every revolution has a leader, someone who expresses the emotions of the masses. In Poland, it was Lech Walesa.

As our team traveled from rallies like the one for Rural Solidarity to the streets of Warsaw, trying to chronicle the depth of feeling inside the country, Walesa seemed to be taking a parallel course, popping up at labor disputes to mediate problems that, ironically, he had caused by striking the first spark of hope. Now he was attempting to hold the rising spirit of Solidarity within control, preaching patience and nonviolence, knowing that all too easily it could spill beyond the limits that the Communist power structure would tolerate.

Having witnessed violent riots in American cities and the results of the Vietnam War—the bodies shipped home day after day in plastic bags—I was often shocked to realize that the revolution of Solidarity took place without a single martyr.

We had a difficult time covering Walesa, since he was moving around the country quickly and without a prearranged schedule. Once we met him entering a Solidarity organizational meeting, another time arriving to speak with strikers, always with a trail of cameramen and reporters. He would pause briefly amid the blue television lights to talk with the press—not playing to it, but responding dutifully to those who had supported him and elevated him to his position of leadership. Walesa appreciated the power of the press and used it as his personal means of communicating with the Solidarity membership. In private conversations he liked to bypass the reporters and talk with the technicians because he regarded them as the "workingmen" of the media, separate from the reporters and producers, who were management and were ordered around by their "corporate, capitalistic bosses" in New York.

One night in Warsaw, David and Skip found Walesa in the dark restaurant beneath the lobby of the Intercontinental Hotel, on Victory Square. They ingratiated themselves with a bottle of $80 champagne. Walesa was grateful and promised to open up his schedule for a brief interview the next day.

As he sat for the questions, his quiet confidence was evident. The thick, chestnut mustache was split by a curving full-bowled pipe he had taken up to stop cigarette smoking. His clothes were those of a laborer, his hair slightly uncombed as if he had just left work.

Patiently Walesa answered my questions about Solidarity's future, expressing confidence that the union was not trying to accomplish too much too quickly, that labor unrest could be controlled, and that Solidarity would be able to turn the economy around. The rising criticism that Solidarity was inviting Soviet intervention prompted me to repeat the single most-asked question of the time: "Aren't you afraid of Soviet troops?"

Walesa replied bravely and calmly, his thoughts reflecting his years of living with the threat of Russian military might. "We are not afraid," he said. "They are our friends. Besides, we can't live our lives always planning against the

possibility of Russian troops being sent into the country.'' After 15 minutes, he walked alone to a private car for the trip to yet another strike several hundred miles away.

We live in an age in which leaders must excel in two arenas, one that is out of the public eye—in Walesa's case, the negotiating table in Gdansk—the other in front of the camera. By presenting the public image of a plain-speaking laborer, Walesa, the lightning rod for 36 million Poles, was following a pattern set by other popular leaders. Gandhi gained support for his crusade against the British by living as most of India did: in poverty, spinning his own cloth. Martin Luther King addressed his audiences as a black preacher would lead a congregation, a manner familiar to most blacks. Walesa spoke for the common man of Poland, the worker, with whom every Communist would identify. He was an uncomplicated man whose education had come from a factory and who had never been outside his native land in August of 1980. Yet he took the reins of leadership in one of the most startling displays of defiance of the Communist system in its history.

Always Walesa checked his emotions, rarely displaying anger in tense situations. He had told strikers in Gdansk that when one has lived with anger and hurt for so long he learns how to control them. He could also direct the mood of a crowd as a conductor might lead an orchestra from one movement to another. He did it with humor and a casual delivery.

Before martial law was imposed in December 1981, one of the most popular books in Poland was *The Book of Lech Walesa,* a collective portrait written by Solidarity members and friends who had observed him at close range from his first days in the Lenin Shipyard through the 17-month life of Solidarity. One of them, journalist Neal Ascherson, describes Walesa as ''a born troublemaker, but a troublemaker who lusted after compromise rather than extremes. . . . [He] adored the actual business of negotiating: the shatteringly hard opening position, the leaving of doors ajar, the gradual trading-off in hard talk sessions until both sides could shake hands with pride on a gleaming

new settlement.'' Walesa, Ascherson writes, was truly ''a workers' tribune, which is more than a spellbinder. . . . [He] dominated the Gdansk strike not through oratory but by something much more proletarian: patter.'' That portrait agrees with the impression I received of Walesa. His speech was common and yet he could achieve an electricity with a crowd.

One example of how the workers thought of themselves, which might explain why Solidarity caught their imagination so quickly, can be found in the days before the birth of the trade union. A temporary cross had been raised in front of the Lenin Shipyard to mark the spot where the first dead protesters had fallen in the December 1970 uprising. On it was placed a piece of paper decorated with a red-and-white ribbon and a small picture of the Madonna, with the words of Lord Byron slightly paraphrased in the Polish translation:

> Battle for freedom
> Once begun,
> Bequeathed by father
> Passes to the son.
> A hundred times crushed
> By the foe's might
> Still it will be won. . . .

Walesa nurtured these sensitive memories of past demonstrations and used the resistance of the authorities to turn this memorial into a rallying point for his own strike in 1980. He once told a crowd of workers to bring a stone in each pocket to their next gathering and they would make their own pile as a memorial. It was pure and natural leadership.

The first time I saw Walesa was during his trip to Rome in early January 1981, just a few weeks before our visas were granted to enter Poland. David, Skip, Phil, and I had been in Israel reporting on a group of Black Hebrews from Chicago who declared they were the chosen people and were returning to claim their homeland of Israel. We had stopped in Italy for a quick visit to the area hit by an earthquake in November 1980 and just happened to be in Rome when Walesa landed on his way to an audience with the Pope.

The entire European press corps seemed to have turned out at Leonardo Da Vinci Airport to see Walesa, creating a scene not unlike a riot. We lined the hall that led from the plane's exit gate, wedged together so tightly it was difficult to function. David, Phil, and I tried to shield Skip from the pushing and shoving so he could hold the camera steady as Walesa was led by body-blocking Italian police through the throng. He and his entourage were spewed into a waiting bus, but Walesa found an open window and began mugging for the cameras following his every move. He appeared to be enjoying the experience, taking it completely in stride, even though the mob scene left others bruised and cursing.

That afternoon I walked with him, literally elbow to elbow, through St. Peter's Basilica as his small group toured the area near Bernini's canopied altar. The casual tour allowed me to mingle with these Polish visitors as a Polish-speaking

This wire-service picture, showing Lech Walesa with the Pope at the Vatican, 1981, was an important symbol of the Church's approval of Solidarity.

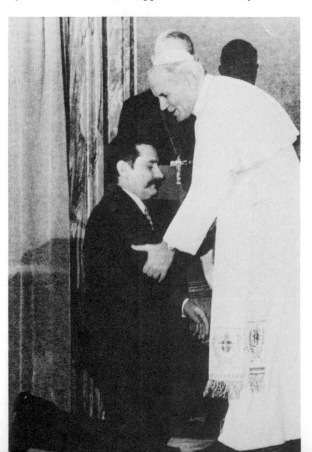

priest led them from Michelangelo's dome to his *Pieta*. At one point they knelt for a short prayer, and I saw tears on many of their faces, a measure of the true devoutness that had been a key to Solidarity's acceptance throughout the country.

Every Pole dreams of seeing the Pope at the Vatican. When the wirephotos reached Poland showing Walesa kneeling before John Paul, and the Polish Pope helping him up, it was more than a greeting for a Polish laborer, it was a papal blessing of Solidarity. The symbolism was the validation the movement sought, and it gave Solidarity inestimable strength.

The importance of the link between the Pope and Solidarity might be judged by the assassination attempt made on the Pope in May 1981. There are suspicions that the KGB, working through Bulgarian police, sponsored Turkish gunman Mehmet Ali Agca. The motive? The Pope's support of Solidarity and the fear that he might return to Poland if the Soviet Union invaded, as he reportedly warned the Soviets he would in 1980.

We had arrived in Poland only six months after the Solidarity movement began, but there was already a remarkable change in attitude. Where once we would have been under surveillance during our time within the country, no attempt was made to watch our movements. Conversations were freer and included the public exchange of political views, a clear departure from the past, when the old Polish saying "When a Pole comes home from work he changes his shoes and his views" was sadly apt. After the rise of Solidarity, one Polish man told us, they were changing that phrase to "When a Pole comes home from work he changes his shoes—period."

The new feeling of optimism was apparent on every level. I saw it in the face of a tall man, his dark coat turned up against the chill winter wind, straining to see the beginning of a serpentine line he had joined. He saw only the cold breath of his fellow Warsaw shoppers and the shifting of their heavy frames from one foot to another, which gave the column a false sense of movement as it twisted out of sight around a corner. One full city block

from the newcomer's position, the line ended in a flurry of arms and elbows struggling to enter the doorway of a *delikatesy* to buy a few tins of tomatoes.

It was a common scene in Poland that winter. Lines were longer than at any time in history, created by shortages of meat, fruit, dairy products, flour, and appliances. No store was immune from the empty shelves. Yet this particular line showed something far more significant than just another shortage. Even after standing for hours in the cold dampness, the people were cheerful, their rugged faces smiling. They spoke animatedly about Solidarity.

The appeal of the new movement was illustrated further on the second night I was in Warsaw. A successful Polish couple invited our team to dinner in their apartment. I was suffering from jet lag and fought to keep my eyes open, which is always the time when the most important interviews fall into your lap, those little events that provide key ingredients to understanding a story. In this case we were after the reason for the attraction of Solidarity.

The husband was a member of the Communist party and an engineer. His wife was also an engineer and had joined Solidarity.

After a delicious meal of ham and sausage, spiced with generous helpings of Polish vodka and a favorite beverage of cherry juice, our hostess felt compelled to explain how she could serve such an ample meal in a country with block-long lines. She also seemed a bit self-conscious about their apartment, which was full of the latest appliances and was luxurious by Polish standards.

"We get the food through connections, some by knowing people in the party, some by diplomatic sources," she volunteered. "That is a way many people get by—trading through friends and," she repeated, "connections.

"I hope Solidarity will influence supplies on the market and the standard of living," she added. Obviously, her membership in Solidarity was based on very pragmatic reasons.

Despite the late hour and excessive amount of vodka, I managed a question. "Can you describe for us the difficulties you now have getting goods on the market?"

"Well, if someone wants an automatic washer, he must pay the total price for the privilege of having his name placed on a list of buyers who must wait, for years sometimes, for the next shipment. Young couples routinely live for five to six years with their parents until they become eligible for housing. It is a practice of many parents to place a child's name on the housing list when he enters elementary school, so that when the child nears the age of marriage the wait won't be so long."

Although the wife had done the talking to explain her support for Solidarity, it was the husband who summed up, "All these things we hope will be helped by Solidarity."

The evening grew late. As Skip and Phil packed away the lights and camera, I walked slowly toward the door with the husband, now deep in thought. He admitted that within a few days he would join Solidarity, too, and not just to please his wife. He explained, "I think we are dealing with the particular character of the Polish economy. There have been restrictions in recent years, import restrictions, employment restrictions, and all of them have obstructed the economy. What we need is a new approach. There are enterprises that require many employees. When there are restrictions they can't function. That's why changes are needed, along with a new responsibility on the part of managers."

That was the kind of talk I found dominating conversations in homes and public places, not the latest sporting event or wave of punk music. The country was seriously engaged in deep thought about the individual's responsibility to society, the kind of issue Western nations leave to elective courses in a liberal arts college. Here in Warsaw, it was the stuff of life, and it provided an atmosphere tingling with the unknown, similar to what we knew in the sixties when the youthful counterculture of America was challenging major institutions and beliefs.

Solidarity had wrought many other changes in Polish society. Before August 1980, state-controlled television and radio broadcast only cen-

sored information. The Gdansk shipyard agreement of August 1980 granted Solidarity access to the media for the union's purposes, a startling concession, for it created an alternative source of information that would bypass the Communist government.

Also included in the agreement was permission to broadcast religious services over radio, Solidarity's gift to the Church, another example of the hand-in-glove relationship between the trade union and the Church.

Sixty thousand printers became members of Solidarity and pressured their censors to let them print the truth, threatening to print blank spaces where the censor's cuts had been made. At one point, printers working on the *Zycie Warszawy* newspaper refused to print articles critical of Solidarity. Journalists also benefited from the printers' negotiations.

Two thirds of the employees of Polish television became members of Solidarity.

The five-day work week, which had taken ten years to achieve in East Germany, took only six months in Poland under Solidarity.

The atmosphere was best described by our driver, a student working as a tourist guide, who spoke wistfully of his father.

"My father is a disappointed man. For 35 years he's worked hard in the belief that it would be good for his family, and now we don't even get a washing machine, automobile parts, or food. Thirty-five years ago he thought it would all work out, that his generation would sacrifice for later generations of Poles—his sons—but he's bitterly disappointed." It was for this kind of man, he said, that Solidarity had the most appeal.

Solidarity signs were hanging from buildings throughout Warsaw; small window shrines bore pictures of Pope John Paul II wreathed in the red-and-white banners of Solidarity; the familiar lettering appeared on T-shirts and small pins everywhere. The feeling? It was the pride of Neil Armstrong's walk on the moon, the triumph of Charles Lindbergh crossing the Atlantic, the belief that man can achieve anything.

But the optimism created by the bright scarlet letters of Solidarity was soon to be shaken. Things were happening too fast.

A strike by workers in Jelenia Gora in February 1981 included demands to relinquish a vacation resort used exclusively by Communist party members, an example of what the country's leader, Stanislaw Kania, described as the growth of Solidarity into a political opposition force. Even those sympathetic to the cause were afraid Solidarity was going too far, that Walesa was dangerously close to losing his comfortable negotiating relationship with the ruling party and precariously near the edge of chaos.

I left Poland holding my breath in fear that Walesa's tenuous control would vanish before I could file my reports. These included a half-hour docu-

Pope John Paul II celebrating an afternoon mass outside the Jasna Gora monastery in June 1983.

mentary—"Poland: A New Spirit," which aired on WBBM-TV on February 20—and two articles for the *Chicago Sun-Times*. The Chicago Polish community was extremely interested but holding its breath as well, nervously watching Walesa walk the line between his radical supporters and the fearful party.

In the end, of course, it wasn't the Soviet Army that invaded. Poles moved against Poles. The final action that precipitated a move against the union took place on December 12, 1981, when a faction of Solidarity's leadership called for a referendum on establishing a non-Communist government, declaring that "society cannot any longer tolerate the existing situation in the country."

The next day, the government declared a state of emergency and issued a decree of martial law, suspending civil rights and banning Solidarity. And Poland found itself slipping into yet another miasmic period of despair.

Rain fell on the crowd at Jasna Gora monastery that day in June 1983 and then gave way to sun, which shone briefly through the broken clouds before being pushed aside once again by soft showers. Sun and shadow played across the immense throng, giving it new movement as half the people put up their umbrellas while the other half took them down. The crowd seemed undaunted by the weather and continued to wait patiently for Pope John Paul.

His was a delicate mission. How would he tell

Priests prepare for communion at a mass conducted by the Pope at Jasna Gora. The massive crowd retreated under their umbrellas from time to time throughout the day but never left.

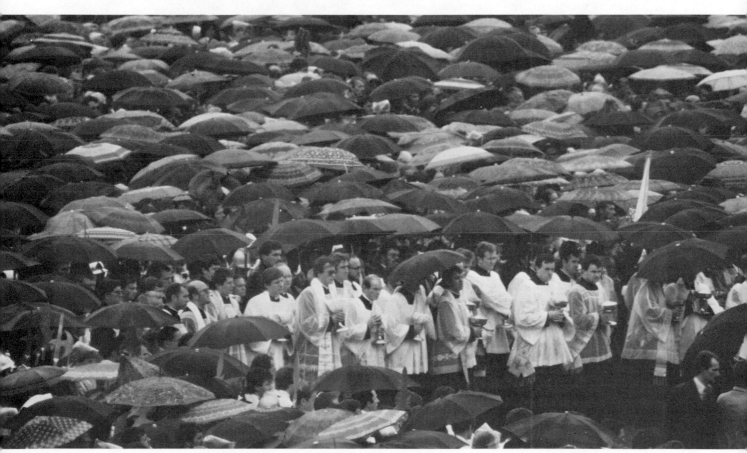

the truth yet avoid calling for change, which would violate the agreement by which the Polish government had allowed him to come and could invite bloodshed?

The Pope had spoken at several locations since his arrival in Poland three days before, and each speech was stronger in its criticism of the government and more daring in encouraging the people to reach out for the human rights due them. He hadn't mentioned Solidarity the trade union but asked the Poles to have solidarity with the Church. This was the language spoken in a totalitarian state, one of double meaning. The Pope's message would have been obscure to an outsider, but the Polish crowds understood exactly what he meant, responding with lengthy applause and enthusiastic choruses of support.

When John Paul finally appeared before the colossal crowd at Jasna Gora, the people released the emotions they had been holding back for hours in a roar of greeting. The Pope slowly began to speak. He described Jasna Gora as one place where the Poles have always been free. When Poland was wiped off the map as an independent state, the history and soul of the nation remained in the shrine of the Black Madonna as a symbol of hope, he preached.

"The evangelization of freedom at Jasna Gora has yet another dimension. It is the dimension of the freedom of the nation. The nation has a right to live in freedom. This is one of the fundamental rights in the moral order. The right to live in freedom means the right to decide for oneself as a community determined by unity of culture, language, and history. This right is realized through the institution of a sovereign state."

Then he added, "And it is here, too, that we have learned the fundamental truth about the freedom of the nation: The nation perishes if it deforms its spirit, the nation grows when its spirit is ever more purified, and no external power is able to destroy it!"

Those words were not meant as crowd-pleasing rhetoric. They were offered as guidance and stated without qualification.

There were occasional outbursts of applause and cheering for the sturdy blond Pontiff; when the word "solidarity" was mentioned the masses would poke the air with their fingers in a V-for-victory sign. The Western press interpreted these actions as defiant support of Solidarity, easy to capsulize in headline form.

But for the most part the people were quiet. The television cameras did not show the ring of militia at the rear of the crowd, hundreds of uniformed police fully equipped to handle any disturbance. The crowd knew they were there and that small riot squadrons were stationed around the city with mobile high-pressure water cannon. The scene at Jasna Gora exemplified the nation's plight perfectly. With their faces trained upward the Poles listened to the words of hope that came from their beloved leader, but at their backs beat the heart of the Communist party—the militia.

From my vantage point high above the crowd on the monastery wall, I stood musing about the future of Solidarity, wondering if it could survive military rule. So, as John Paul went on to address the faithful at Poznan, Katowice, and other cities, I struck out across the countryside to measure the effects of the crackdown and to judge whether Solidarity was really dead.

Some signs of martial law were easy to spot, like the constant presence of police. Others gradually became clear through conversations with Polish scholars and Western observers.

All Polish newspapers had been shut down in December 1981 except the three official government outlets. Gradually they were allowed to re-open but journalists were forced to appear before a commission and vow that they didn't believe in Solidarity, much like early Christians renouncing their faith in Jesus to the Romans. Some chose dismissal rather than doing so. Those journalists who had been active in the union were blacklisted and not rehired. Others elected to work on minor journals, like the head of the journalists' union, an active member of Solidarity, who dropped out to work for the *Journal of the Cooperative for the Blind*. Its distribution was only 500 copies, half of them in braille. Suddenly, with the infusion of new ideas, it became the most popular journal in War-

saw. Although a new journalists' union was set up by the government, Poles boycotted it to protest martial law.

Members of the actors' guild took similar steps, refusing to appear on government television. The result was boring entertainment.

So at a time when Poland desperately needed professionals, thousands of well-educated people from all walks of life were giving up their careers to drive cabs, run used book stores, or simply retire at the early age of 55, as permitted by Polish law.

There were, of course, many who chose to continue working under the government, some because they couldn't afford to drop out. The underground journalists' organization provided for such an exception and allowed the member to work as long as he or she didn't write anything against Solidarity. In other cases, workers were seduced back into service by the beckoning administration, which was admittedly more liberal than previous Communist regimes, probably because of Solidarity's protests. Liberal professors and journalists were employed in responsible positions, a far cry from the bureaucrats who traditionally rose through the Communist party apparatus. Despite martial law, these people actually found oases of liberalism. Academics, for instance, enjoyed a surprising degree of freedom.

As a result, tension arose between those who took hard stands of sacrifice and the "collaborators." It was common, I was told, for confrontations to occur at parties, with people accusing their friends of giving in to the government and those individuals insisting that even under martial law Poland had to survive.

Perhaps the most serious consequence of military rule was the death of hope. Poland's population, half of which is under the age of 30, faces a future with a $26 billion foreign debt and a government unable to feed its people.

Late one night, I visited American scholar Jane Curry, who was renting an apartment in a complex not far from Warsaw's center. We sat in her large living room, which she said was lavish compared with the scale of most Polish apartments. She described living with the high prices that had replaced the lines outside food stores.

"I earn an average salary of about 10,000 zlotys a month [about $100; a zloty is worth about a penny according to the official exchange rate], about what most bureaucrats are paid," she said. "If I were the main breadwinner in my family I could hardly afford it.

"A pair of sneakers for a child costs 2,000 zlotys, if you know where to find them. Everyone hopes they can find a friend who is going to Czechoslovakia so they can get their shoes cheaper. A blouse costs 4,000 zlotys—again, if you can find one. You see lines in front of stores for material. Cotton, linen, wool—anything that comes in, they line up."

It was true. I had seen such lines in front of fabric stores.

"My housekeeper bought 20 eggs," she continued, "two batches of honey, one liter of milk, and a loaf of bread. It cost 800 zlotys. A kilo of meat costs 450 zlotys. You can't eat much on a salary of 10,000 zlotys a month."

Martial law meant restriction of travel, assembly, and political activity, as well as increased surveillance by secret police, who were seeking evidence not of criminal but political activity.

Some people I talked to believed Poles have become so depressed about their future that they have given up long-cherished hopes, such as being able to travel or to move into a bigger apartment. Instead, the theory goes, they have decided to stay where they are and have children. In 1982, there were 700,000 births in Poland, an unwanted explosion in a country with chronic food shortages.

I returned to the United States in late June and, along with the rest of the free world, watched the careful dance between Communist party officials and Pope John Paul. When he arrived back at the Vatican, Church officials disclosed that an agreement had been reached with the Polish government for the Church to provide aid to Poland's agricultural economy. The money would come from foreign contributions, including donations by the United States Catholic Relief Services and several European governments; some estimates put the total amount at $2 billion. The stage seemed set

for a history-making partnership between the unlikely allies of the Roman Catholic Church and a Communist government. The plan had pluses and minuses for the Church: On the one hand was the possibility of further liberalizing the Communist system; on the other was the explosive potential for economic failure, due to Poland's depressed farm economy, which would be laid at the Church's feet.

Weeks after the Pope had left his homeland, and 19 months after it was imposed, martial law was lifted. The act of July 22, 1983, however, was a hollow one. In the two days previous, the Polish parliament enacted new legislation that was, in some cases, even more restrictive than the provisions of martial law. It granted amnesty to some political prisoners but made participation in secret unions or associations or in those that had been dissolved punishable by up to three years in prison. The new laws represented Solidarity's epitaph.

But the importance of the movement that swept Poland in August 1980 was not in a single name. A human spirit bubbled up from within a repressive system, a spirit that cannot be legislated away but waits for another means of expression.

That is why the new laws were so harsh. The Communist party of Poland knows that the ghost of Solidarity will be back. Sadly, for the Poles, the resistance of their government means a long fight.

The persistent dilemma of Poland was contained for me in a scene in the courtyard of St. Anne, in Warsaw's Old City, where a cross made of flowers was outlined on the sidewalk. The cross was originally formed in 1979 at Victory Square, the site of a speech by Pope John Paul during his first visit. This set up a series of skirmishes between Poles laying down their flowers and police washing them away with water cannon, until finally the square was torn up by the authorities and labeled closed for repairs. Soon the floral cross reappeared at St. Anne's, and day by day messages found their way anonymously among the blossoms—I saw memorial notes to honor demonstrators killed in the early days of martial law, a cross made of small pieces of coal saluting the eight Katowice miners who died in December 1981 protesting the crackdown, and, pinned to withered flowers near the base of the cross, a small note that spoke from Poland's heart in its hand-lettered words:

Only here is Poland free.

Left: The cross in the courtyard of St. Anne became a center of political statements, placed among the fresh flowers. Right: The V-for-victory, a sign of Solidarity's unquenchable spirit.

Under Arrest

In the final hours of my second Poland visit, I experienced an incident that allowed me to appreciate firsthand the repression of martial law.

The Polish communications service Interpress had assigned an interpreter, Jan, to accompany me during my few days covering the Pope. He was a young man who had lived in the United States while his father was on a diplomatic assignment. Our driver, Eddie, was older, having served in World War II. Both men were enthusiastic about my task of photographing not only the Pope but representative vignettes of Polish life, such as the castles of Krakow as well as lines in front of the fabric stores. I had seen much during our trip through the rolling farms of central Poland, including the shocking death camp at Auschwitz.

On my last day in Poland, Jan asked if I would like to see a more typical Polish market in Warsaw in the few hours before I caught my plane home. Of course, I replied, expecting abundant food stalls in a kind of farmers' market.

My expectations were right on target. We walked into a large open area near the city's center that was worn from the traffic of many feet. We were early, so some wooden stalls were not yet open. Those proprietors who had arrived trying to catch the early business seemed part of a line of merchants that stretched back centuries, unaffected by Communist or capitalist leadership. One could find a similar collection of sellers in any community of the world, in the Iranian bazaar, Chicago's Maxwell Street, Spanish Harlem, or a West Coast flea market.

I took pictures with a telephoto lens so I wouldn't disturb the people's natural poses nor intrude. The population had not accepted martial law gracefully, and the popularity of the Polish militia had reached an all-time low. I didn't want to be identified with the government.

I came upon a line of women who, unlike the other merchants who had their wares displayed in stalls, were selling goods they held in their hands.

"Jan, what's this?" I asked.

"These women don't want to pay the slight tax charged for the use of the stalls, so they stand in that one line and try to sell those things in their hands," he said. They held brassieres, slips, some children's shoes and dresses. We walked close by them, and when they saw the camera, instead of shrinking away, they smiled and posed, flattered at the attention.

We got a similarly warm response from vegetable sellers displaying a picture of Pope John Paul among their beets and onions and from a mammoth peasant woman sitting behind an intricate stack of eggs, divided according to colors of pearl, ocher, and russet. I raised my

The extraordinary love felt by the Poles for Pope John Paul II was evident everywhere, even in this marketplace in Warsaw.

150-mm lens, framed her with the eggs, and squeezed the shutter release. A dark form crossed the lens. It startled me because my attention was concentrated on maintaining focus. As I brought the camera down, a middle-aged man of medium height was standing close to me with a serious look on his face. He wore slightly faded blue jeans and a red plaid work shirt. Another man also in civilian clothes stood slightly to his left.

The first man spoke forcefully in Polish as he reached into his back pocket to pull out a folded leather billfold. It contained what I took to be police credentials of some kind. Jan had composed himself by this time and whispered to me in shaking tones, "He says you must go with him."

"Can you talk with him?" I asked. "Surely we have permission. We're only taking pictures. Doesn't he see our passes for the papal trip?"

There was a short conversation before Jan turned back to me. "He says your permission extends only to covering the Pope. This is not the Pope, he says. You have no authority here."

"Terrific," I replied sarcastically. "Maybe Eddie can help." Eddie was a rather salty old veteran of Polish life, and I figured he would know what it took to get out of this situation. Instead, he became angry with the intransigent officers. I was challenged and questioned about what I was doing. It became clear that this was not a case to be forgotten. As we

This was the picture I took in Warsaw's farmers' market just before a plainclothesman stepped in front of the lens and ordered me to accompany him.

talked, a light gray police vehicle rounded the corner, and the man in the plaid shirt walked over to it to make contact.

"Christ," I said under my breath to Jan. "We're under arrest. I didn't think you needed permission to shoot here."

"You don't," he answered. "At least I didn't think you did, but then I'm new on the job. They needed extra men who spoke English to handle all the press covering the Pope, and all they told me was, 'Don't contact the underground.' I thought this was OK."

"Well, let's don't give up any film at this point. We'll just go along and tell our story or, rather, you tell your story." I finished the sentence smiling, but unfortunately young Jan was not in a humorous mood. He seemed to be seeing the dark side of his government for the first time.

The police station was just a few blocks away. I assumed it was a precinct for local police, although there weren't many uniformed men in sight. It had the severe look of a government office, purposely devoid of warmth. I was given a chair while the arresting officers retired to another room, apparently for a series of checks.

I hadn't been so nervous since my drill instructor in the Marine Corps threatened to punish me for failing a rifle inspection. But although I was sure I would be released shortly, I couldn't block the images that came to

me of a gray prison cell, my name etched in the brick above the bunk, and 12 small notches marking the months that had gone by. My light mood gradually vanished as I began to wonder how long we had been followed.

Two days before, I remembered, we had turned off the main highway between Krakow and Warsaw to visit a cherry orchard. It had been Jan's idea to show me a typical Polish setting, a beautiful farmhouse set among orderly rows of cherry trees. We stayed 15 minutes, miles from anywhere, before we backed onto a dirt road and headed for the main highway. When we turned onto the asphalt I saw a taxi pull onto the road going the other way. He had been waiting near our turnoff. It crossed my mind that it was unusual seeing the yellow "Taxi" sign against the background of country green. But it was only a passing thought and quickly blew out the window with the cherry pits I left along the highway.

Another incident came to mind as I sat there in the cold police station. I had left Jane Curry's apartment at midnight, somewhat worried about finding a cab at that hour at a good distance from my hotel. Jane had directed me about four blocks down the street to a cabstand where it was "always easy to find one waiting."

But as I was stumbling through the dark entrance of the apartment complex, a taxi with its lights off pulled up, almost as if the driver had been waiting especially for me. Innocently, I asked if he was available for a fare. He nodded and ten minutes later dropped me at the Forum Hotel. It occurred to me at the time that if the secret police had wanted to keep me in sight, I had made it excruciatingly simple for them, but that was the last that I thought of it until this point.

I was fully aware that suspicious thoughts can warp reality, creating a mental pattern out of disjointed incidents that otherwise would pass unnoticed. But then, that's exactly how life is under martial law.

After an hour, an officer led our two plainclothesmen out of the side office. He spoke English well enough to say, "We made a mistake. We're sorry for the delay. You're free to go." That was it. I declined to file a complaint or protest further. However, I did look my Polish undercover officer squarely in the eye, trying to let him know that I understood what he had been up to. With only an hour before my plane was to leave, I certainly wouldn't be going back to the market to take more pictures. Exit the reporter from America.

Secret police? Perhaps. Other network crews had been detained in Gdansk, their videotape confiscated for no apparent reason, but had my arrest been orchestrated from the inner sanctum of the Communist party? I'll never know. It could have been the work of low-level authorities within the system who feared they would miss something obvious and be reprimanded by their superiors, or who were trying to impress their constituents in the farmers' market with the fact that they could apprehend an American member of the press. What they surely did not realize was the revealing glimpse they allowed into life under martial law.